D1366025

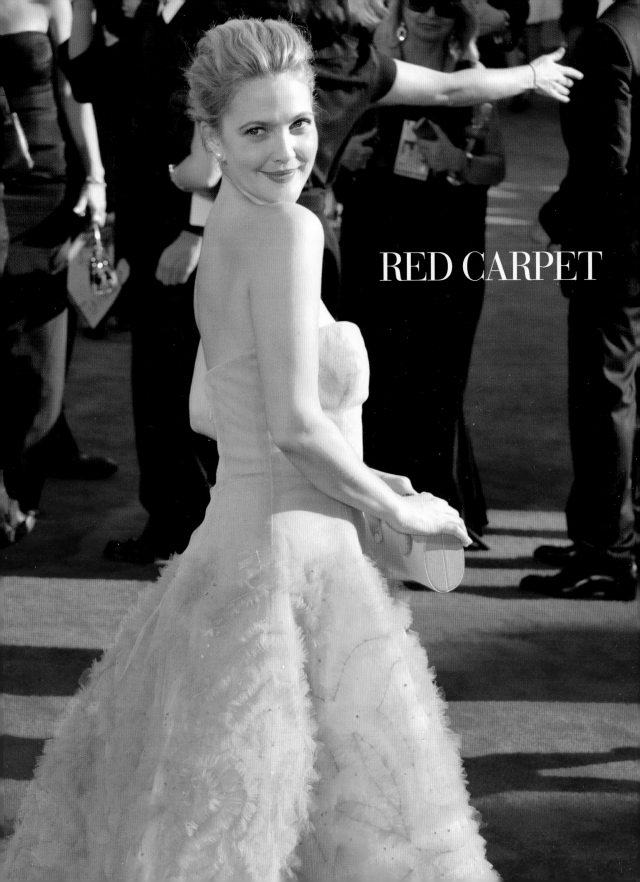

RED CARPET

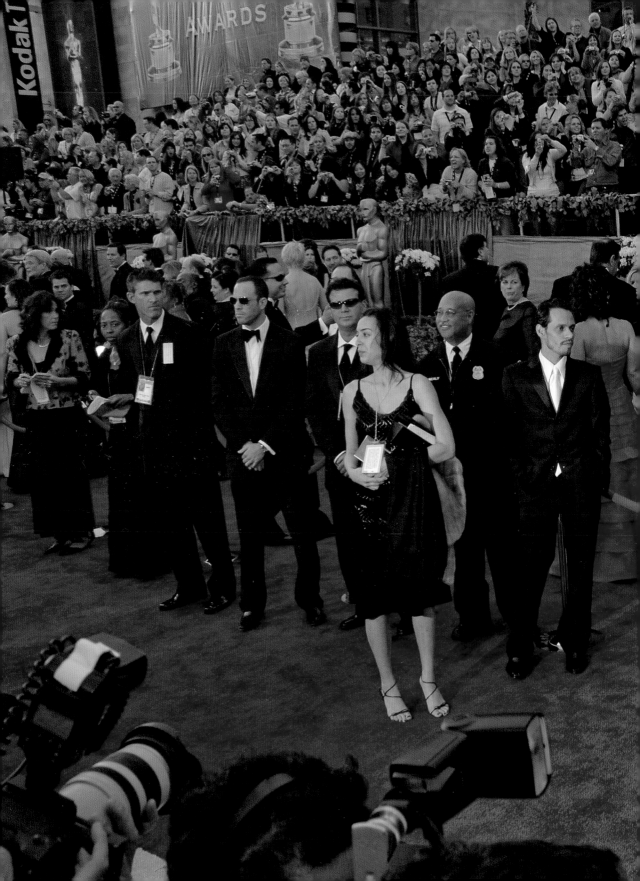

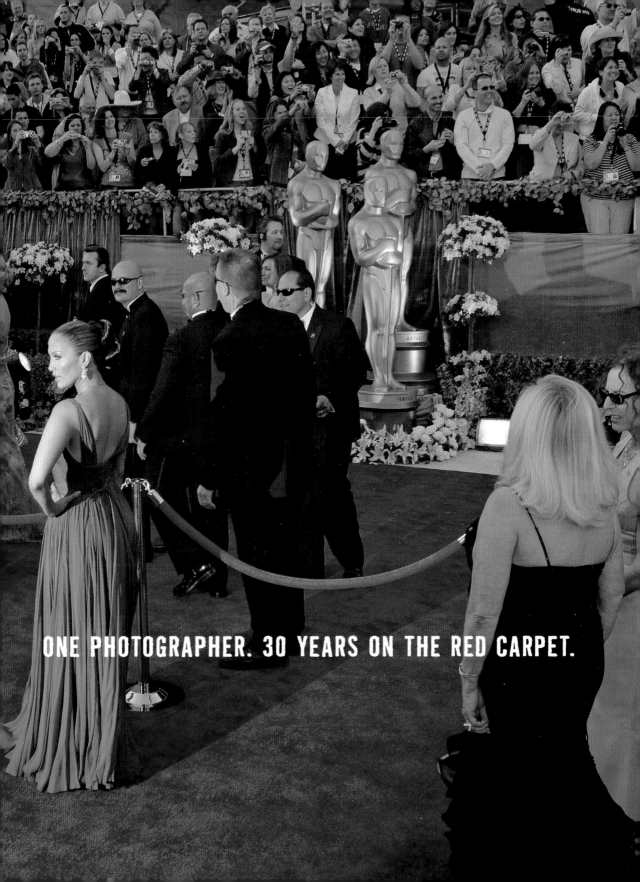

ONE PHOTOGRAPHER. 30 YEARS ON THE RED CARPET.

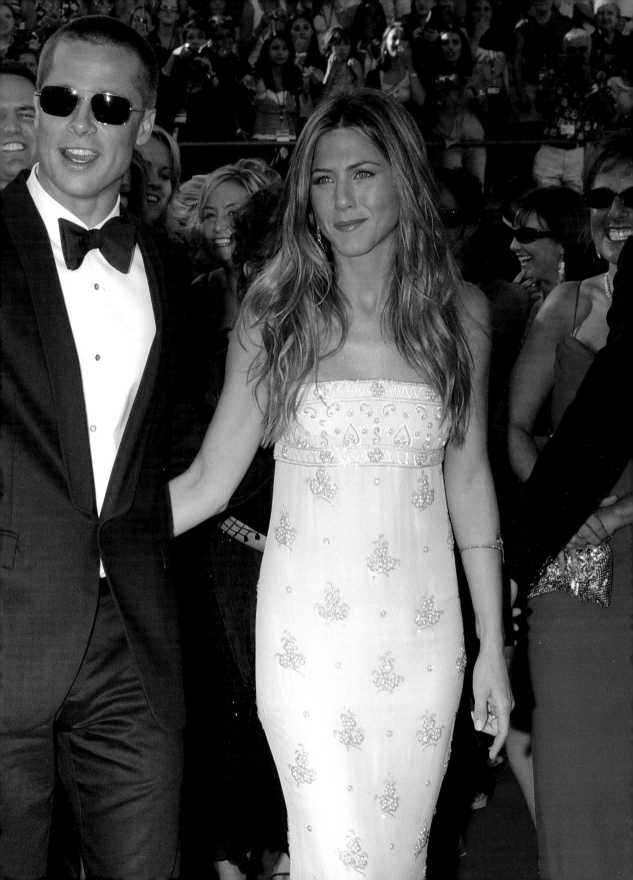

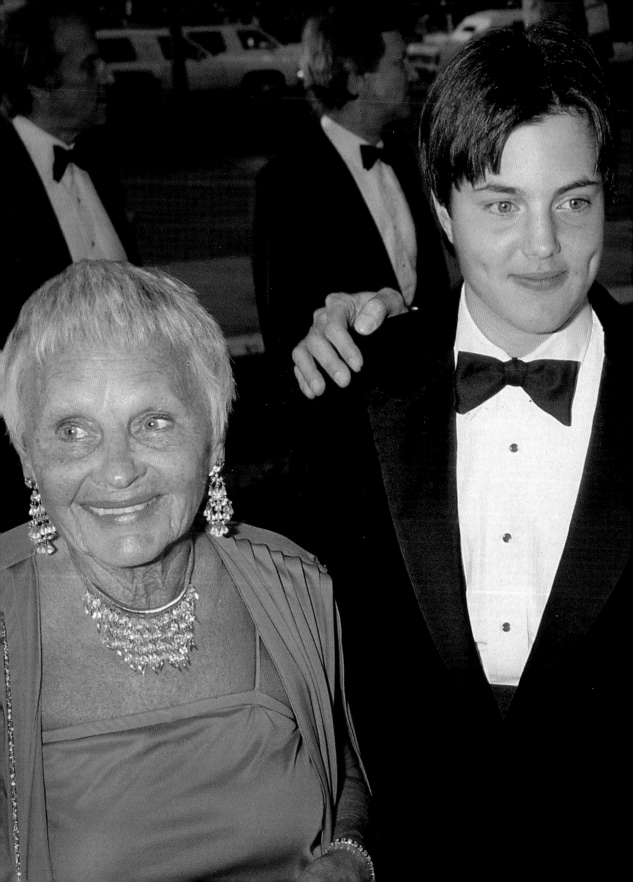

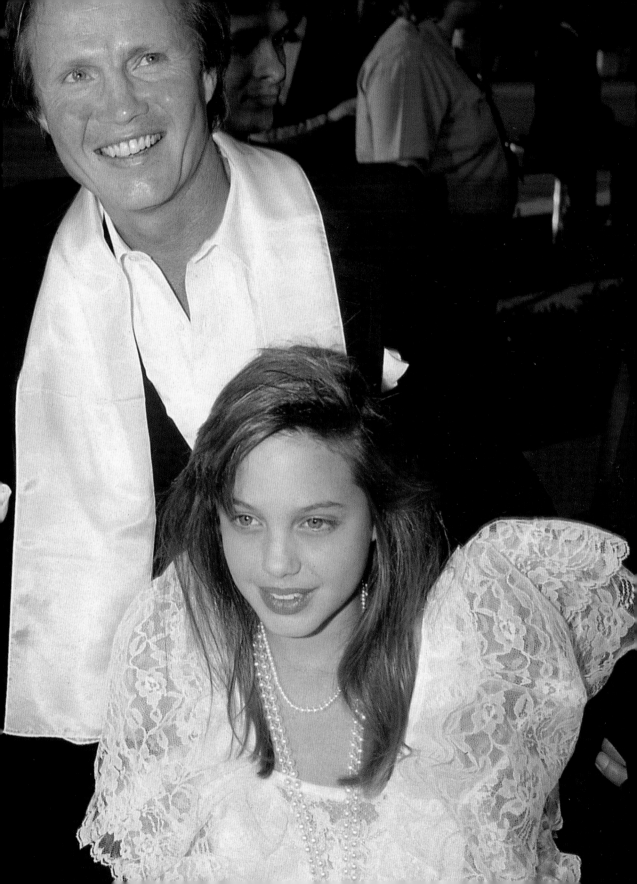

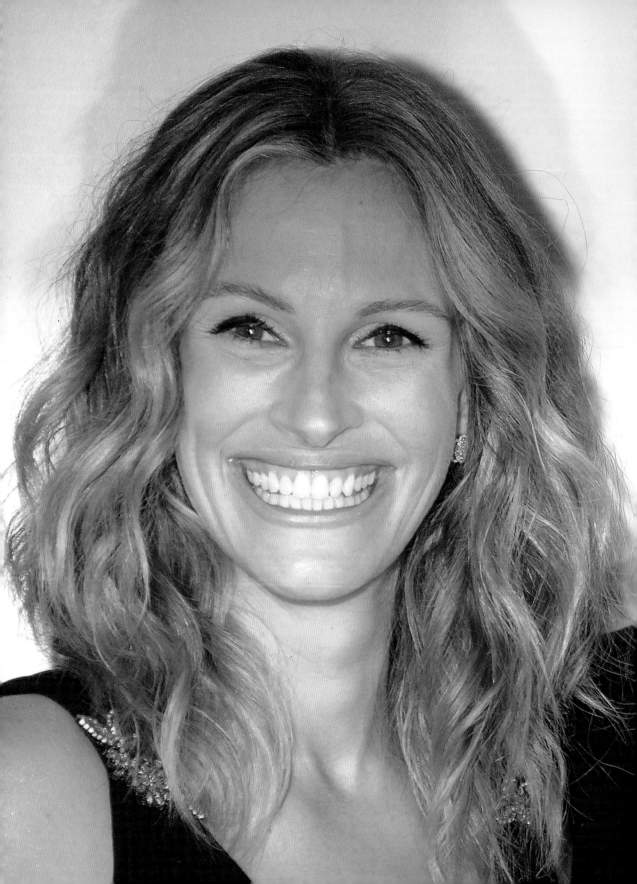

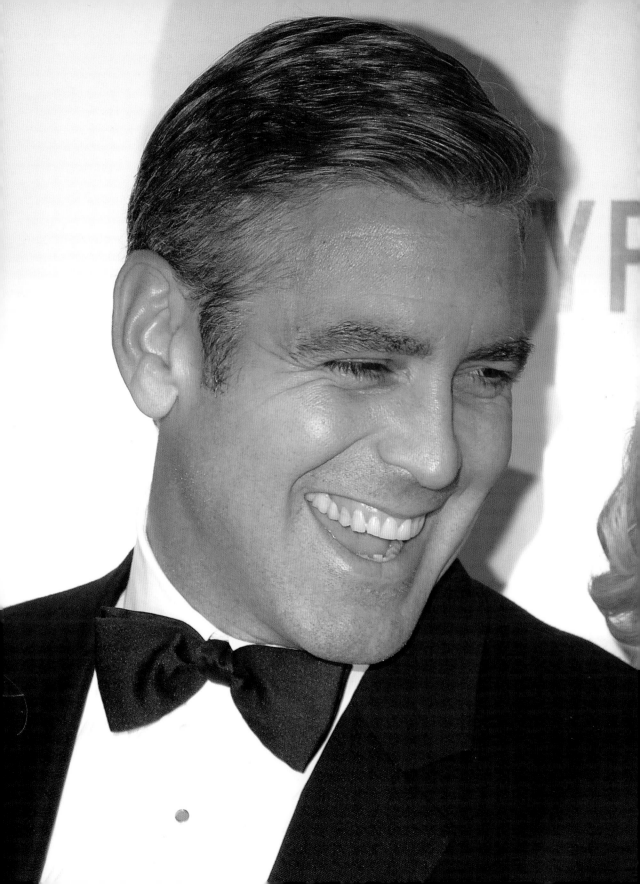

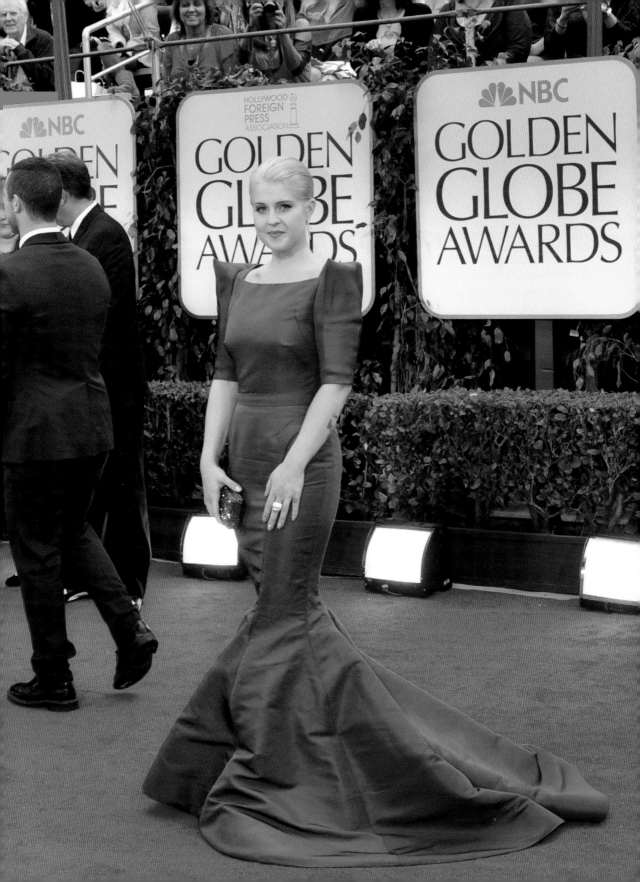

RED CARPET

HOLLYWOOD
FAME AND FASHION

PHOTOGRAPHY
BY FRANK TRAPPER

welcome
BOOKS

A DIVISION OF RIZZOLI NEW YORK

CONTENTS

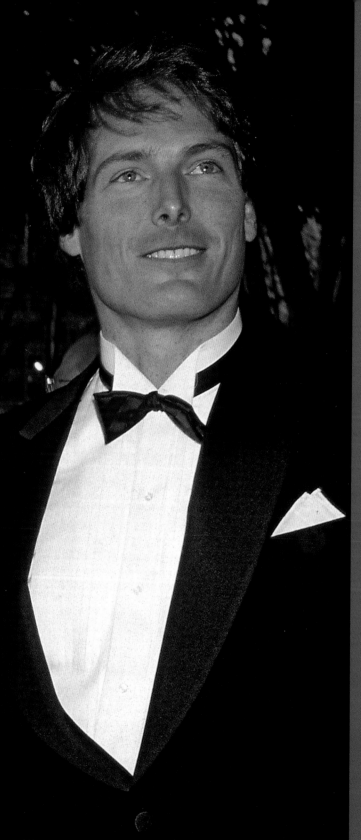

1987

Left: Christopher Reeve, Academy Awards

Opposite: Elizabeth Taylor, Launch party for "Passion Perfume for Women" by Elizabeth Taylor; **Robert Redford** and **Sônia Braga**, Golden Eagle Awards; **Sophia Loren**, American Cinema Awards; **Sylvester Stallone**, American Cinema Awards

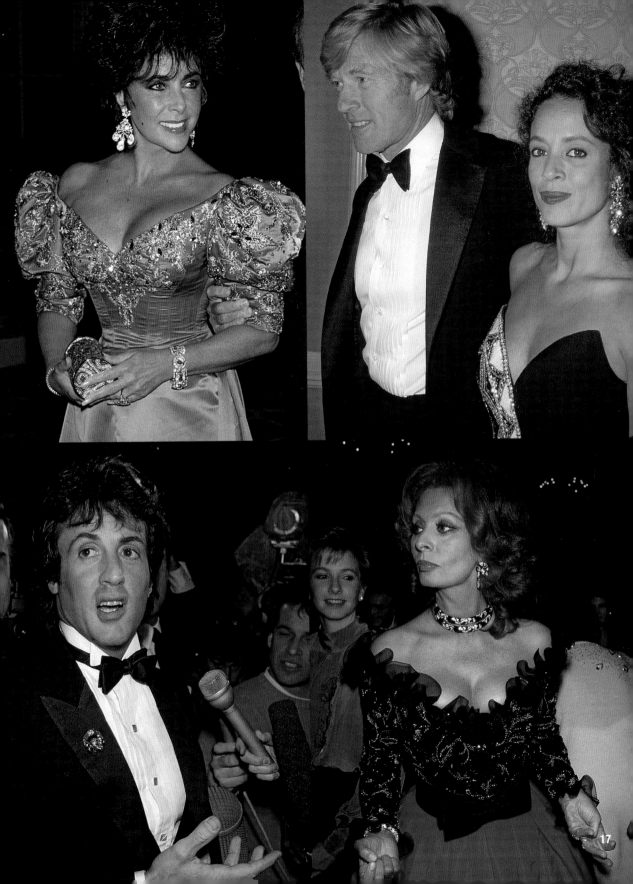

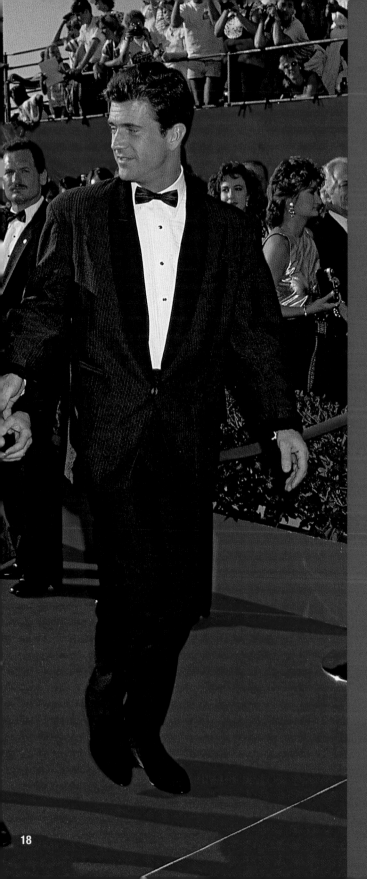

1988

Left: Mel Gibson, Academy Awards

Opposite: LL Cool J, American Music Awards party; **Cher** (in Bob Mackie), Academy Awards; **Audrey Hepburn** (in Givenchy), California Lifetime Achievement Award for the Arts honoring Hubert De Givenchy

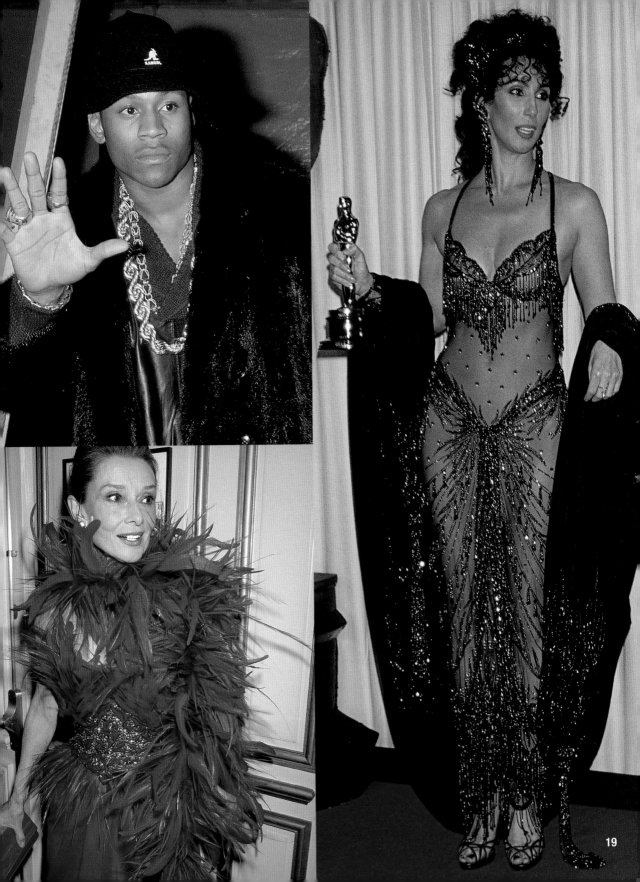

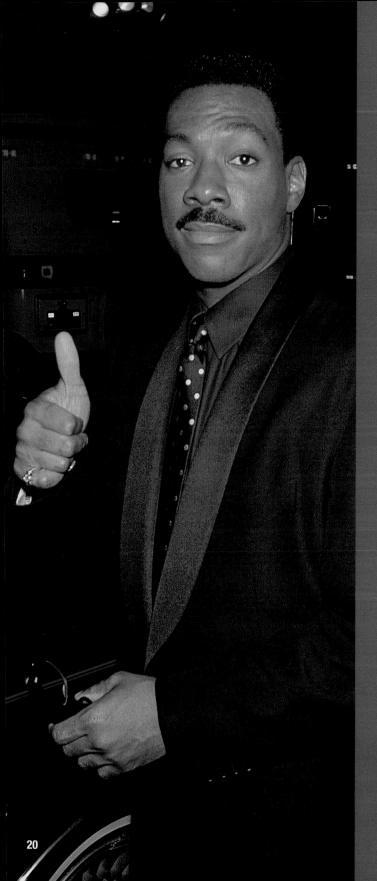

1989

Left: **Eddie Murphy**, Sammy Davis Jr. 60th anniversary celebration

Opposite: **Joan Collins**, AIDS Project Los Angeles benefit; **Dolly Parton**, *Steel Magnolias* premiere; **Jane Seymour**, Simon Wiesenthal tribute; **Paula Abdul**, Emmy Awards

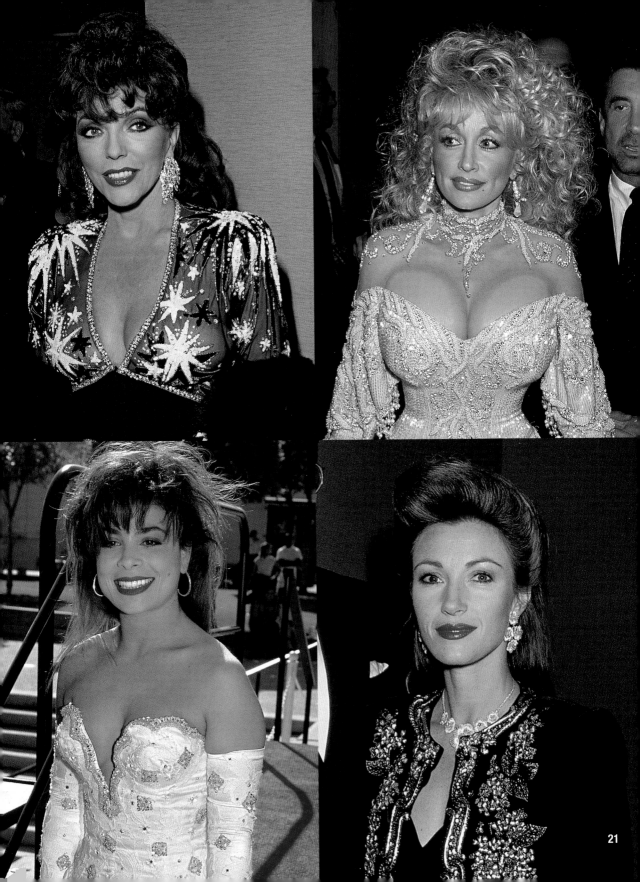

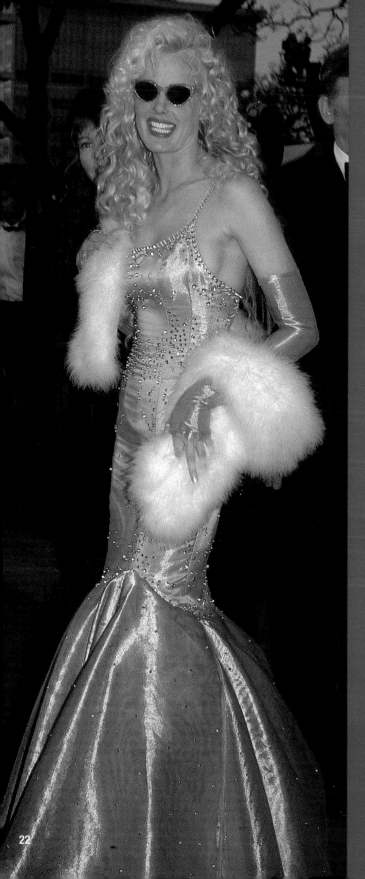

1990

Left: **Daryl Hannah** (in Robin McCarter), Academy Awards

Opposite: **Johnny Depp** and **Winona Ryder**, *Edward Scissorhands* premiere; **Diane Sawyer** and **Barbara Walters**, Television Hall of Fame; **Debbie Reynolds** and daughter **Carrie Fisher**, Thalians 35th Annual Ball; **Michael Jackson**, CBS honoring Michael Jackson

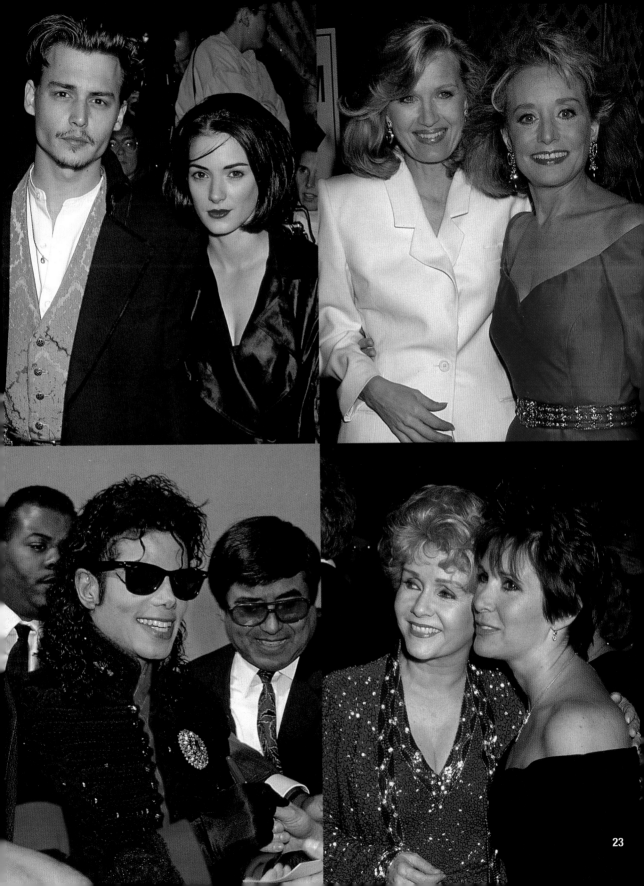

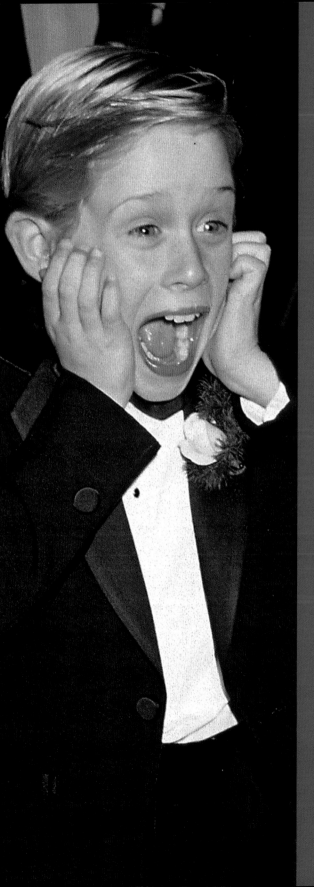

1991

Left: **Macaulay Culkin**, Golden Globe Awards

Opposite: **Nicole Kidman** and **Tom Cruise**, Academy Awards; **Alex Keshishian** and **Madonna**, American Foundation for AIDS Research benefit; **Debra Winger** (in Valentino), Academy Awards; **Lenny Kravitz**, MTV Movie Awards

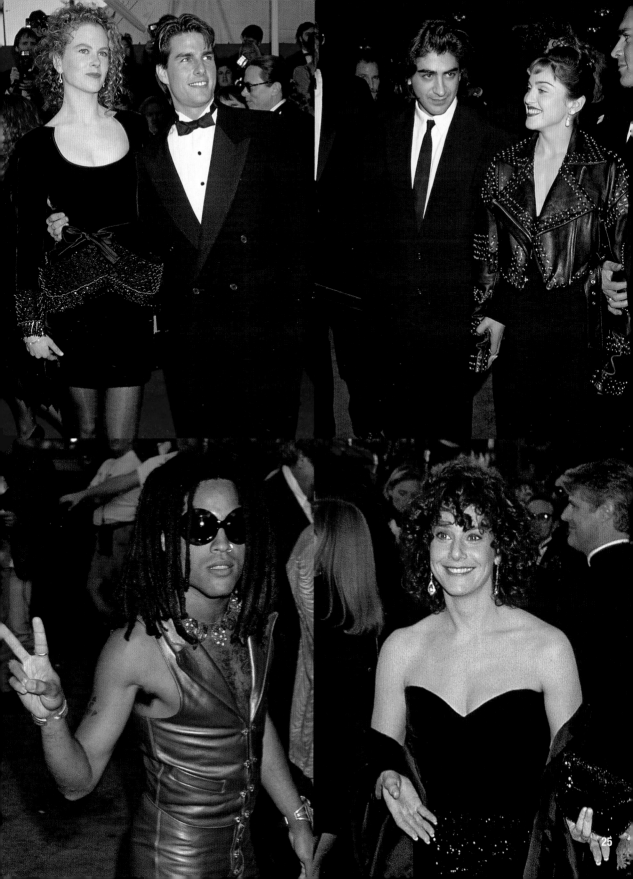

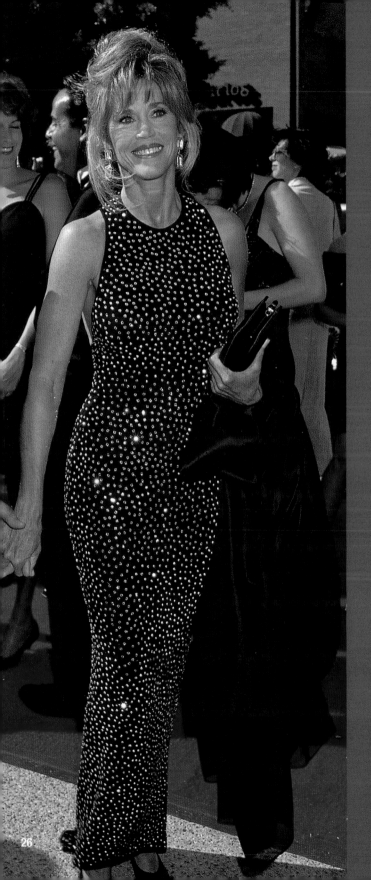

1992

Left: **Jane Fonda**, Emmy Awards

Opposite: **Demi Moore** (in vintage Lily et Cie), Academy Awards; **Elizabeth Taylor**, Carousel of Hope Ball; **Kurt Russell** and **Goldie Hawn**, Carousel of Hope Ball

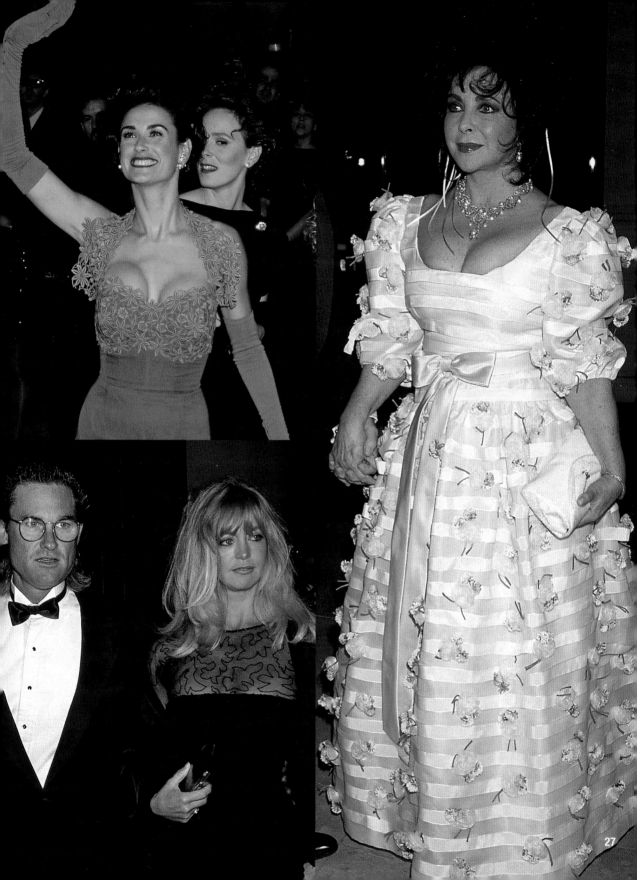

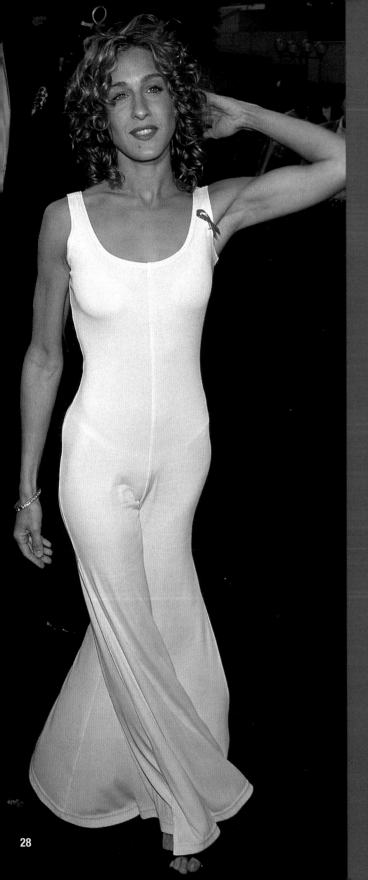

1993

Left: **Sarah Jessica Parker**, MTV Movie Awards

Opposite: **Whoopi Goldberg**, Academy Awards; **Diane Keaton**, *Manhattan Murder Mystery* screening; **Nicole Kidman**, *The Firm* premiere; **Paul Qualley** and **Andie MacDowell** (in Ralph Lauren), Academy Awards

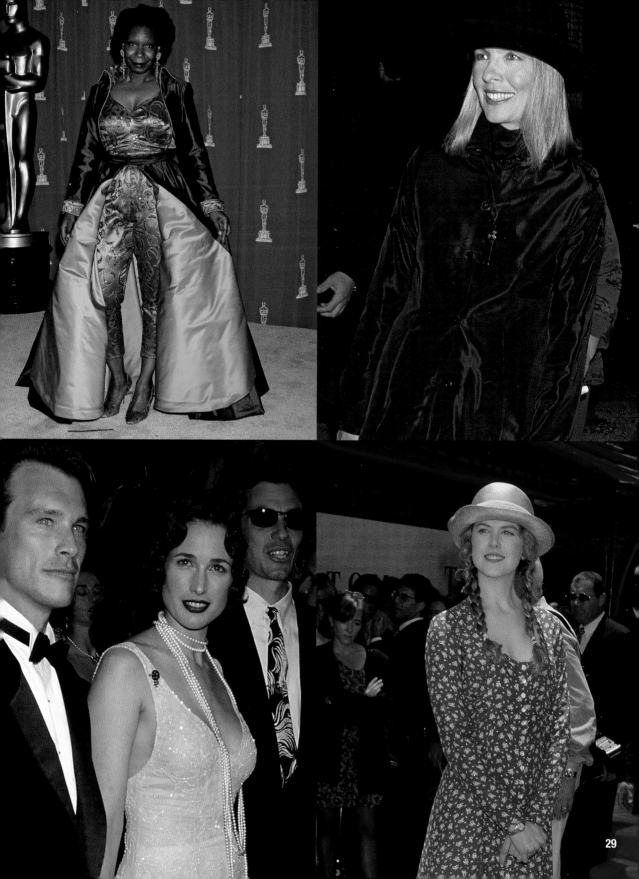

29

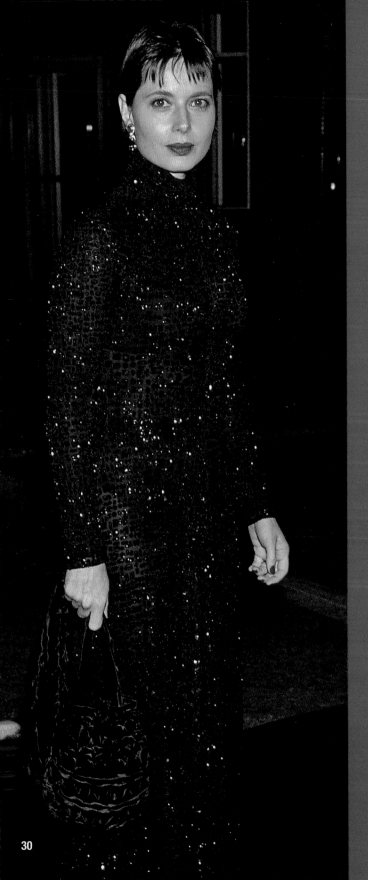

1994

Left: **Isabella Rossellini**, Fire & Ice Ball

Opposite: **Demi Moore**, *Disclosure* premiere; **Claudia Schiffer**, Fire & Ice Ball; **Fran Drescher**, *Little Women* premiere

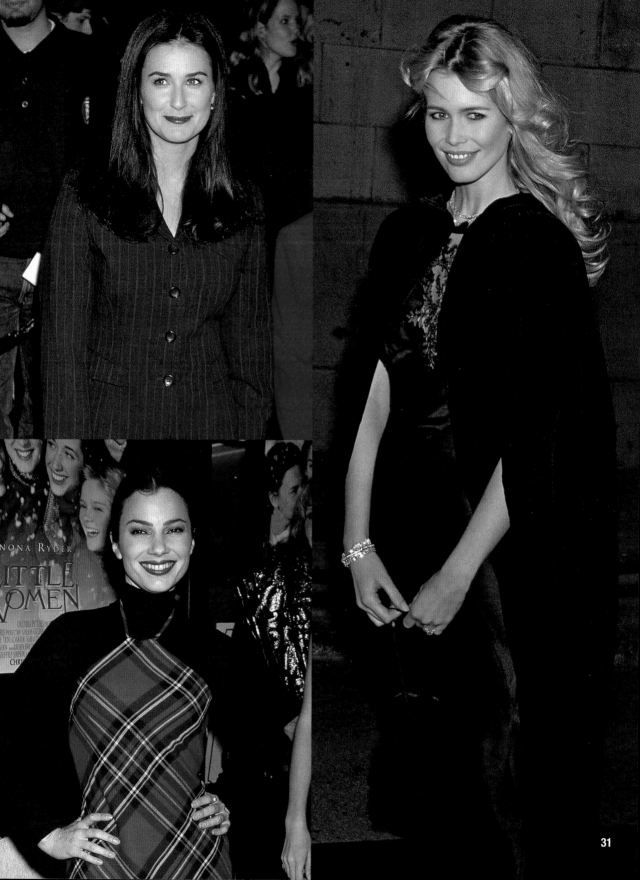

31

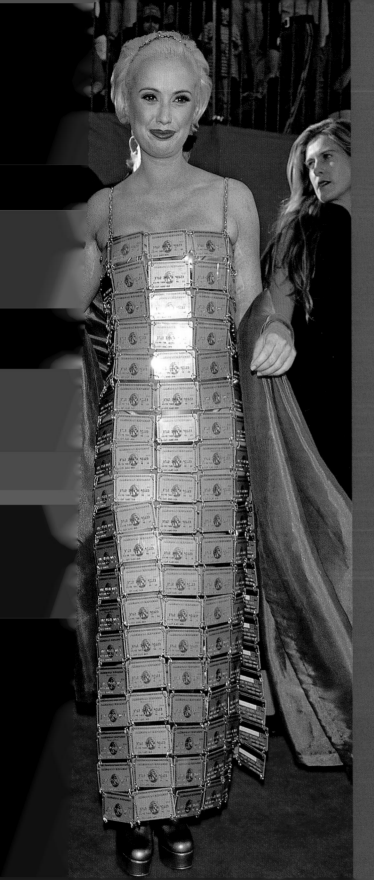

1995

Left: **Tim Chappell** and **Lizzy Gardiner** (in Lizzy Gardiner), Academy Awards

Opposite: **Stedman Graham** and **Oprah Winfrey** (in Gianfranco Ferre), Academy Awards; **Tori Spelling**, *Batman Forever* premiere; **Angela Bassett**, Fire & Ice Ball

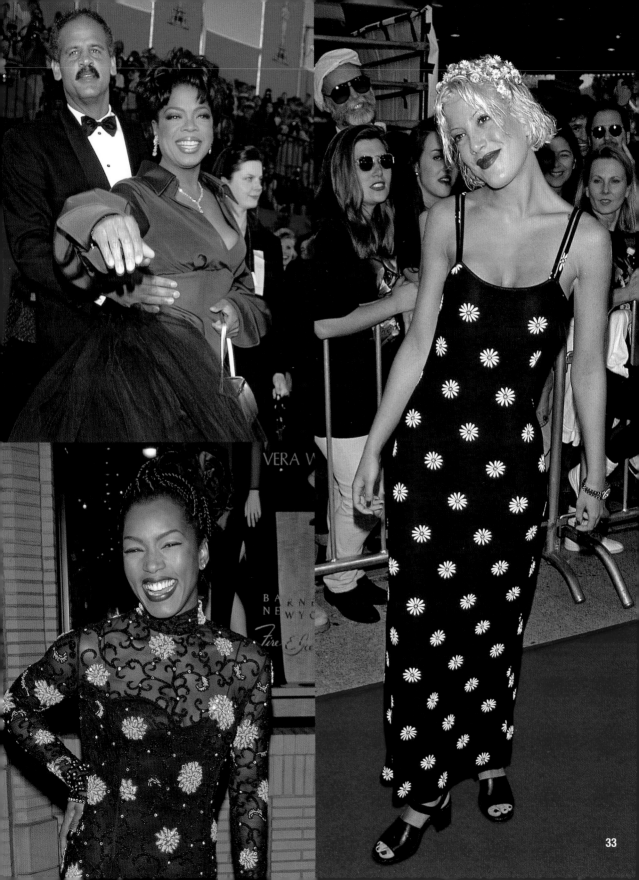

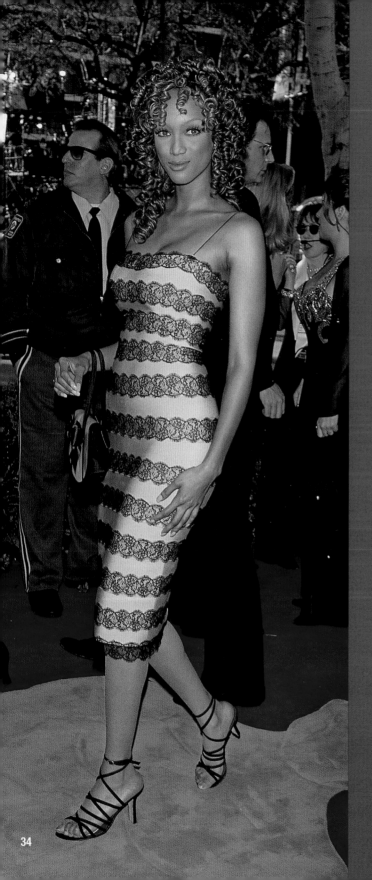

1996

Left: **Tyra Banks**, Academy Awards

Opposite: **Gwyneth Paltrow** (in Calvin Klein) and **Brad Pitt**, Academy Awards; **Hugh Grant** and **Elizabeth Hurley**, *Extreme Measures* premiere; **Jerry Seinfeld** and **Shoshanna Lonstein**, Screen Actors Guild Awards; **Quentin Tarantino** and **Mira Sorvino** (in Armani), Academy Awards

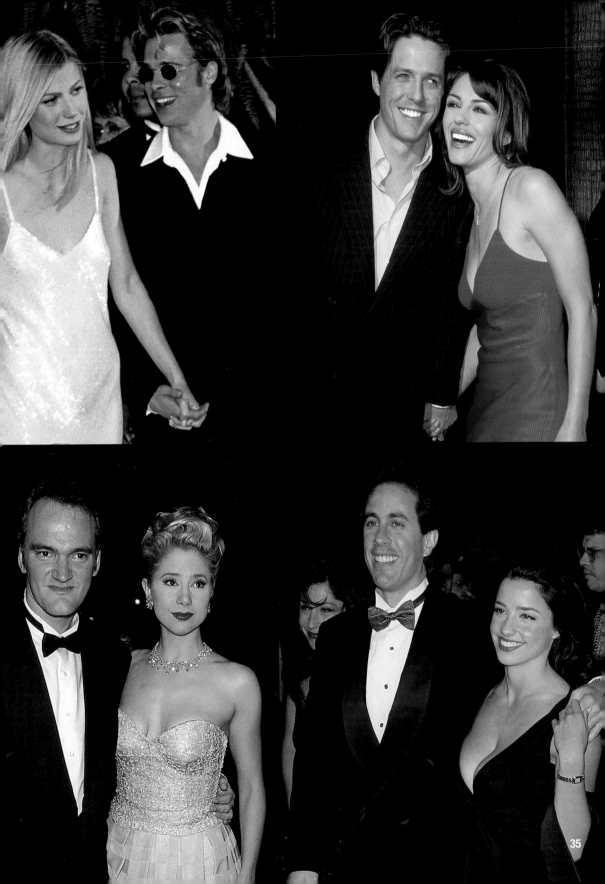

1997

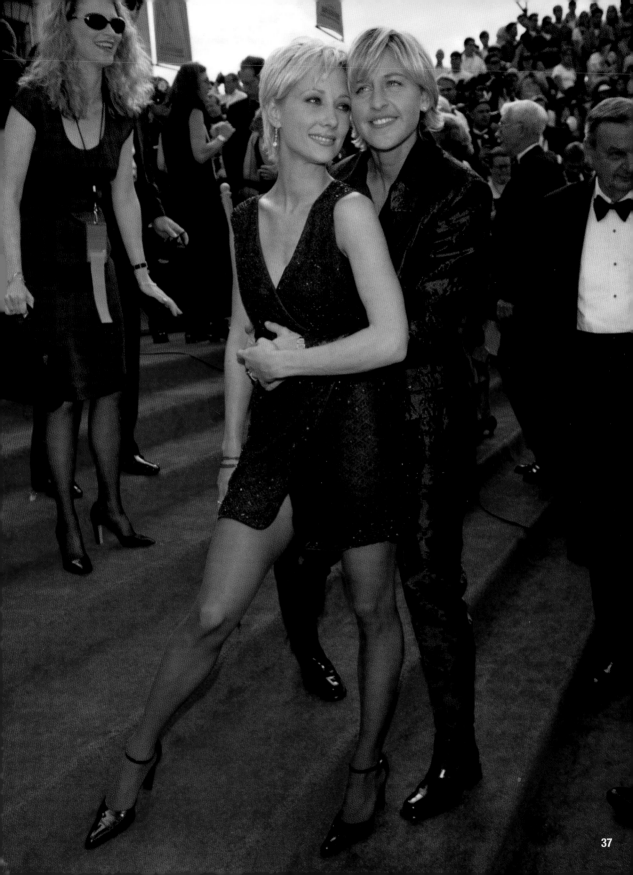

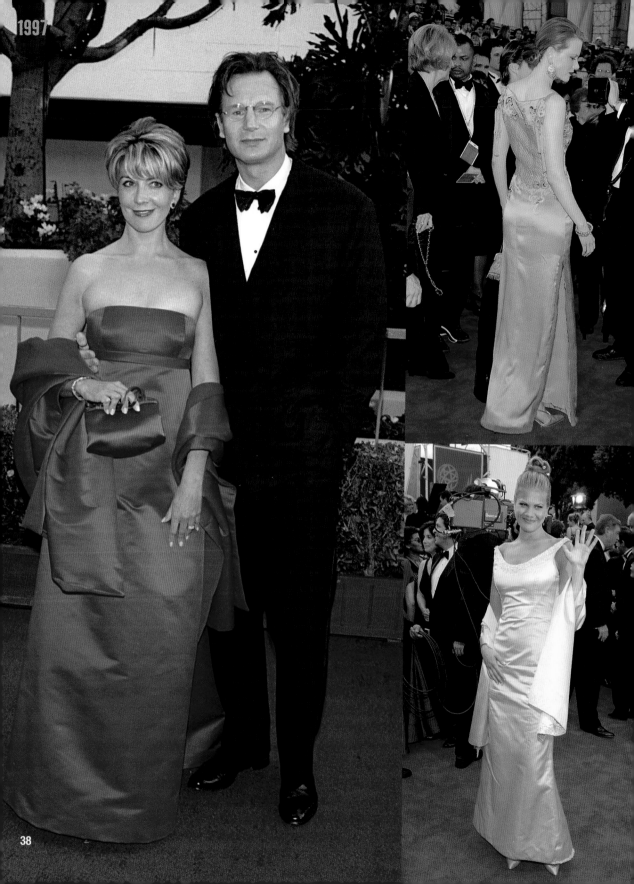

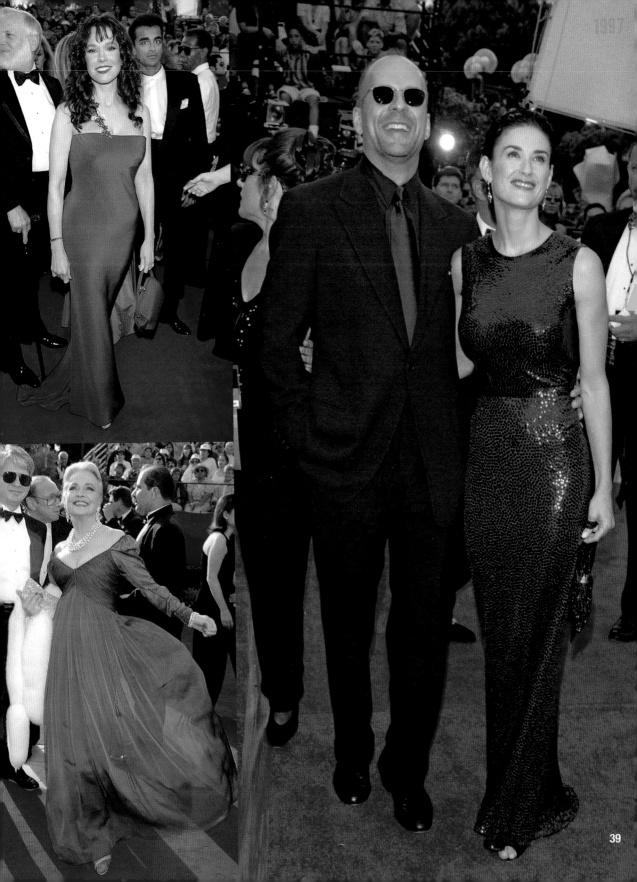

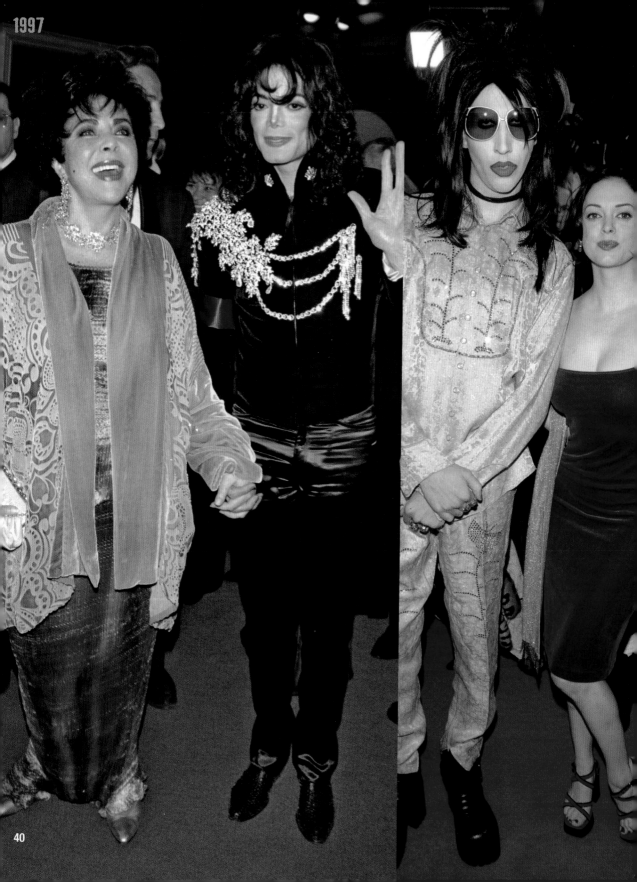

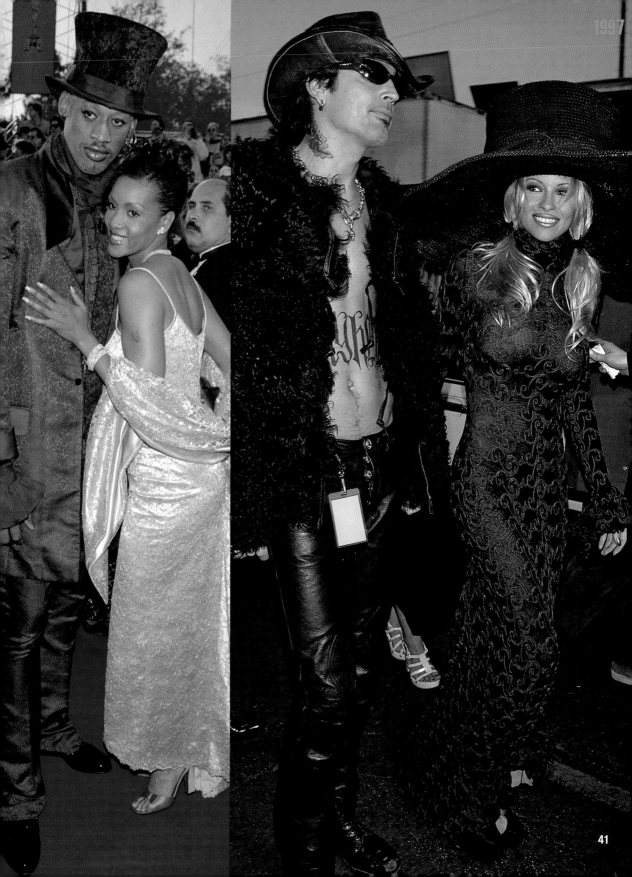

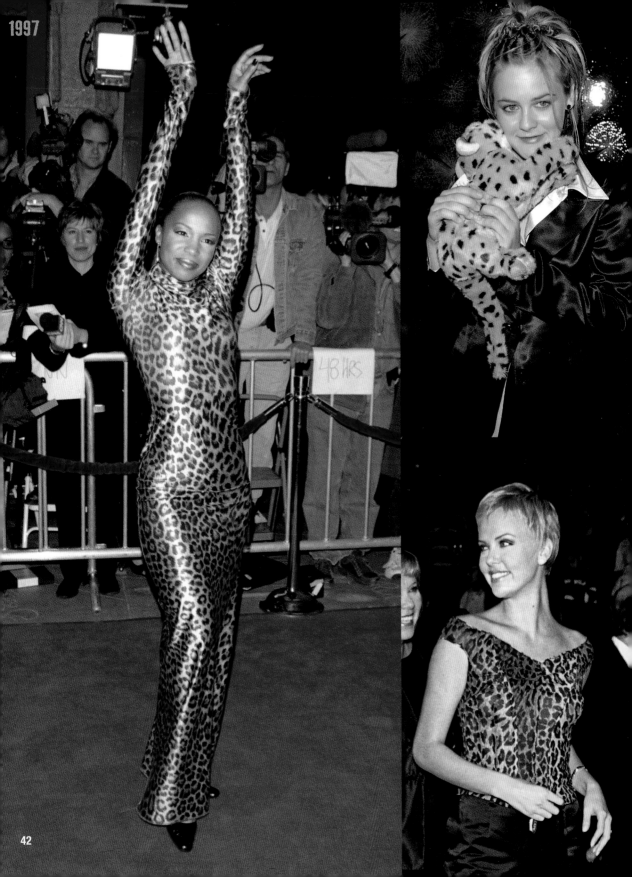

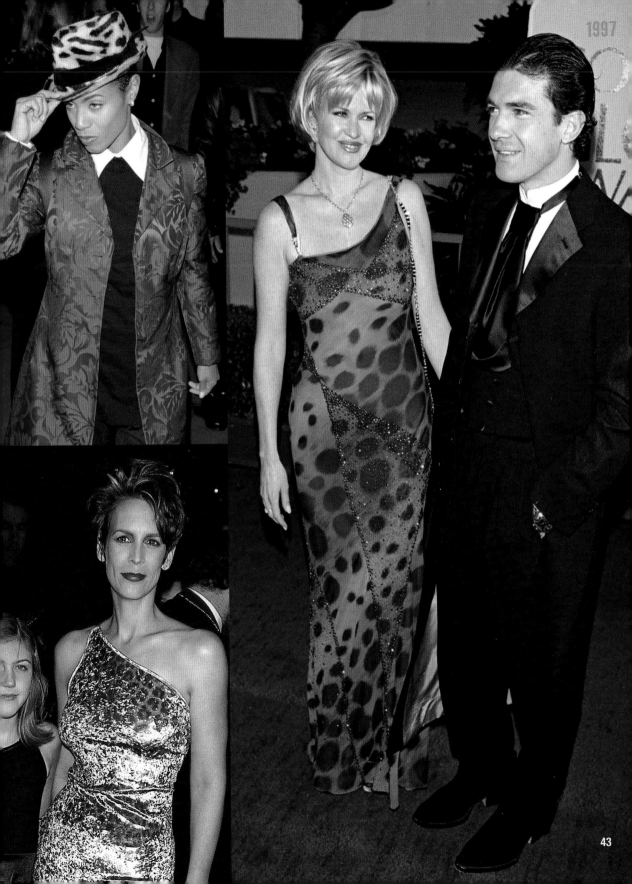

1997

43

1998

45 **Madonna** (in Olivier Theyskens and Jean Paul Gaultier) and brother **Christopher Ciccone**, Academy Awards

46 **Shania Twain**, Billboard Music Awards; **Jeri Ryan** (in Richard Tyler), Emmy Awards

47 **Salma Hayek**, MTV Music Awards; **Angelina Jolie**, Golden Globe Awards

48 **Jessica Biel**, *Halloween H20* premiere; **Brandy**, *I Still Know What You Did Last Summer* premiere

49 **Katie Holmes** (in Badgley Mischka), Emmy Awards; **Kate Hudson** (in Gucci), MTV Awards

50 **Helen Hunt** (in Tom Ford for Gucci), Academy Awards; **Linda Hamilton** (in Pamela Dennis), Academy Awards; **Heather Graham** (in Dolce & Gabbana), *Lost in Space* premiere

51 **Kim Basinger** (in Escada), Academy Awards; **Helena Bonham Carter**, Academy Awards; **Halle Berry** (in Vera Wang), Academy Awards

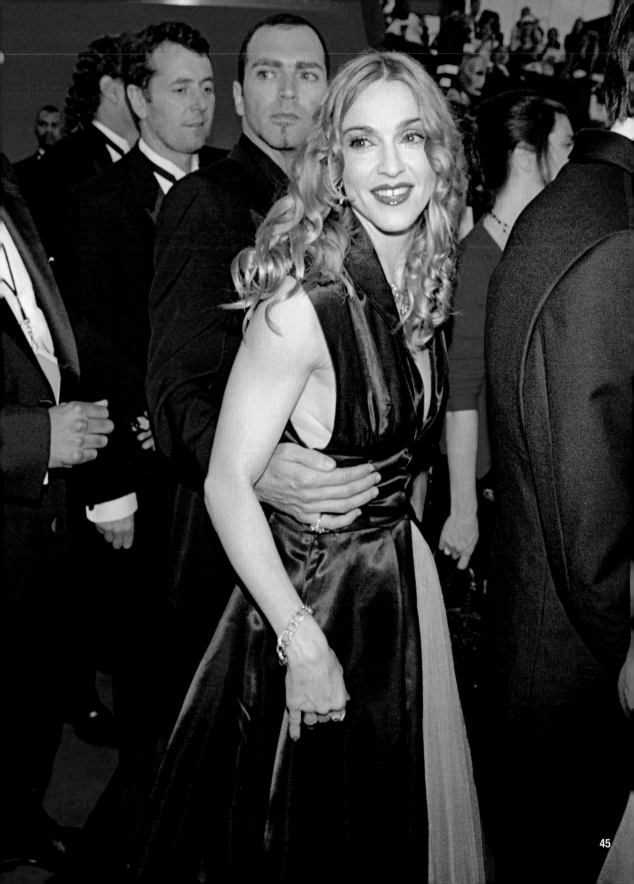

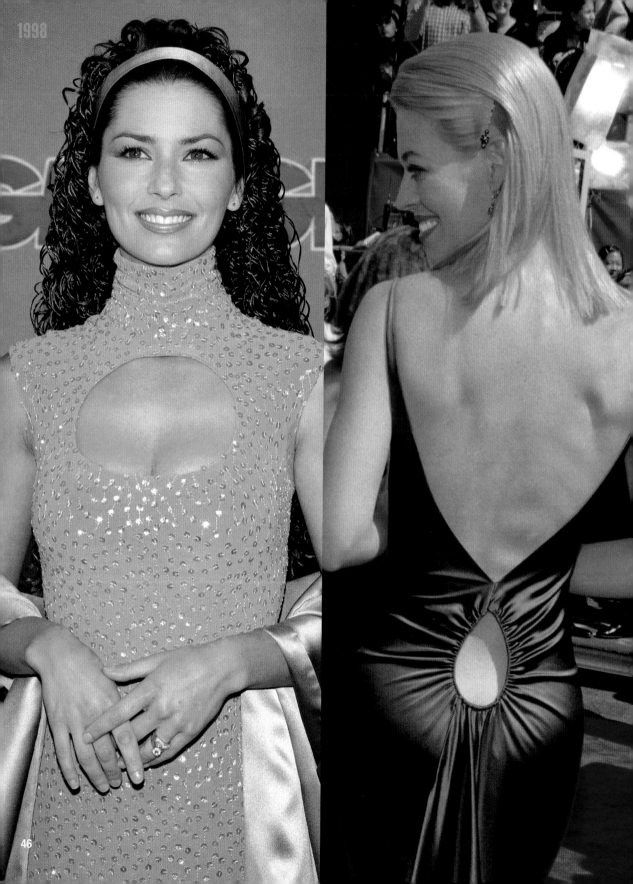

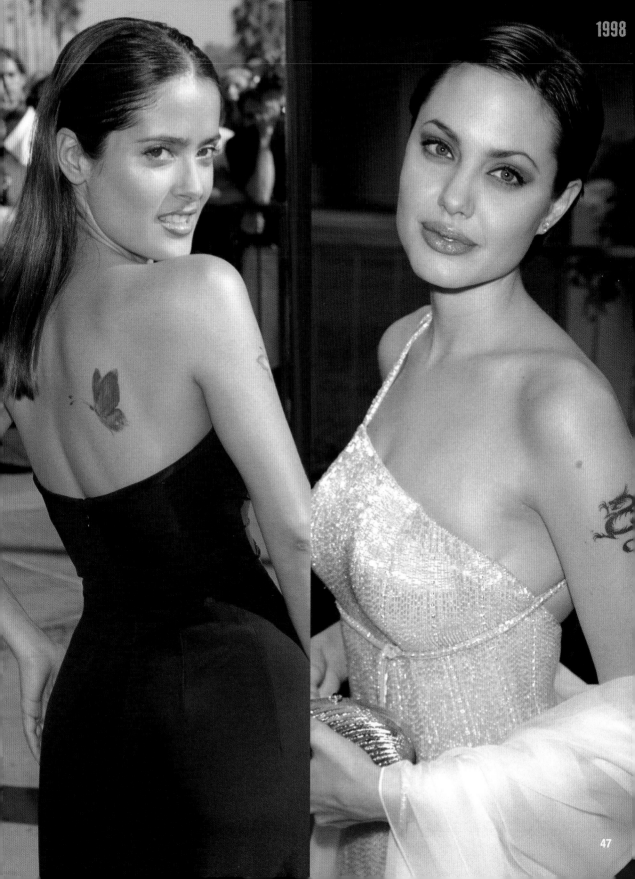

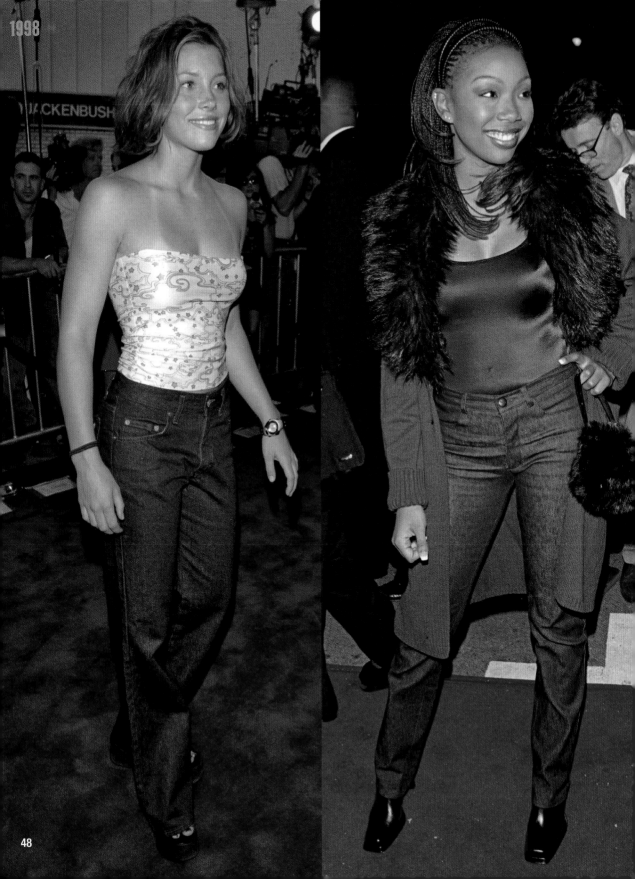

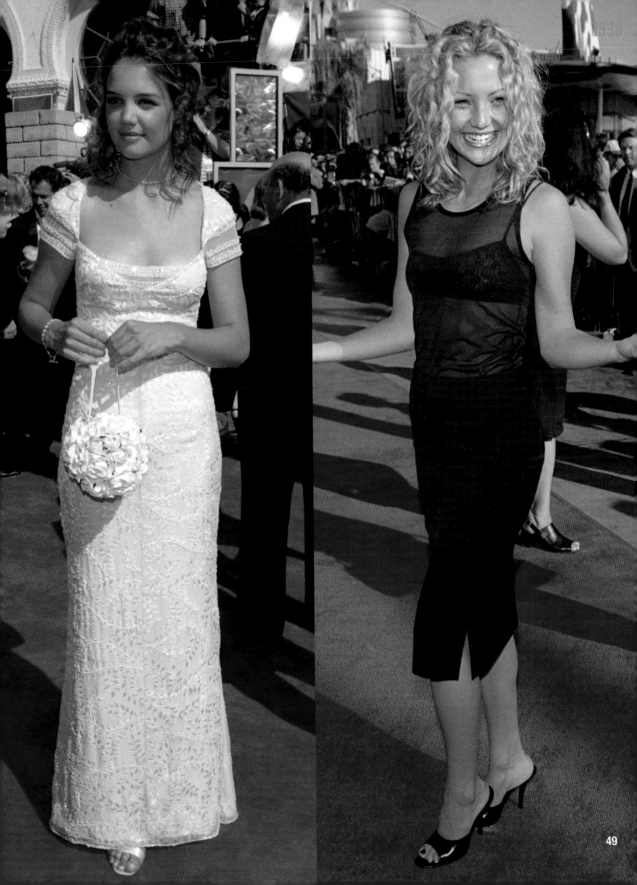

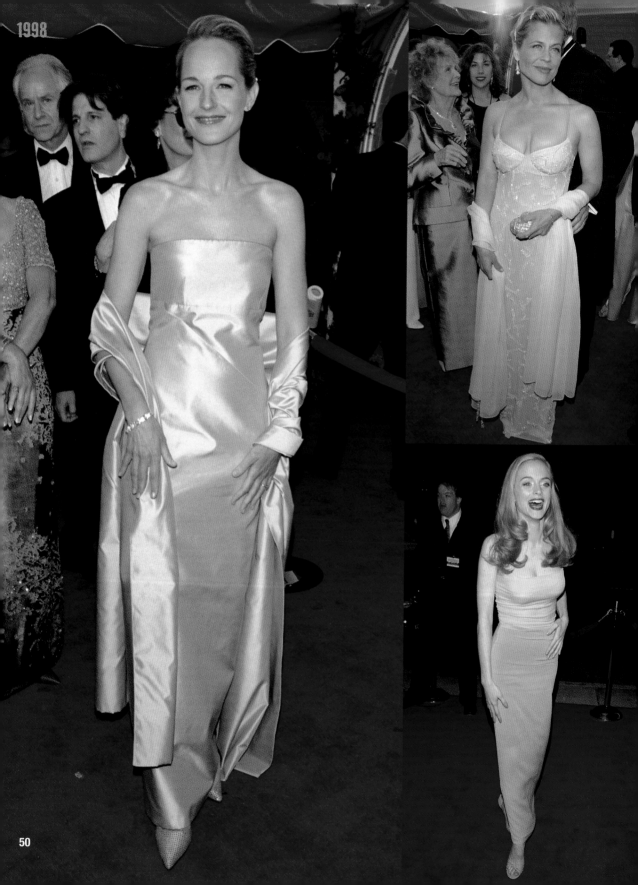

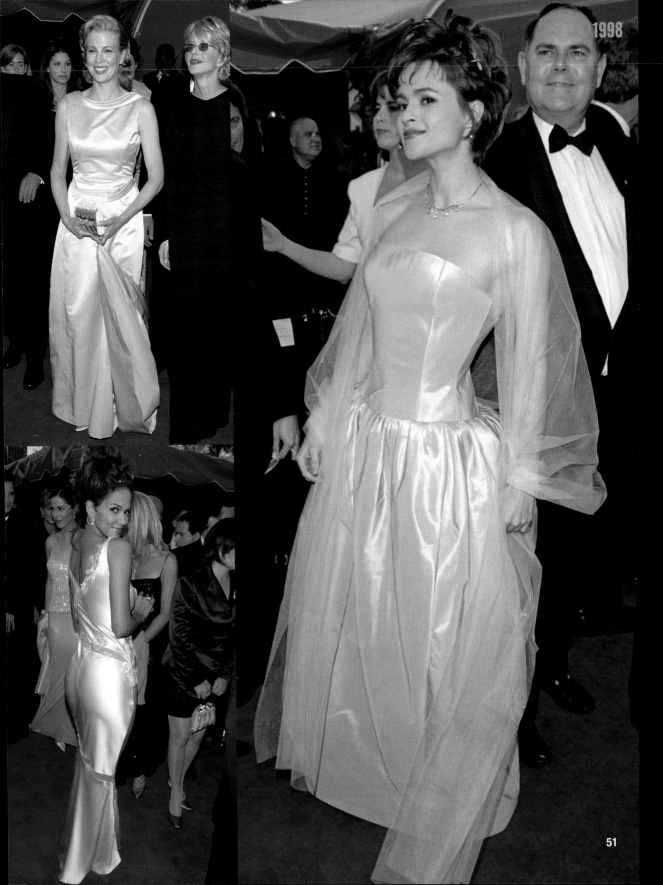

1999

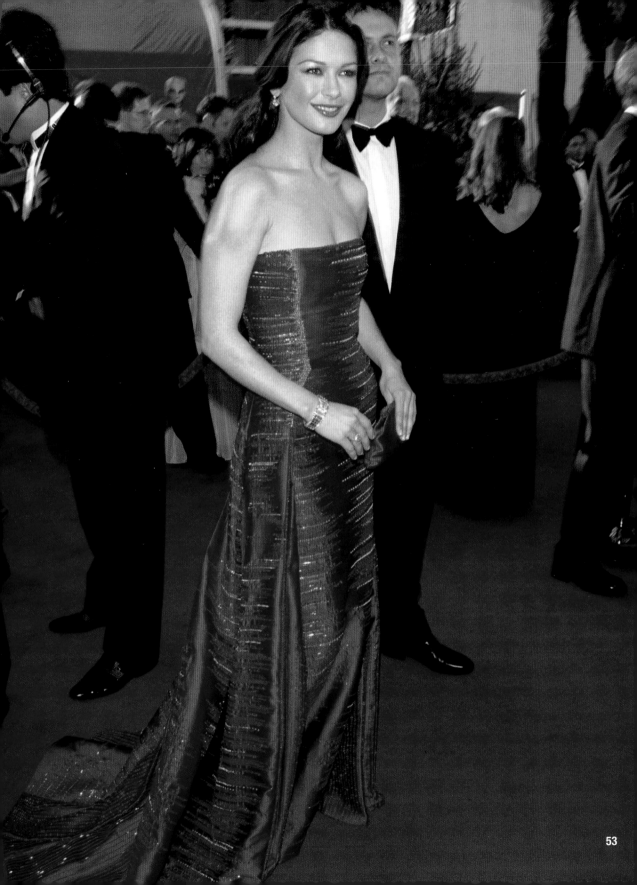

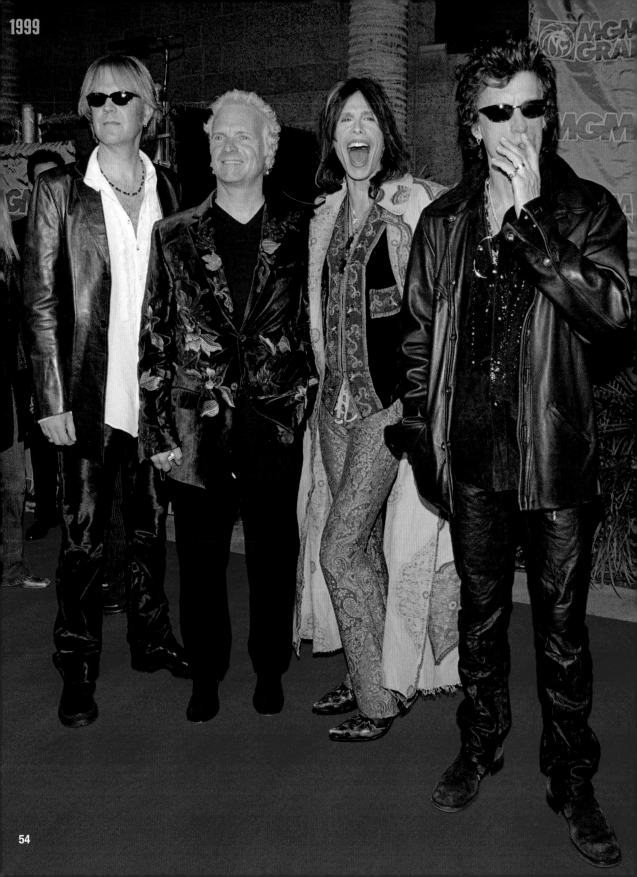

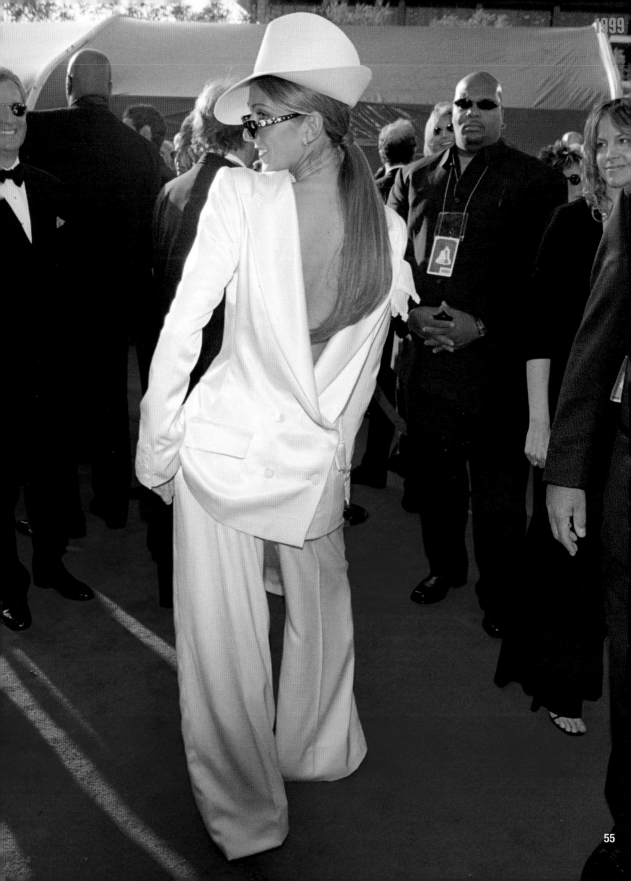

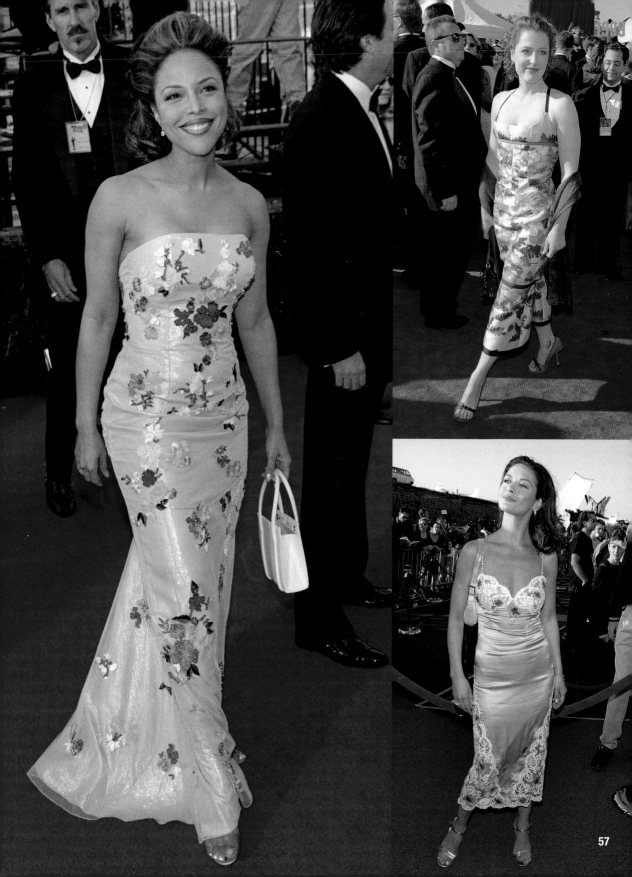

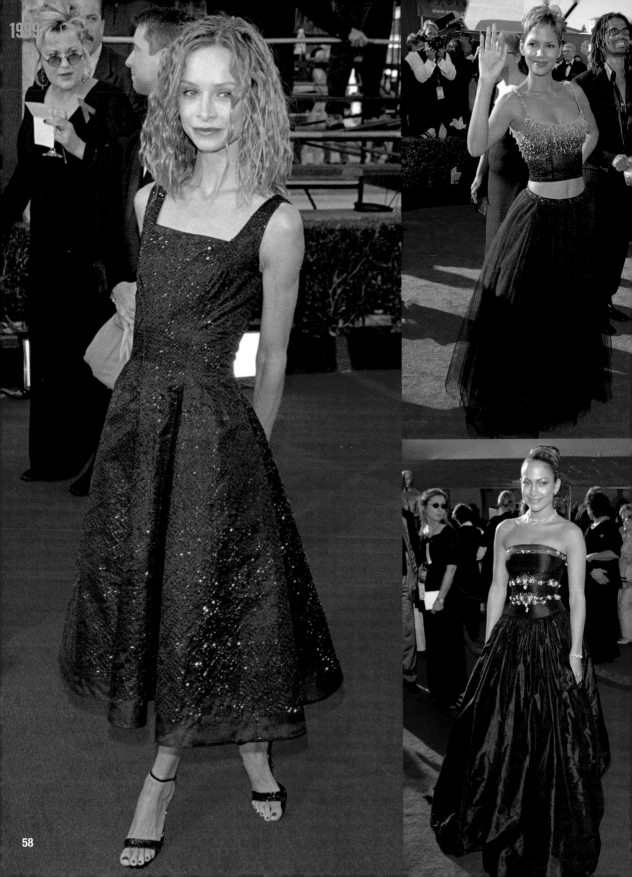

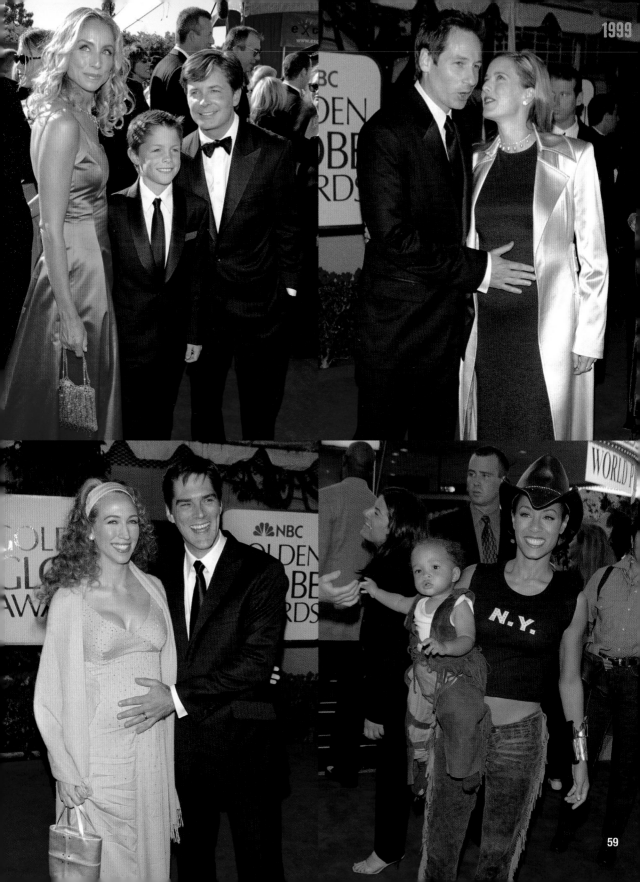

2000

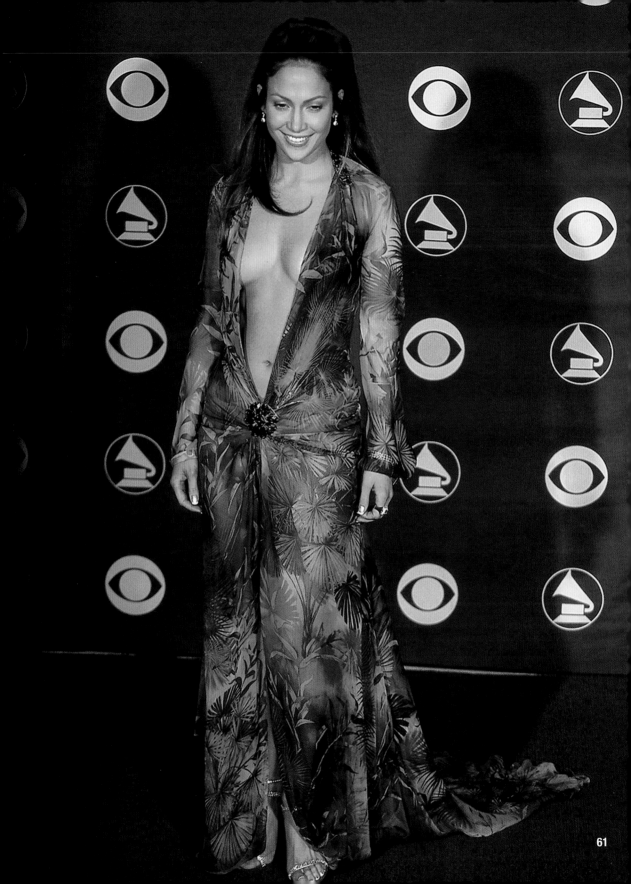

61

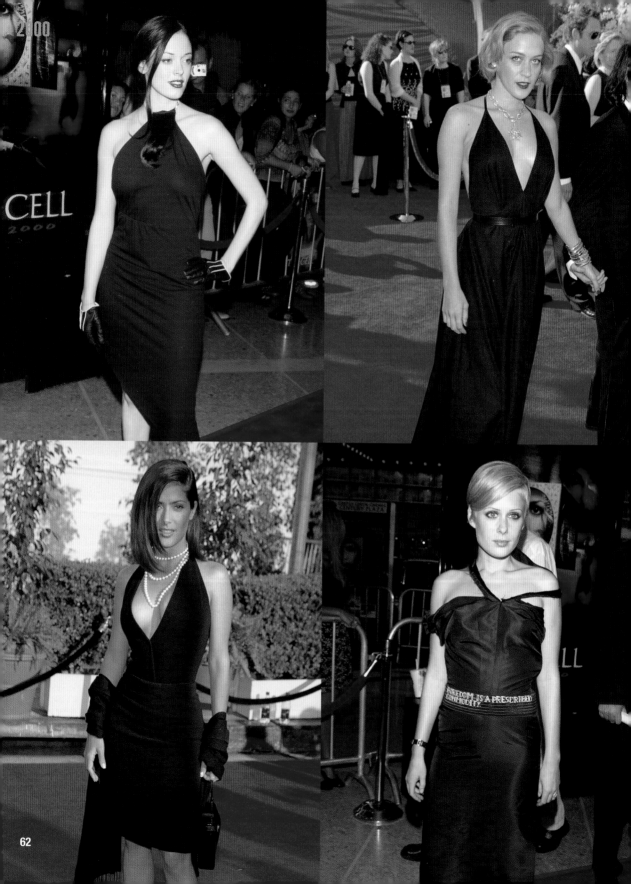

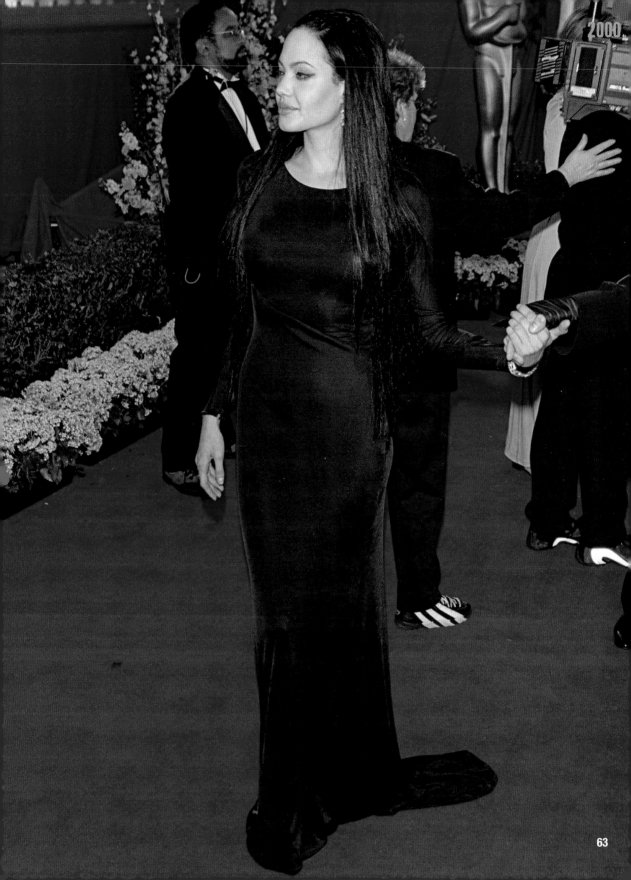

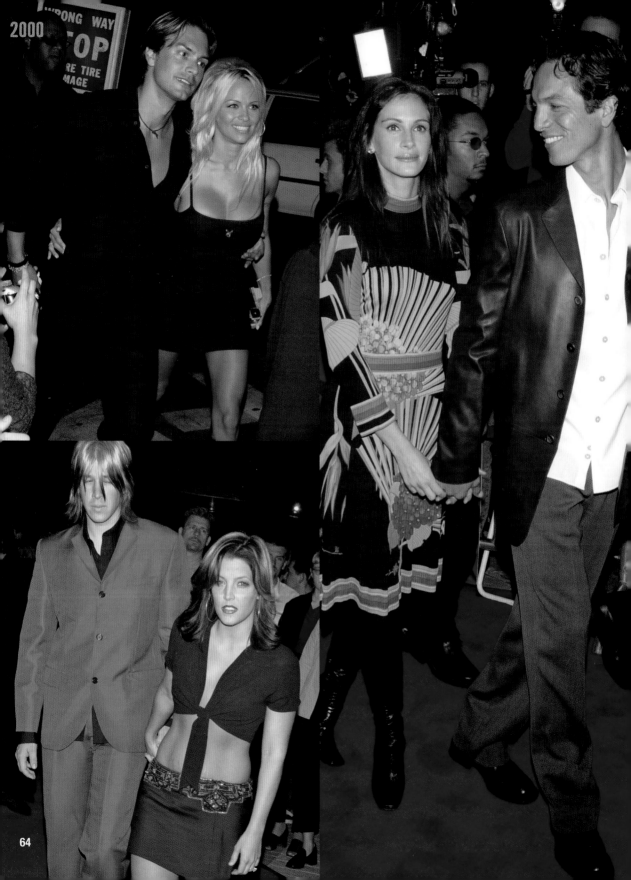

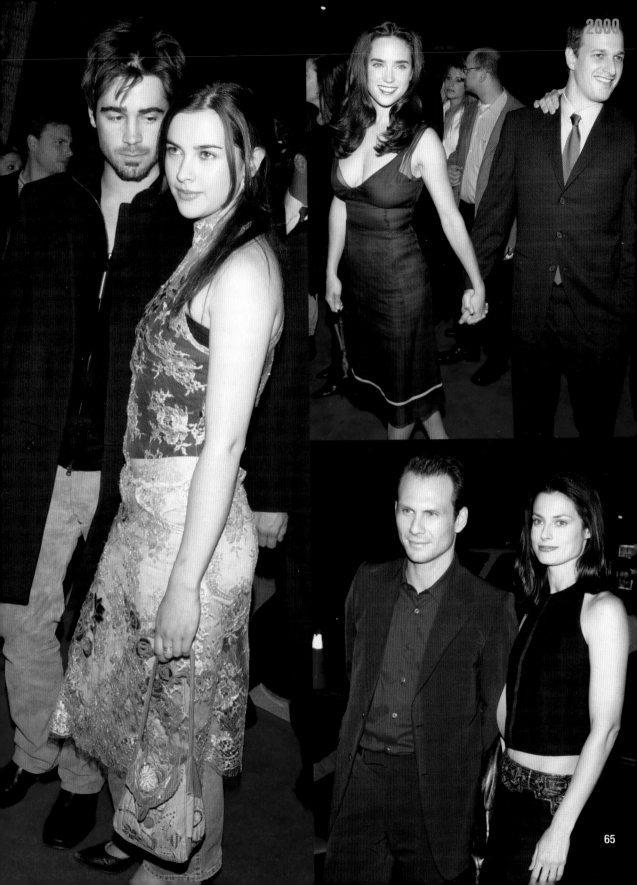

2000

65

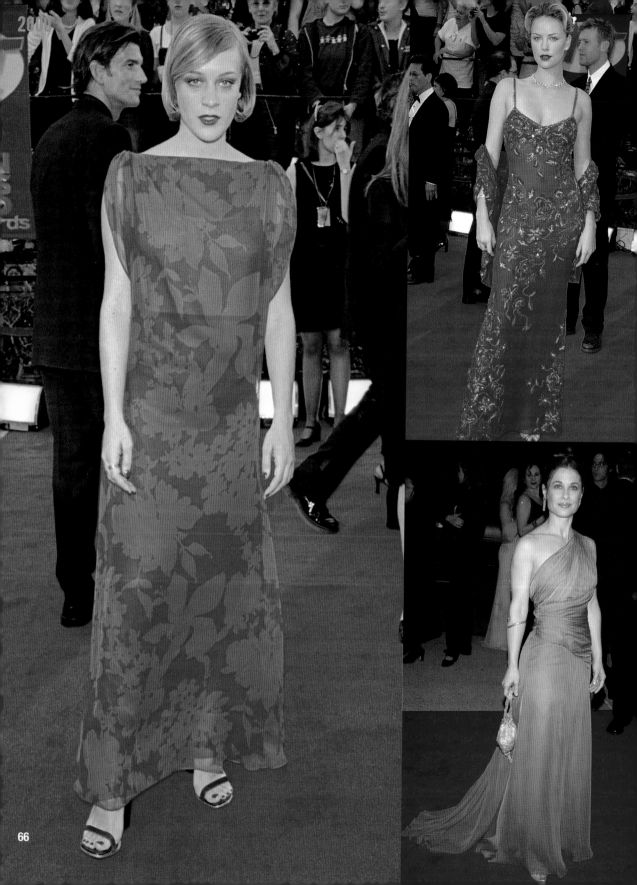

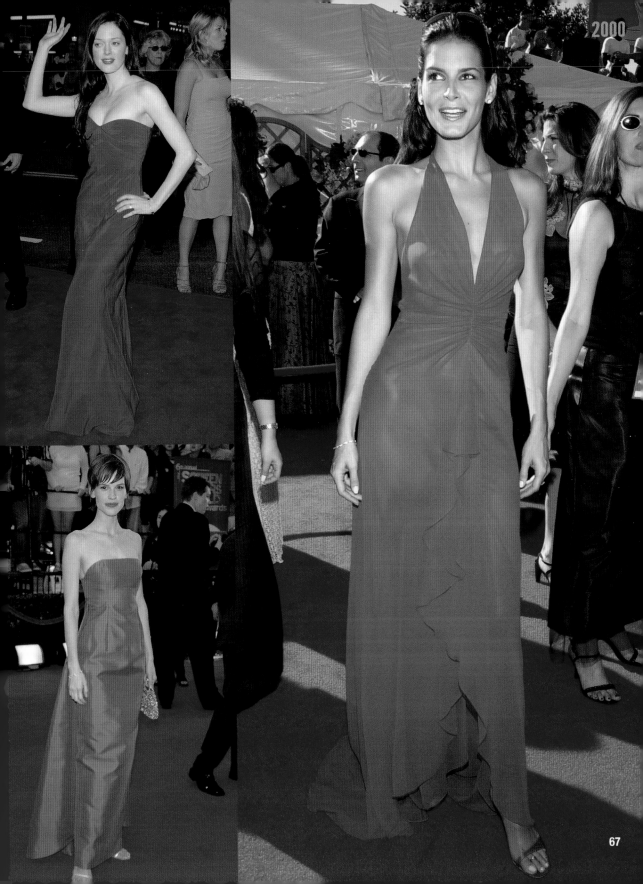

2001

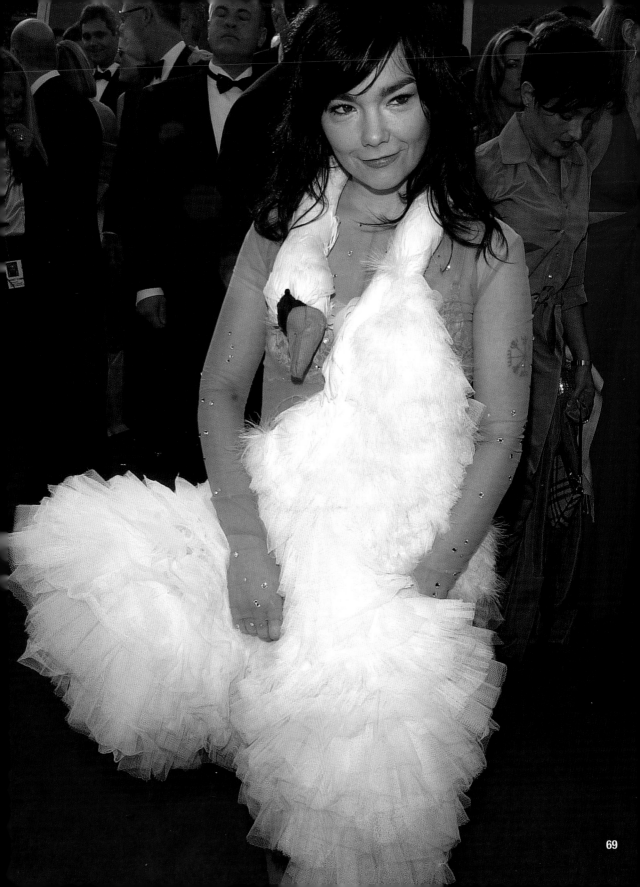

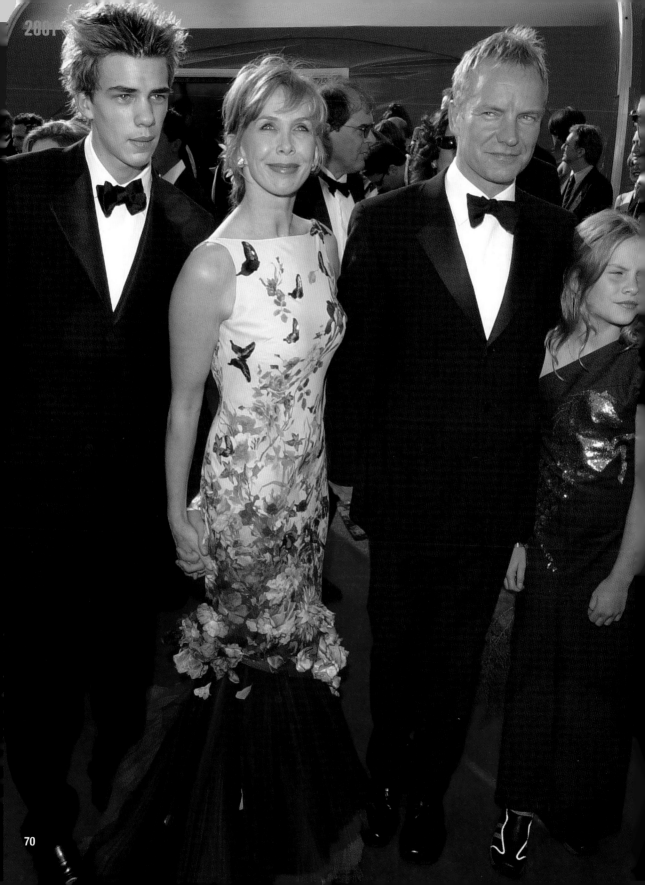

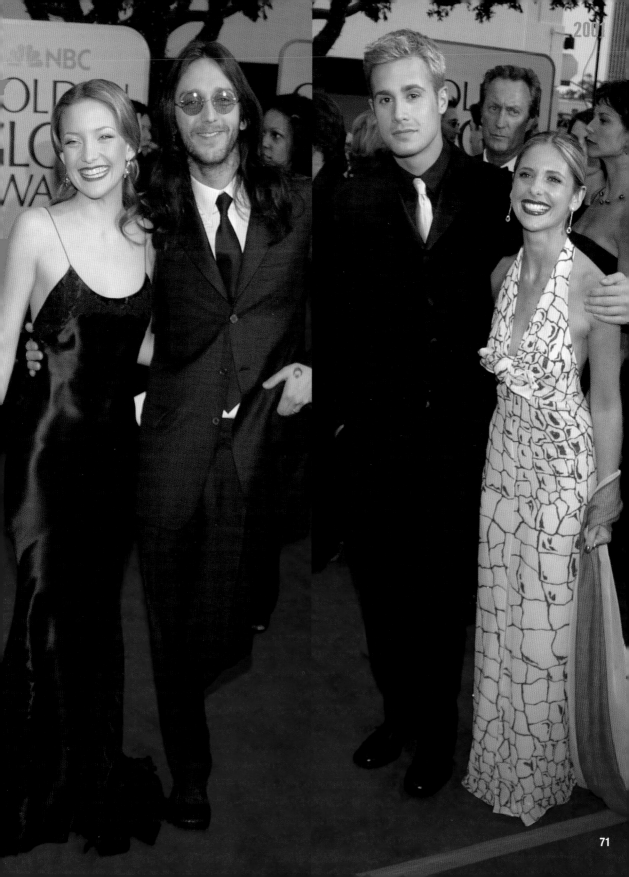

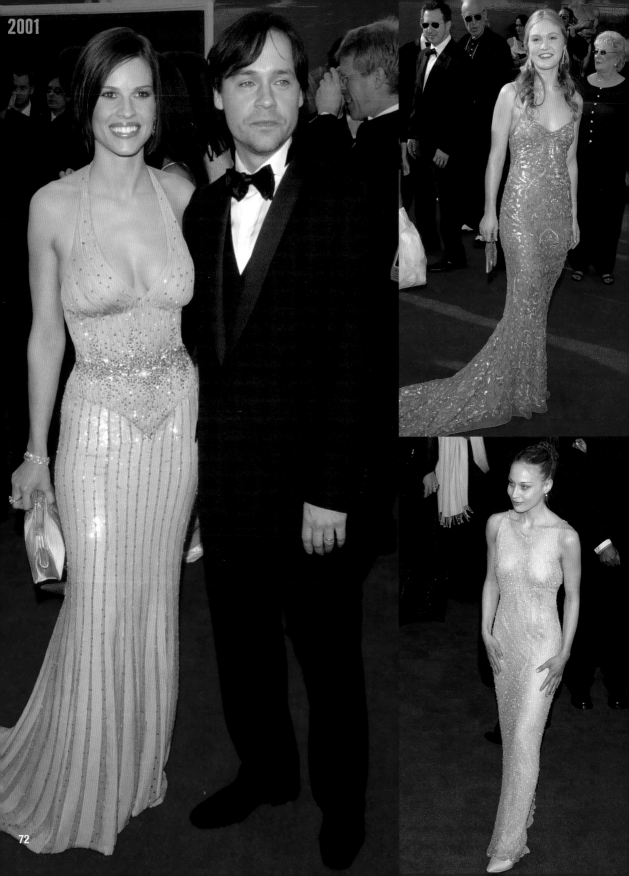

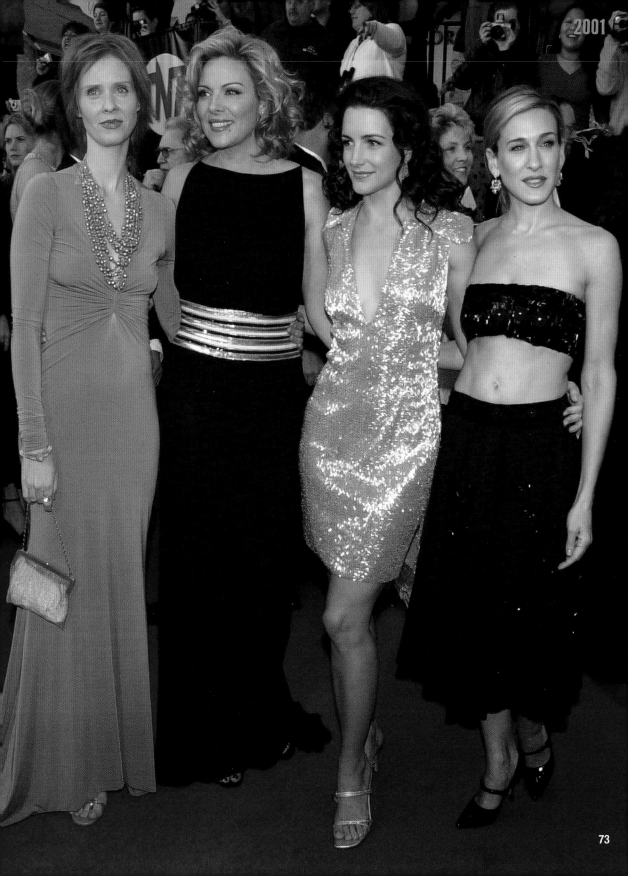

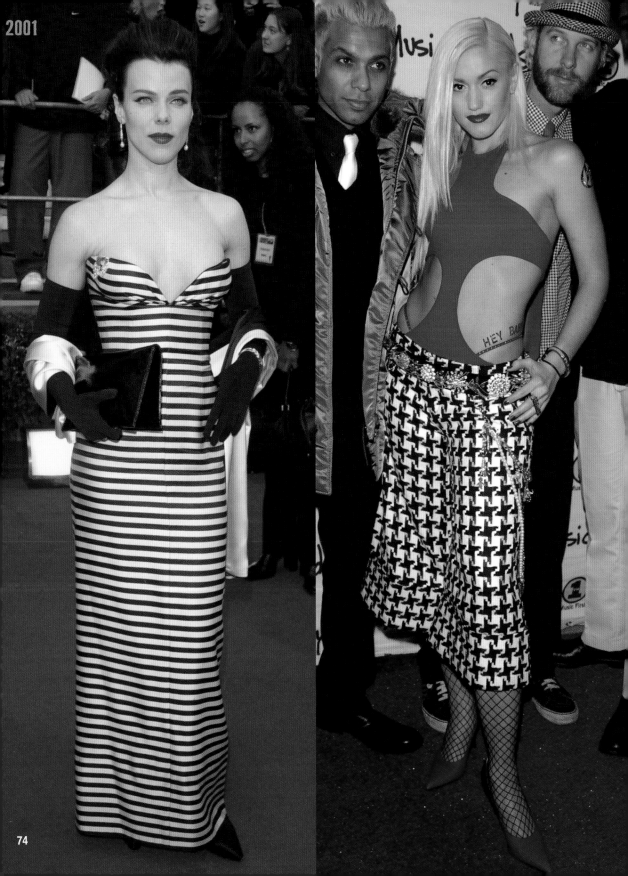

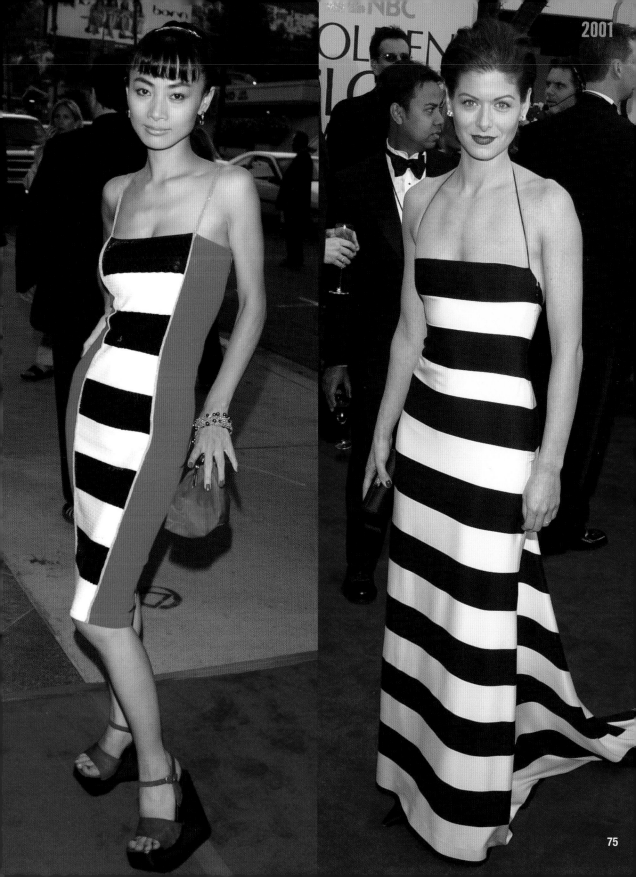

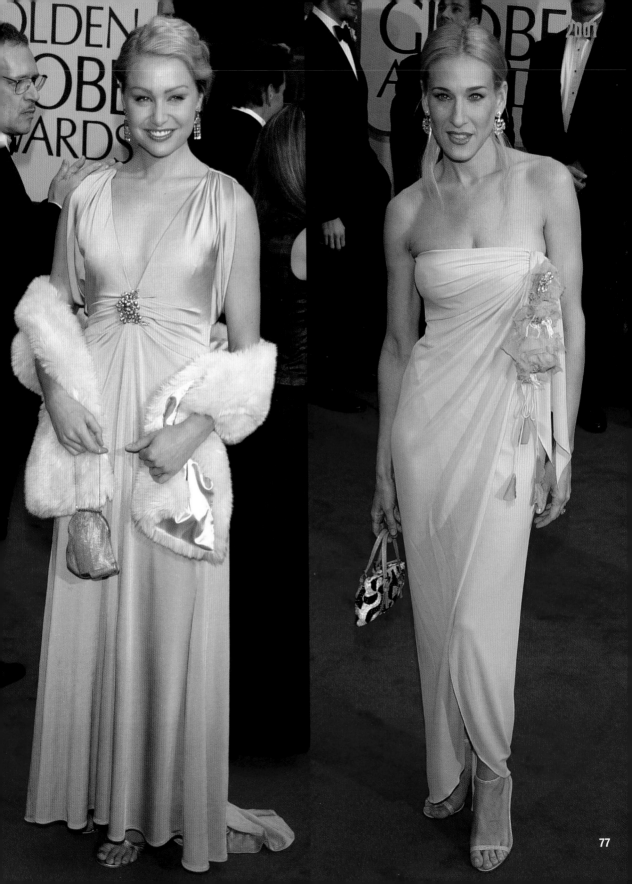

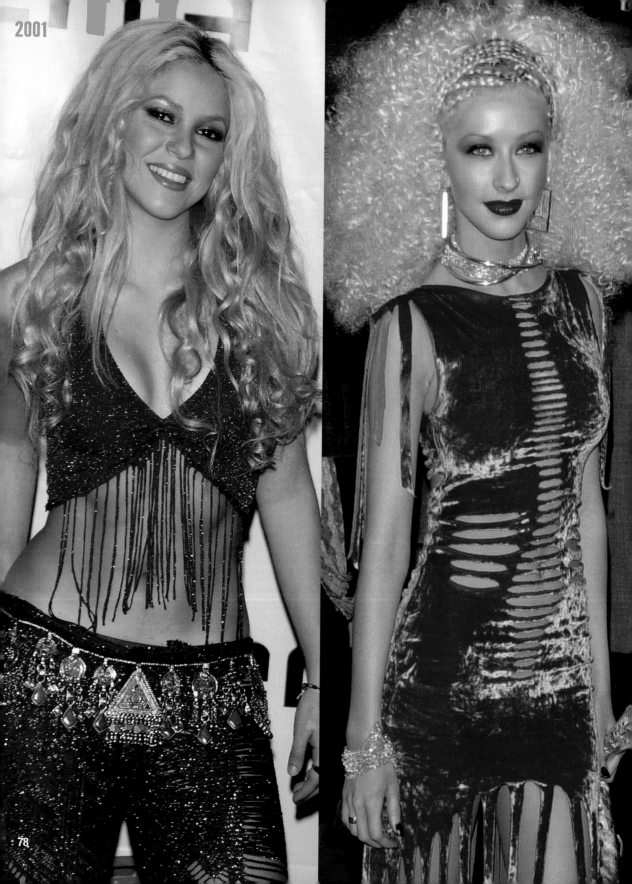

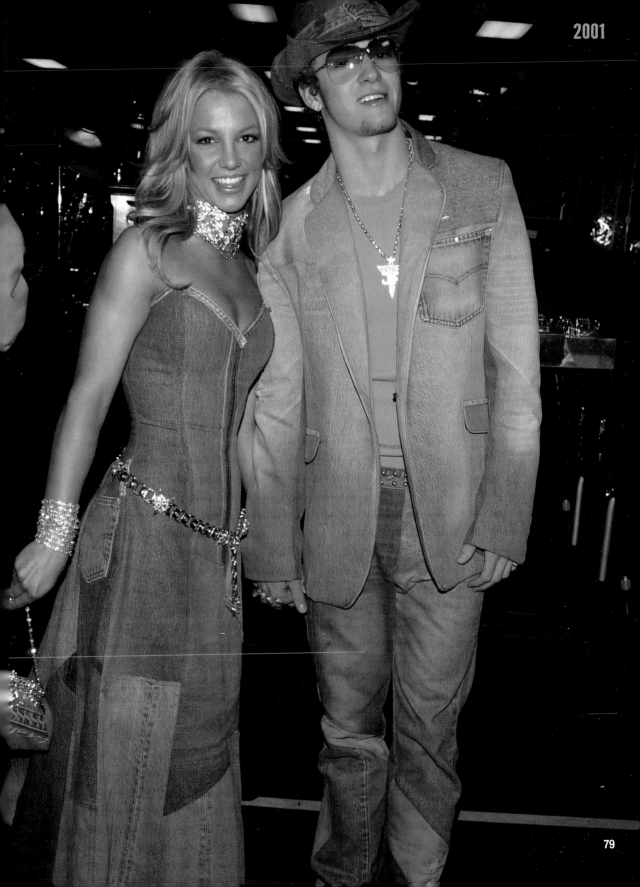

2002

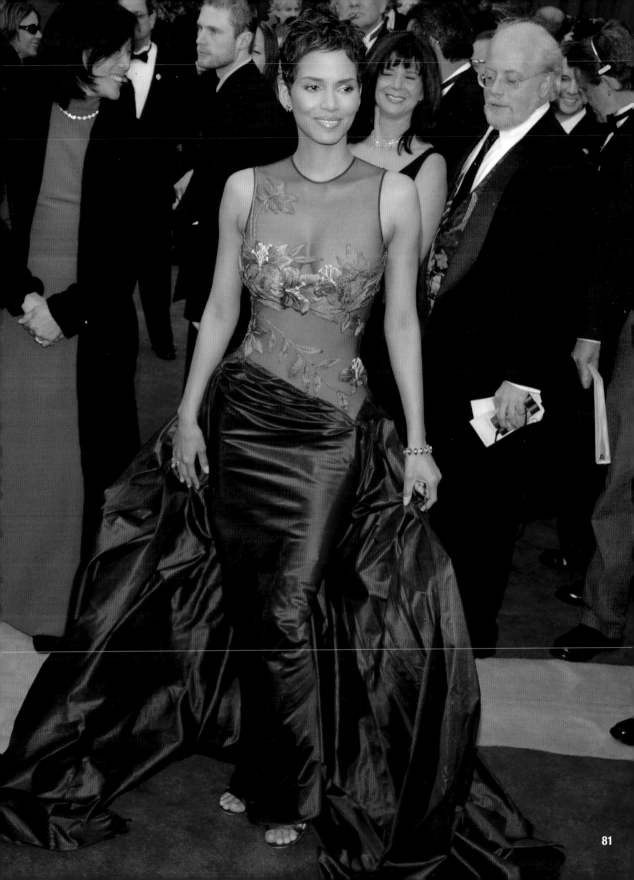

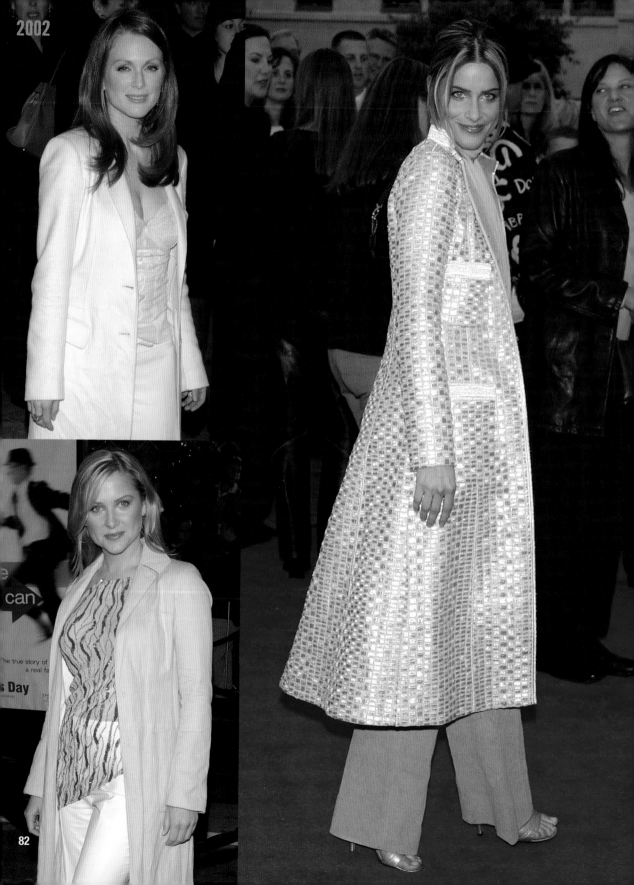

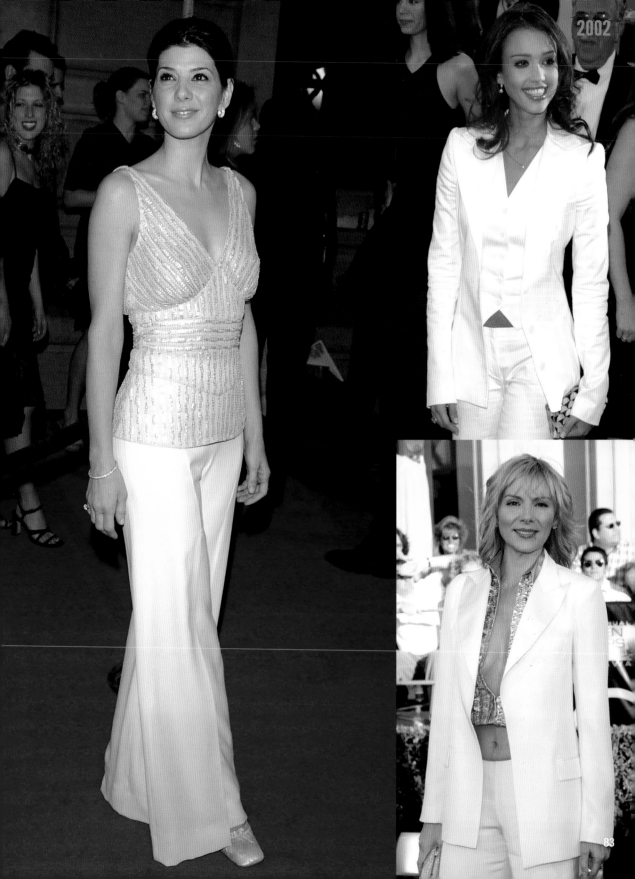

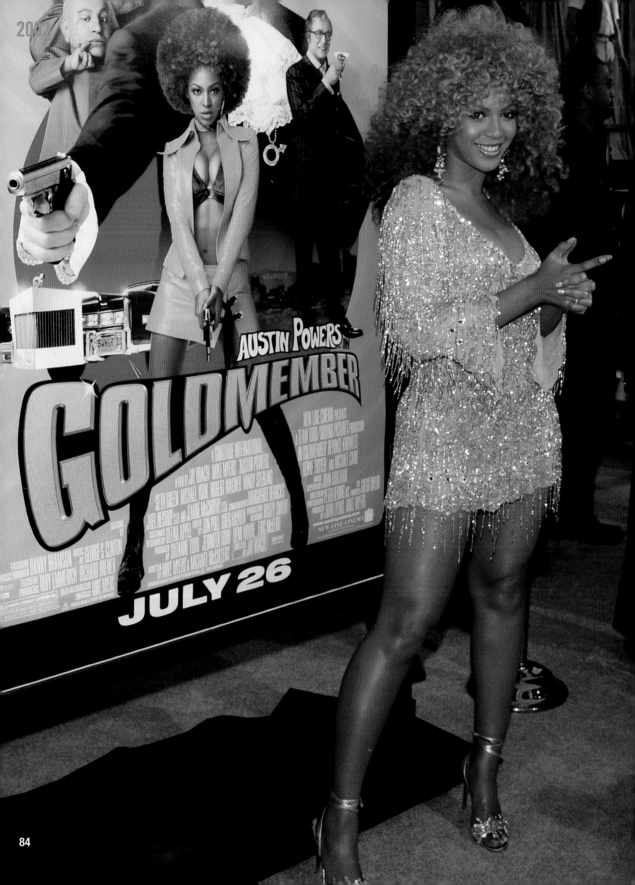

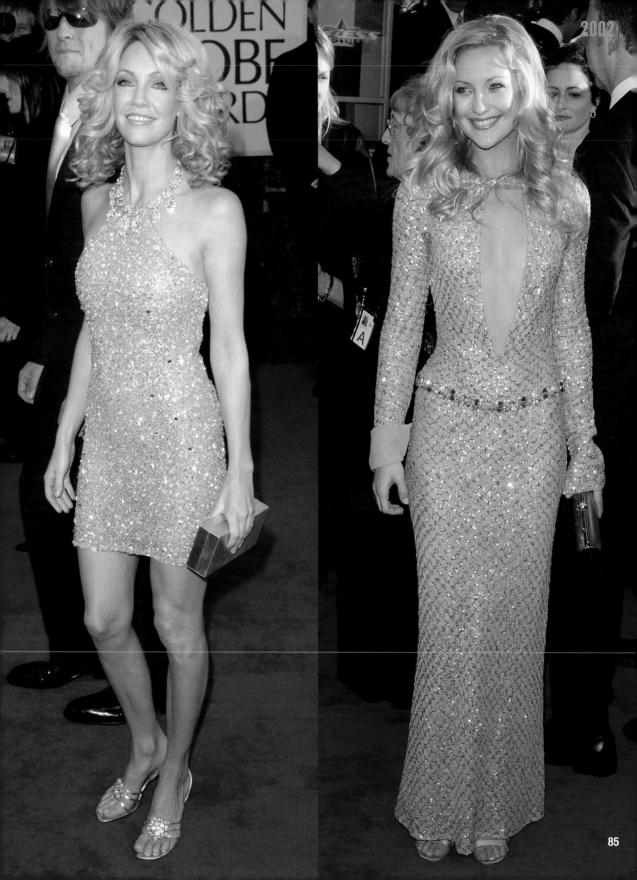

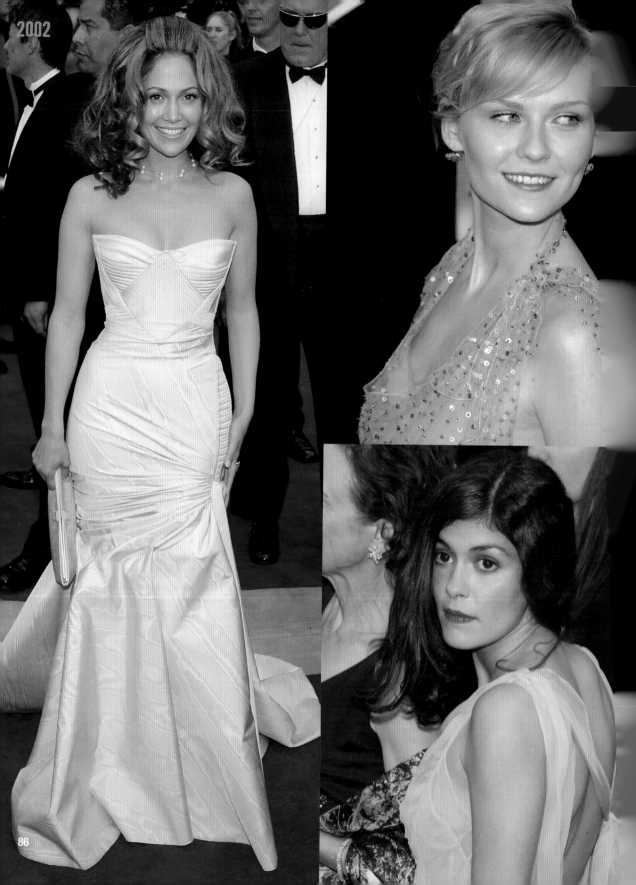

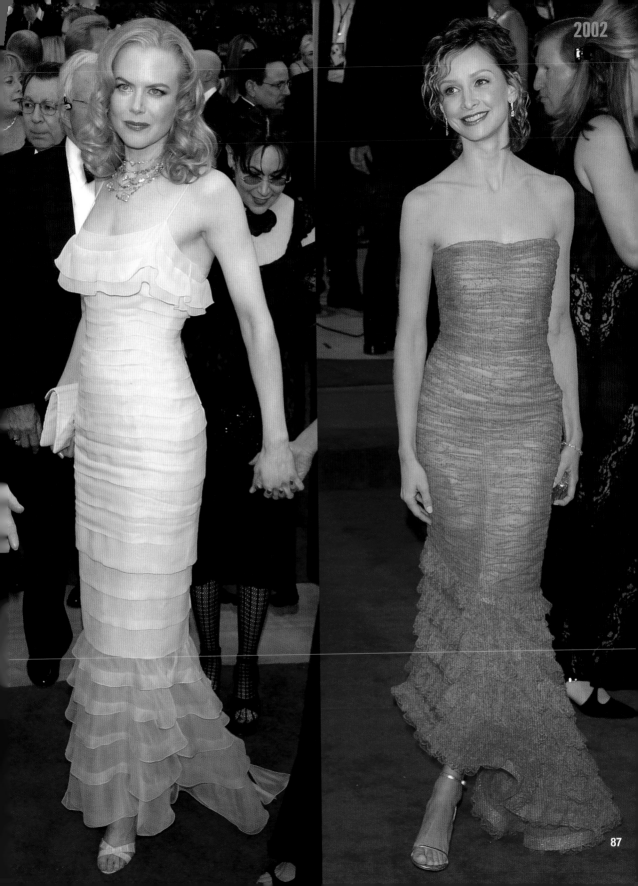

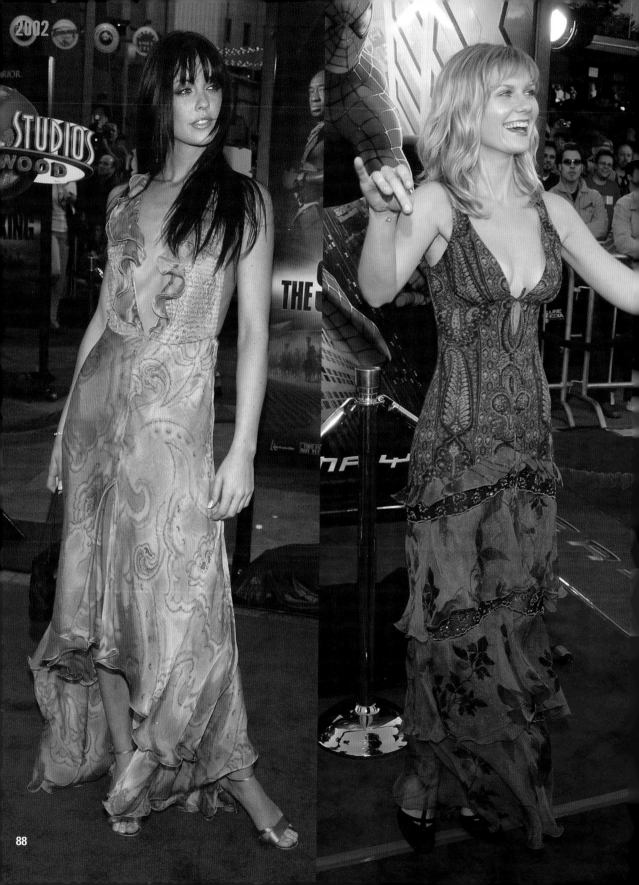

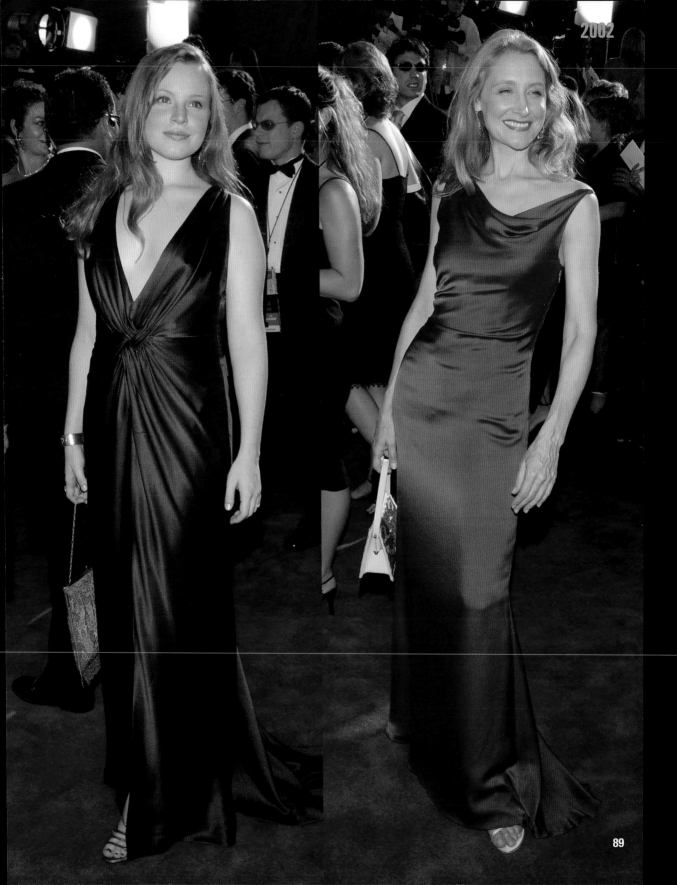

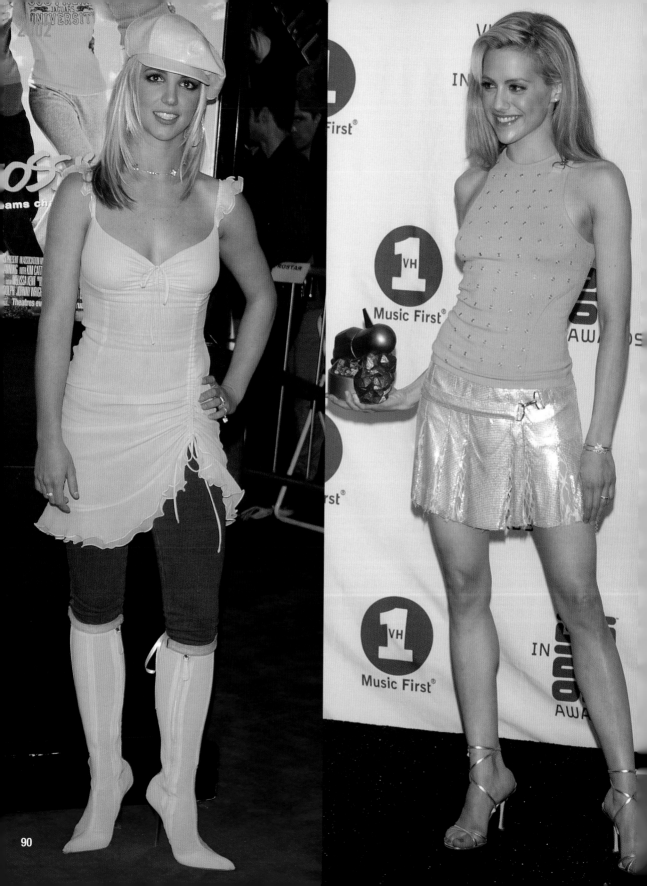

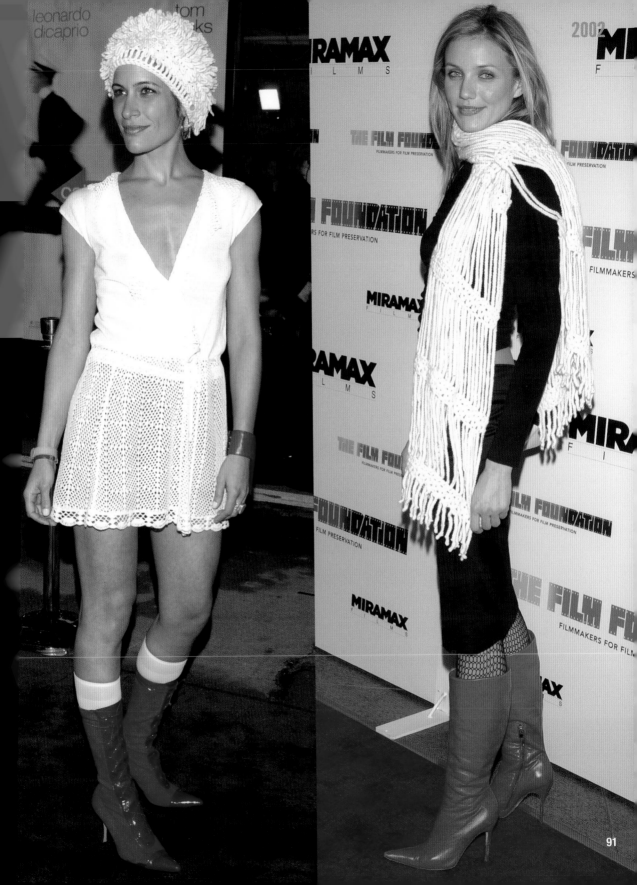

leonardo
dicaprio

tom
hanks

2003

MIRAMAX
FILMS
F

THE FILM FOUNDATION
FILMMAKERS FOR FILM PRESERVATION

2003

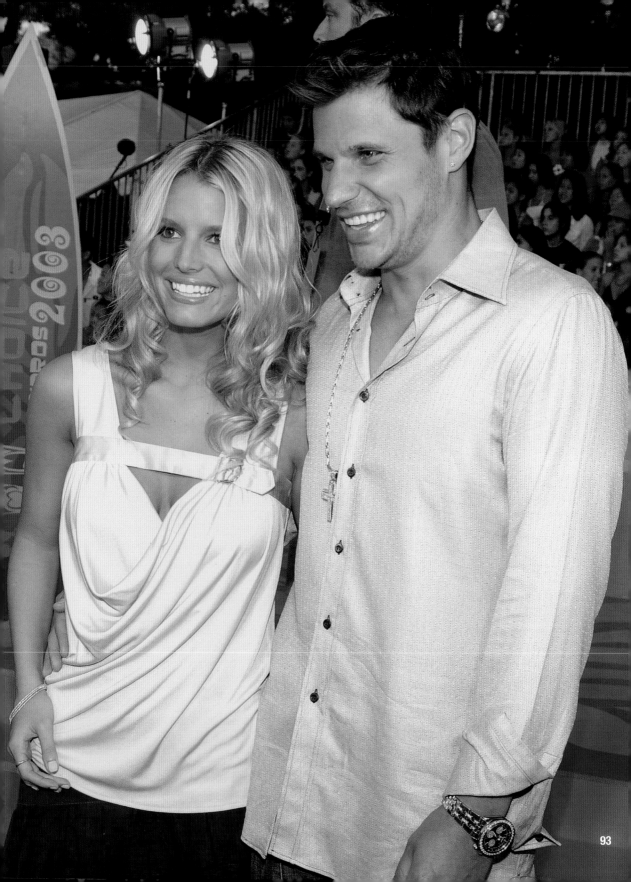

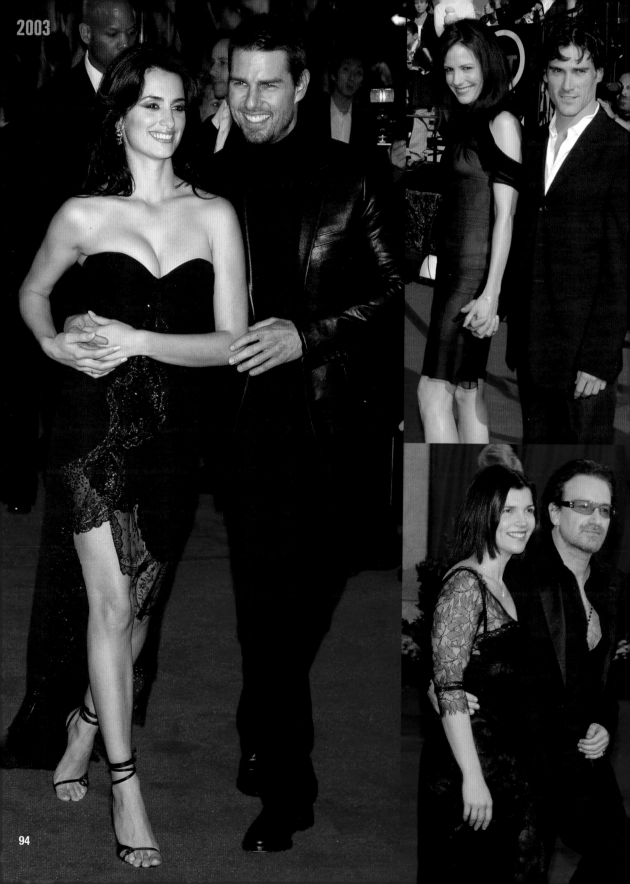

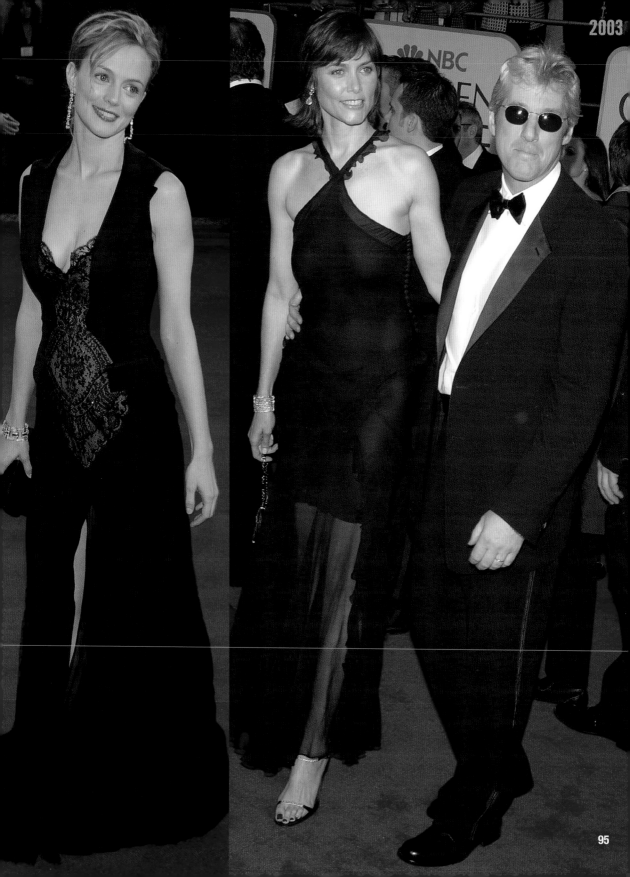

NBC

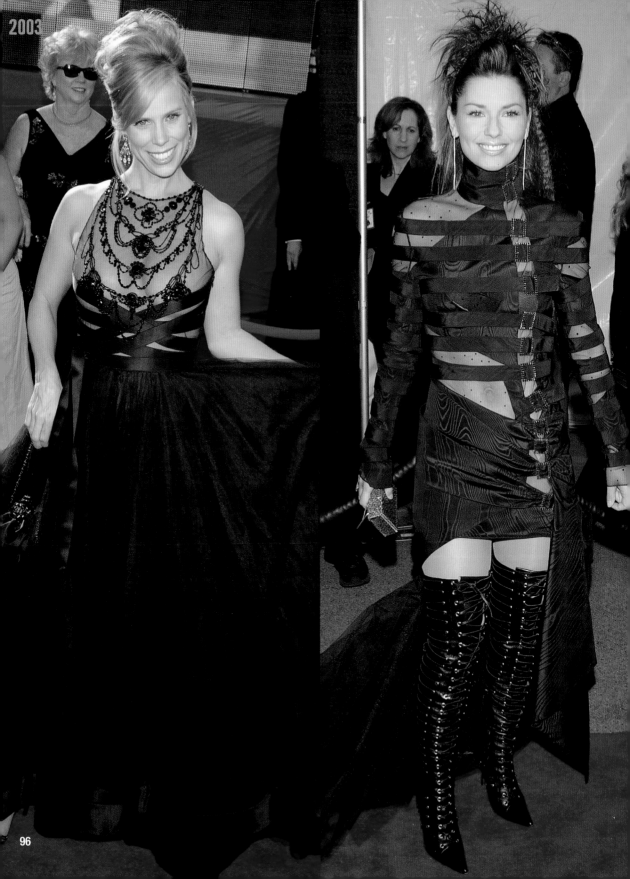

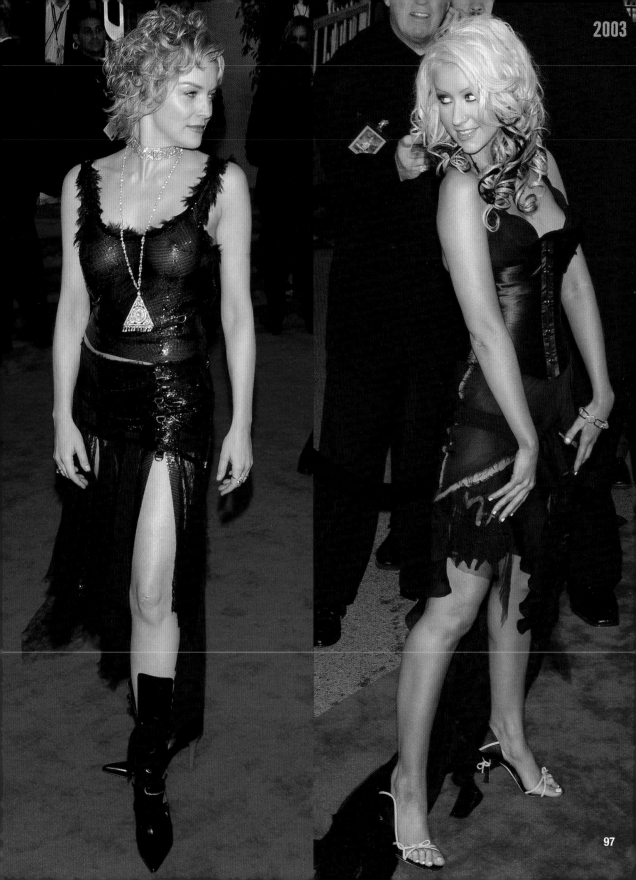

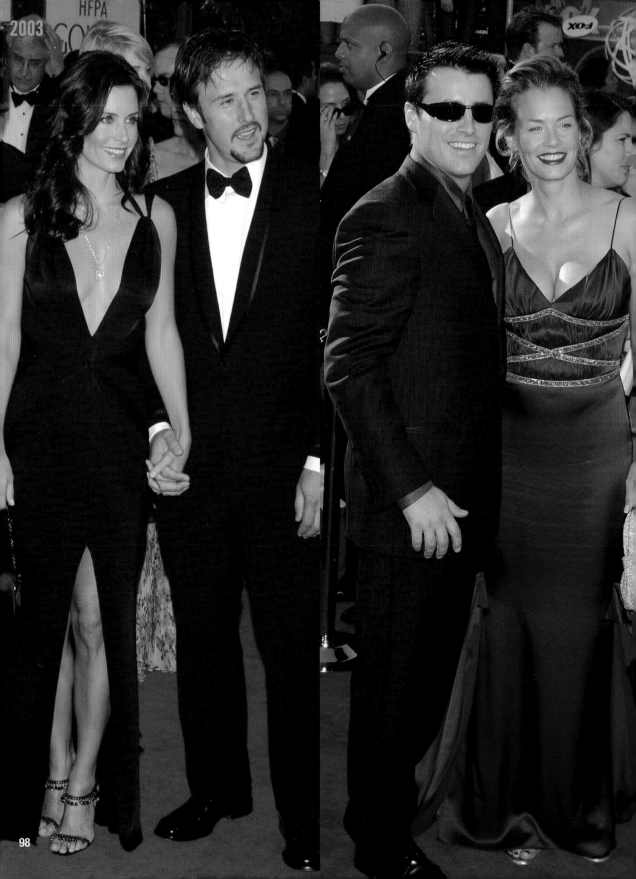

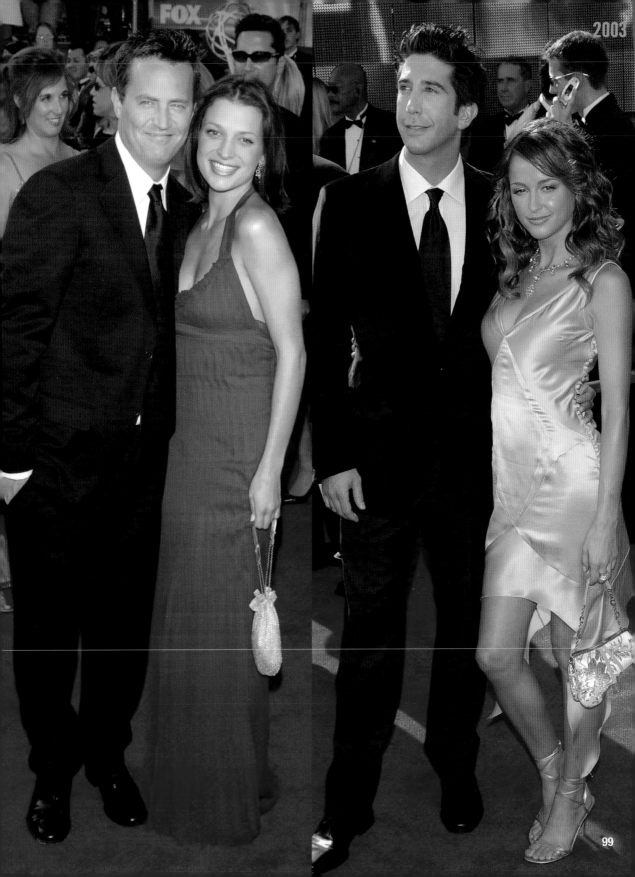

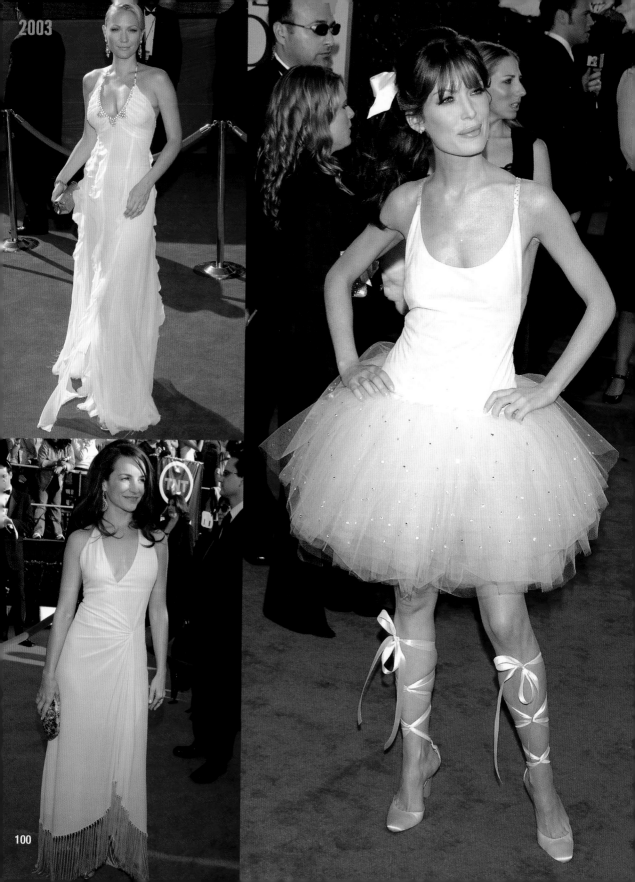

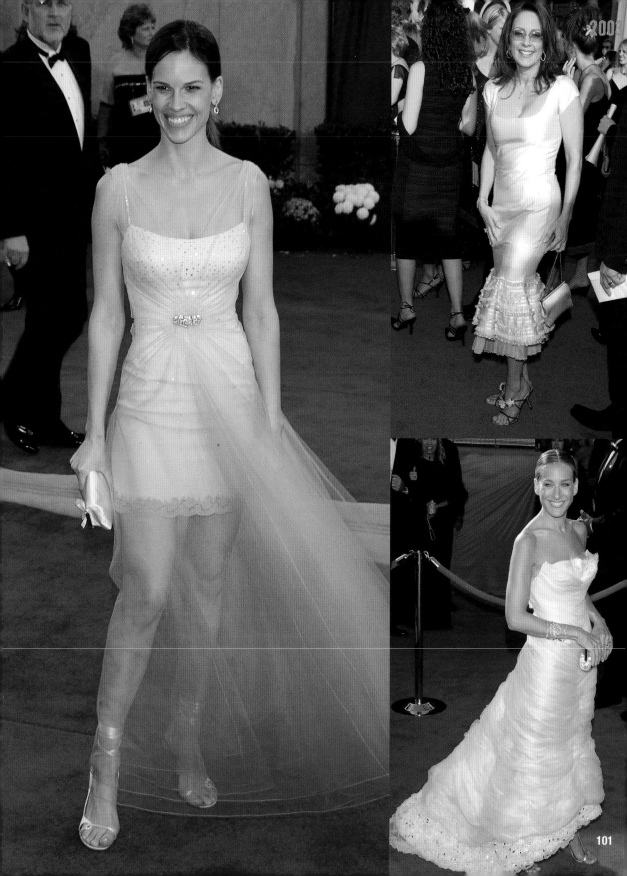

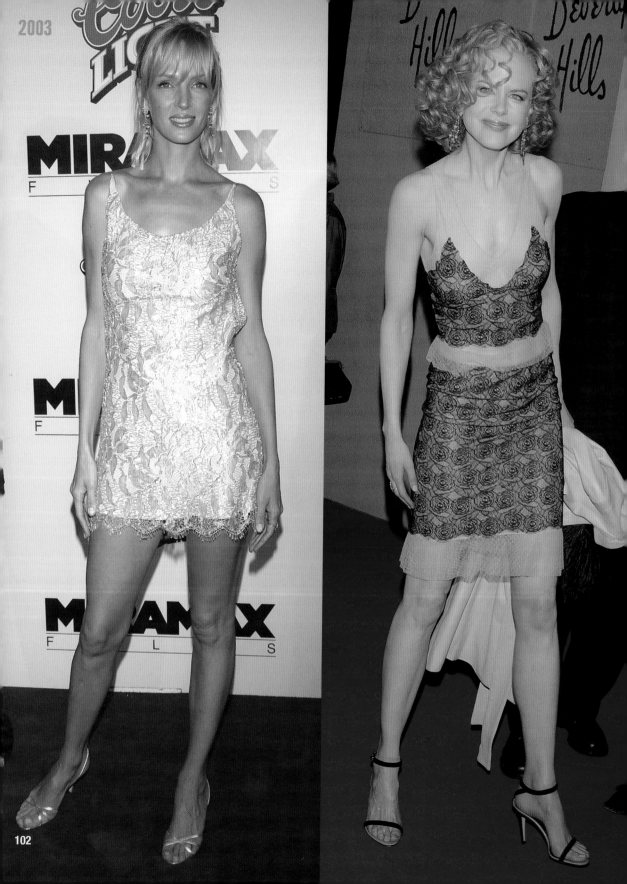

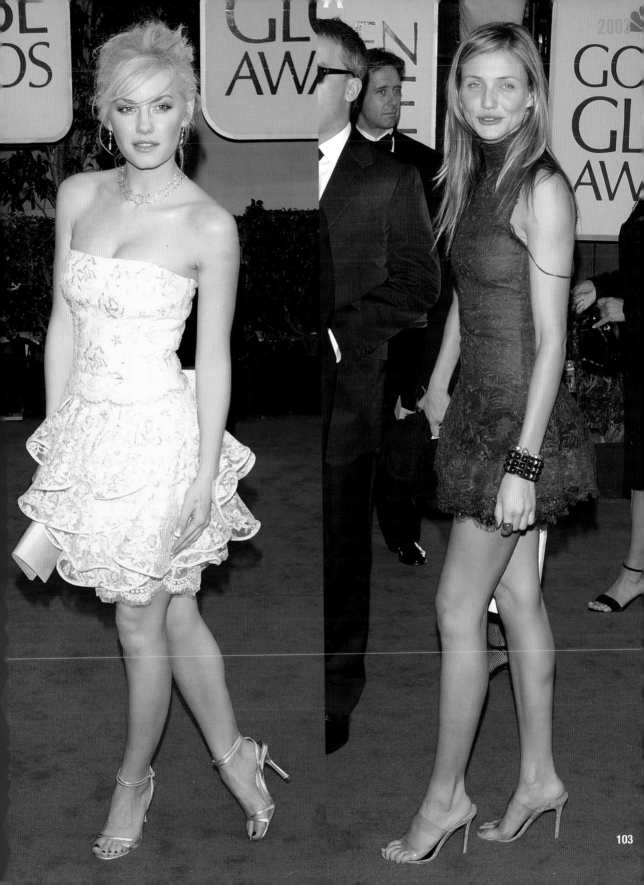

2004

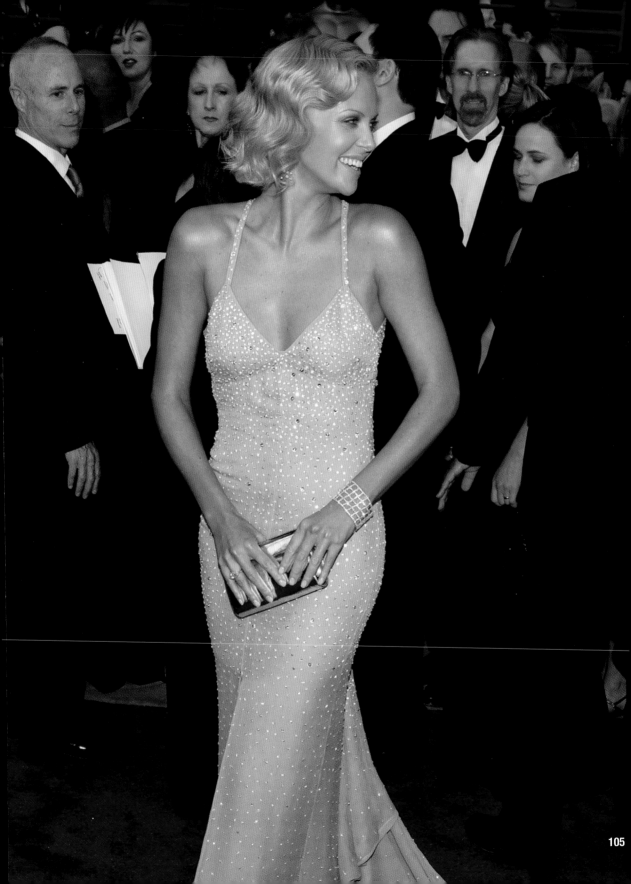

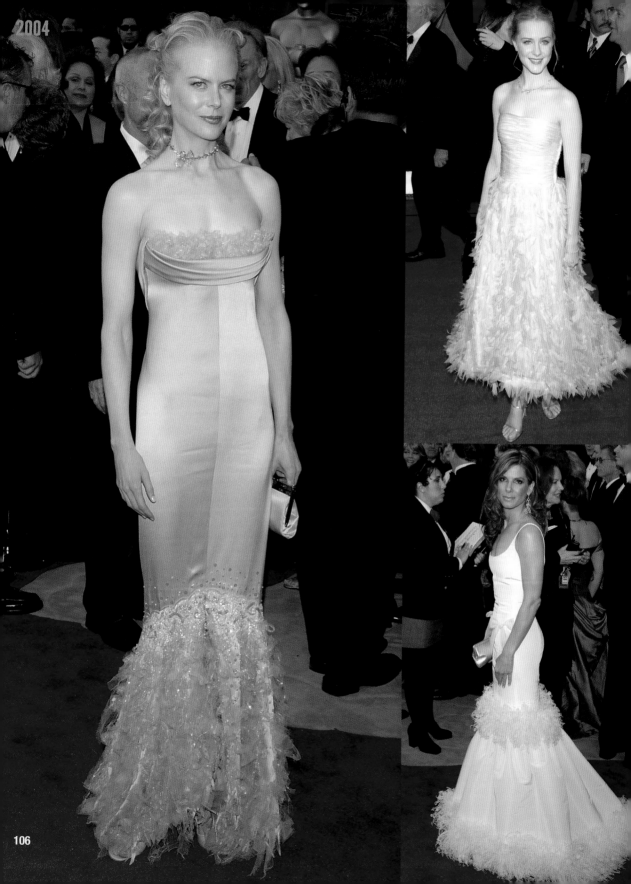

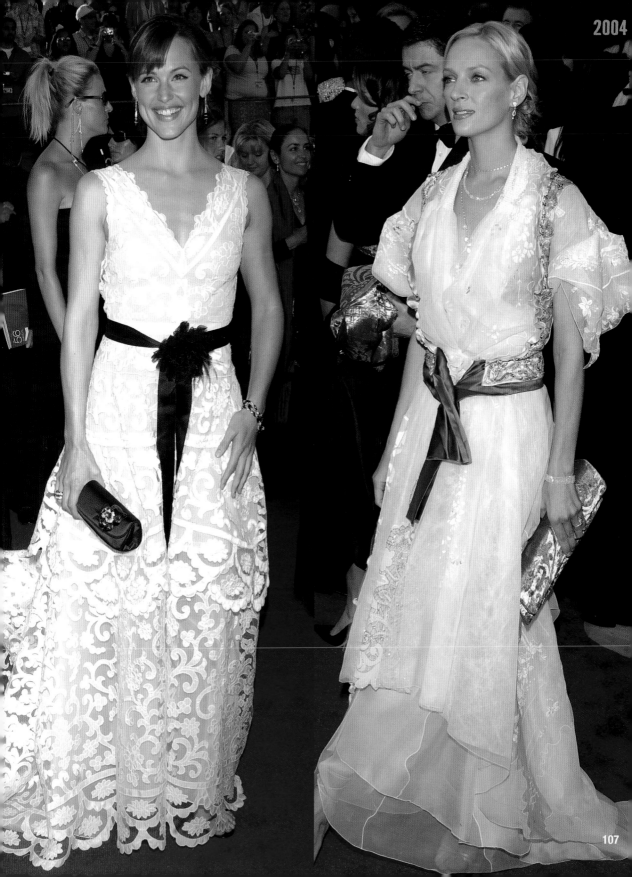

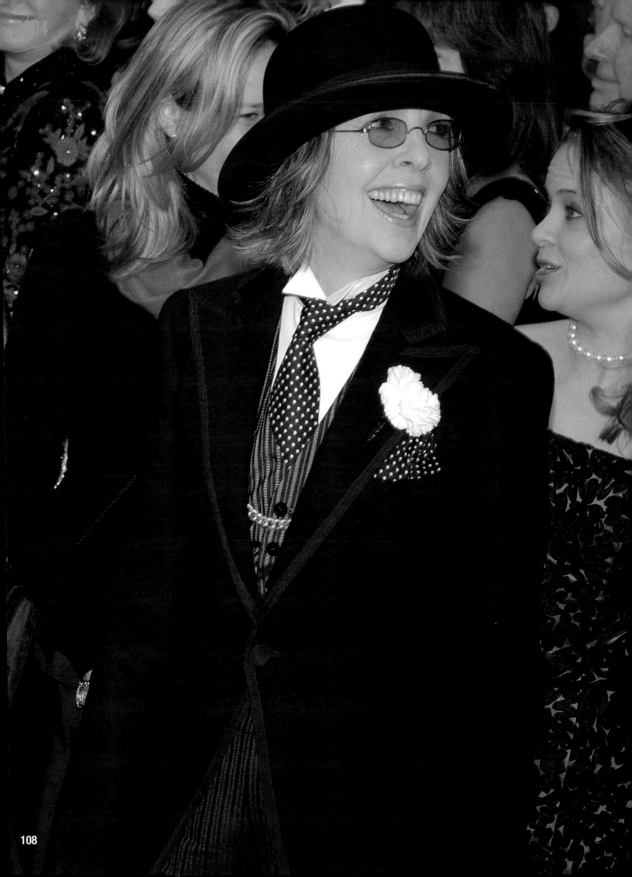

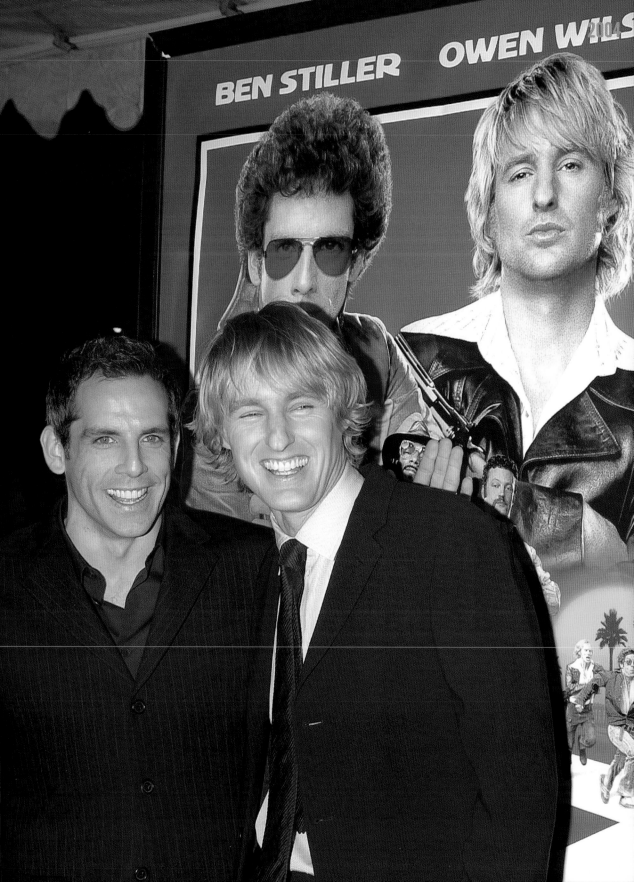

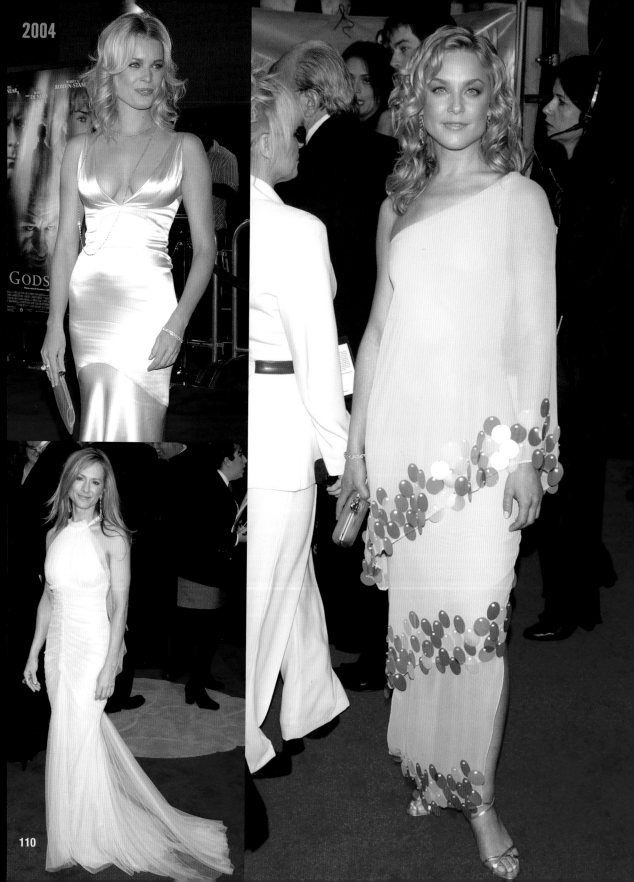

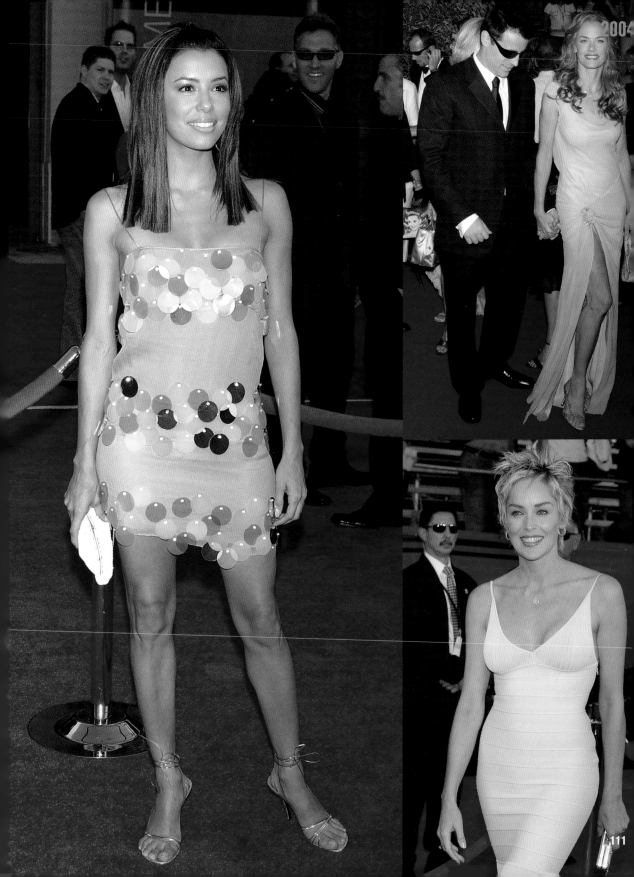

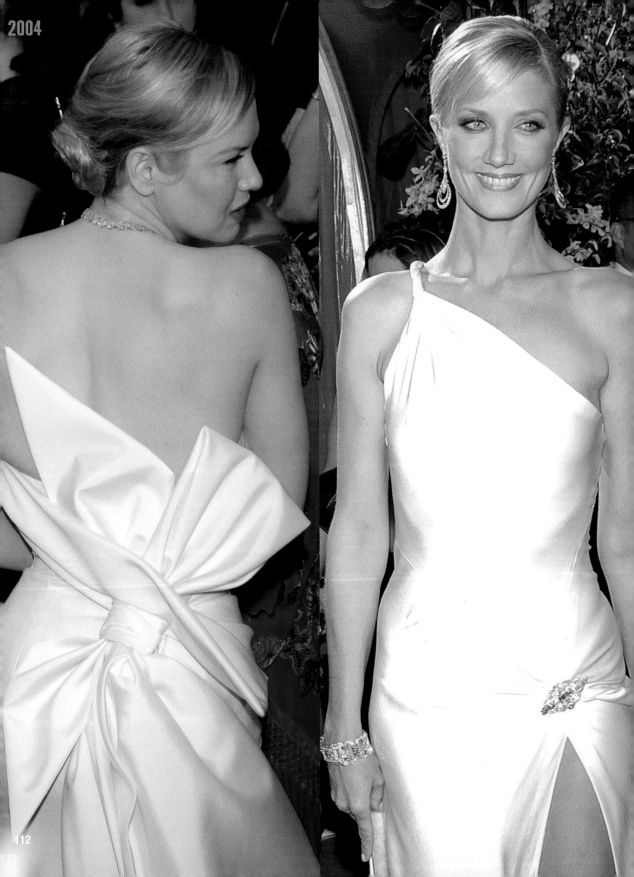

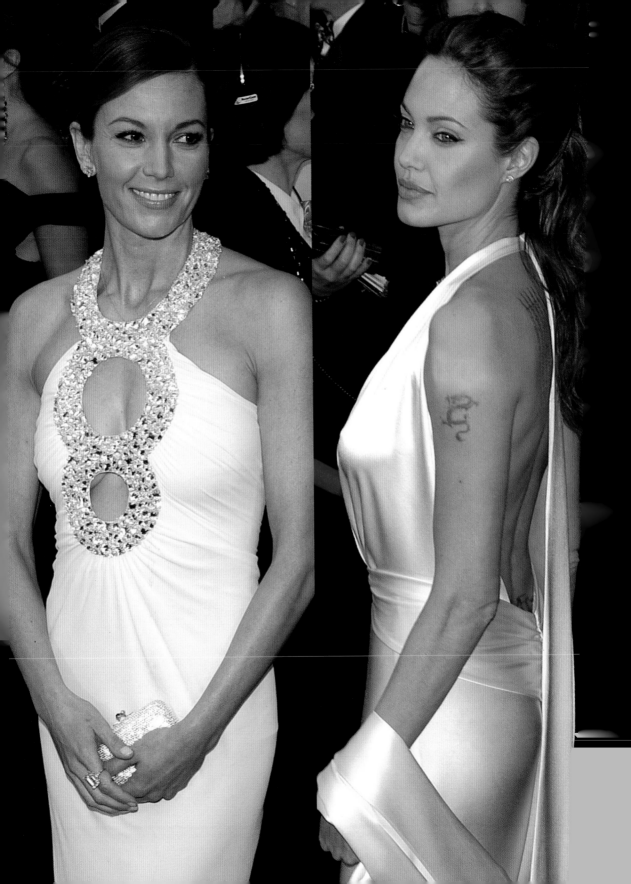

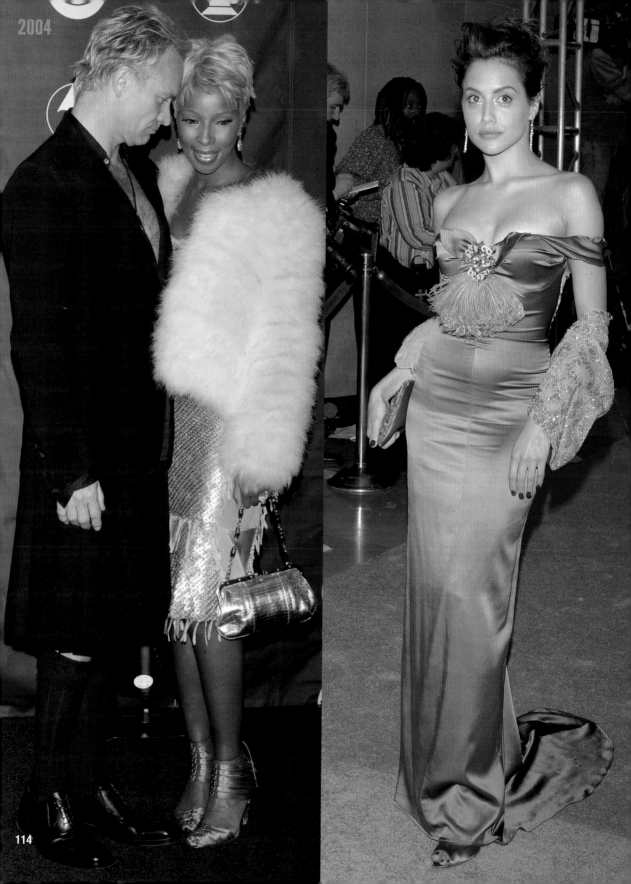

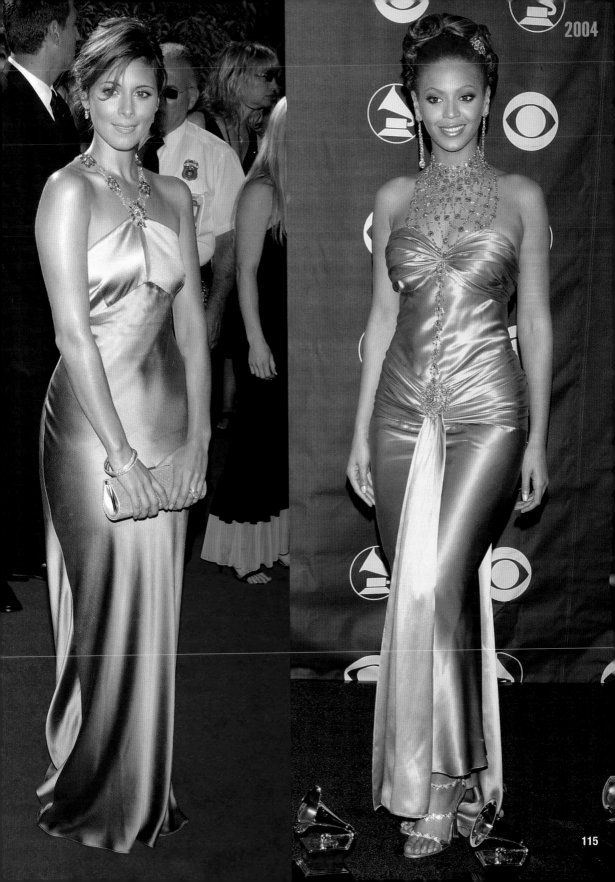

2005

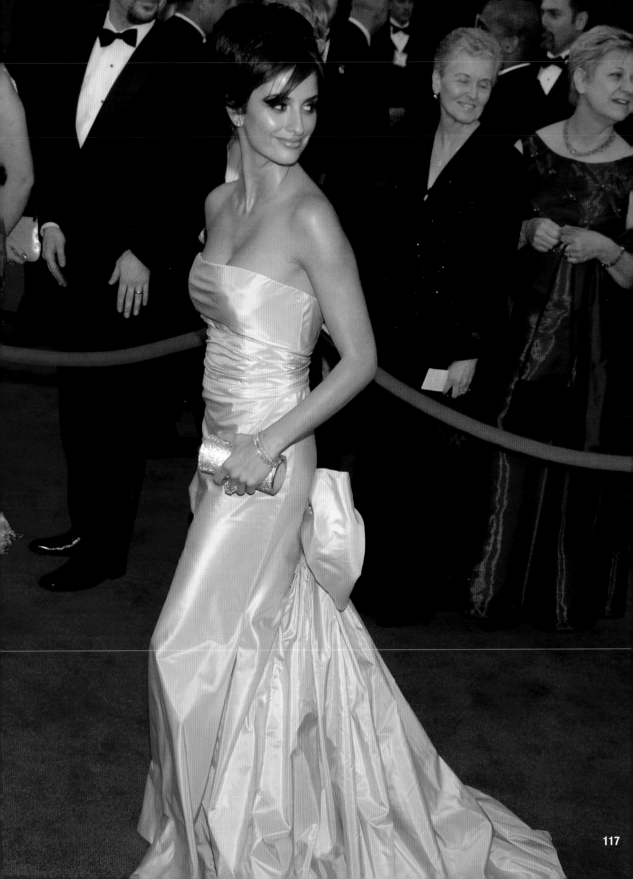

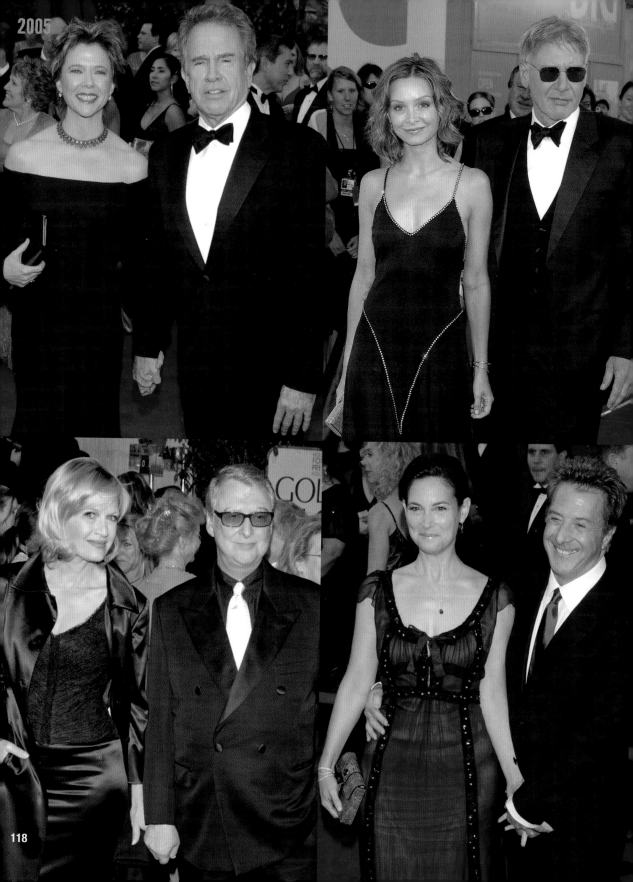

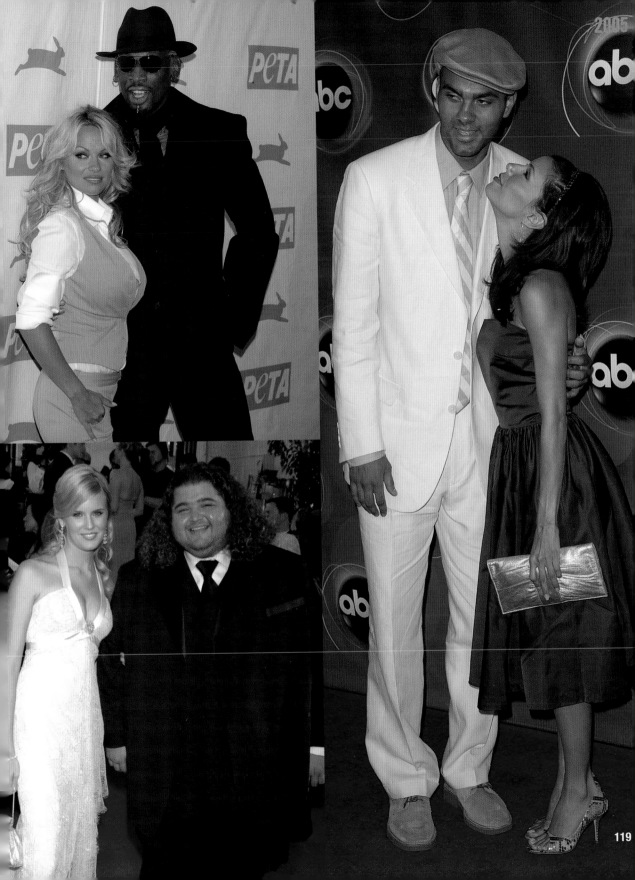

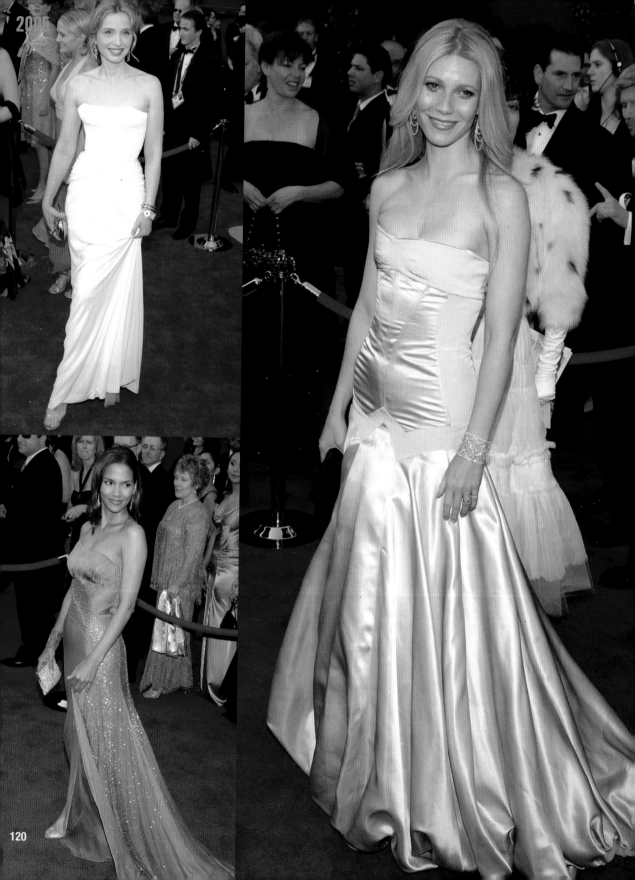

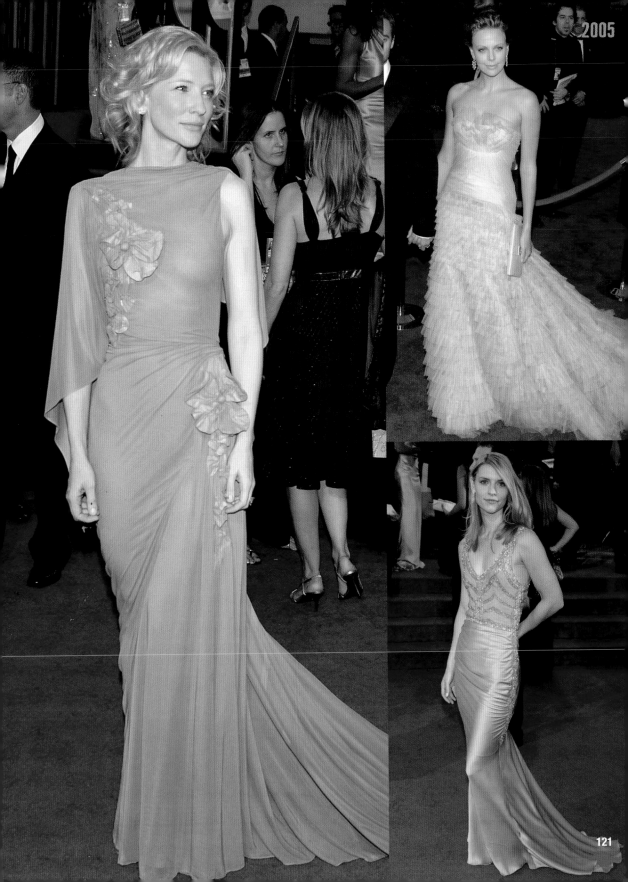

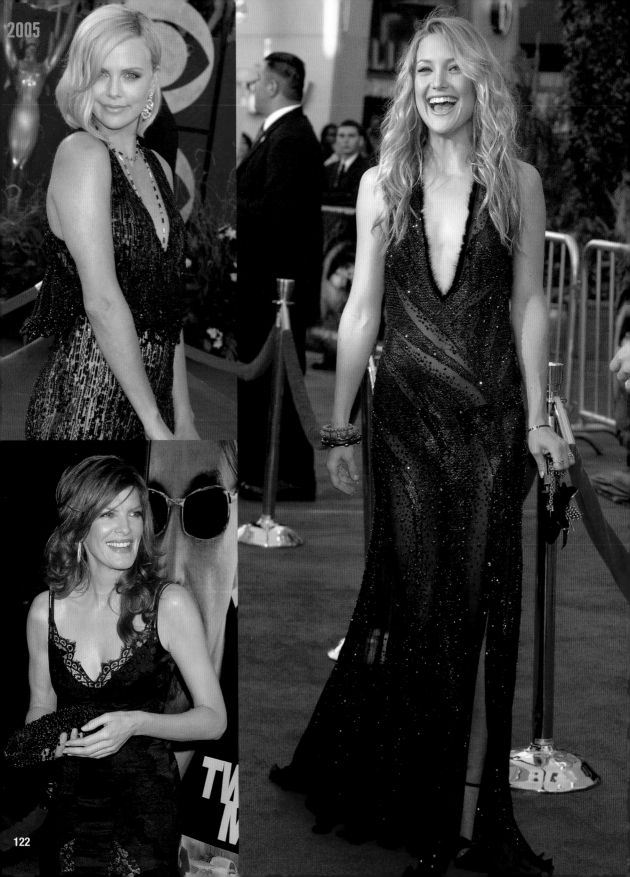

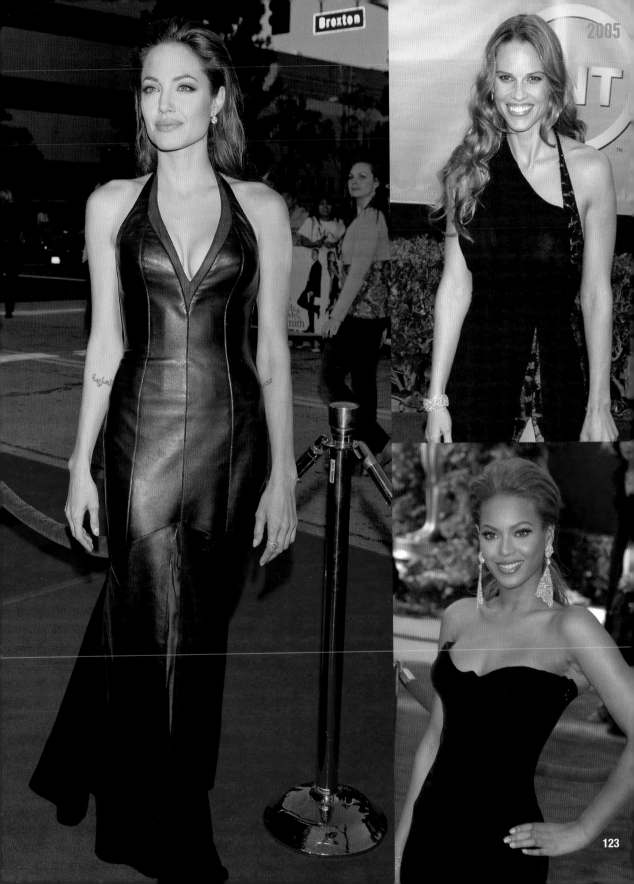

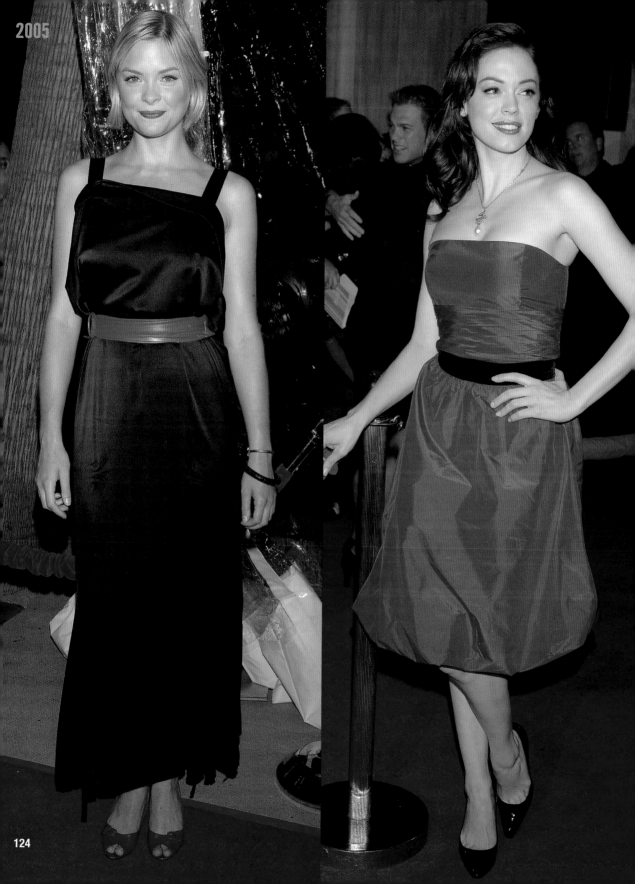

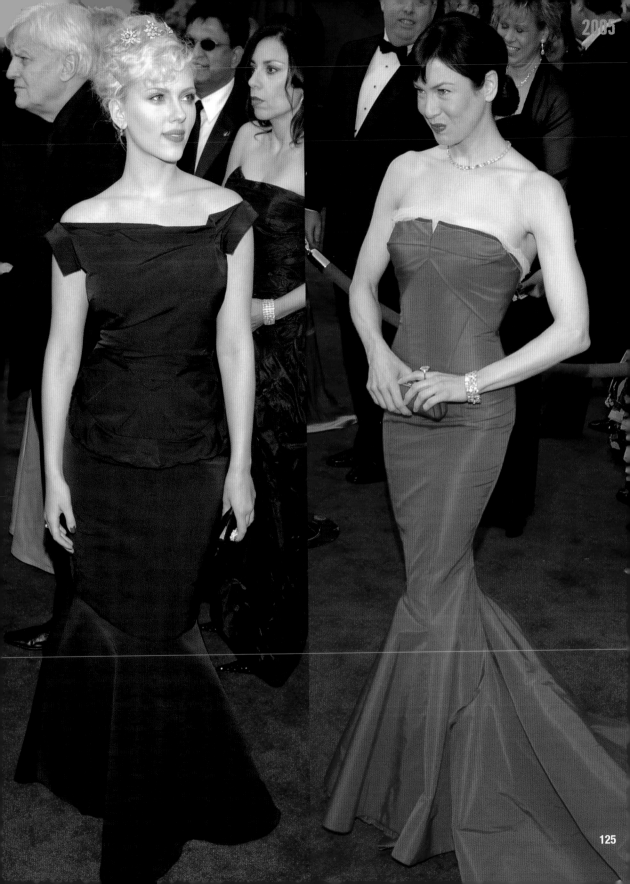

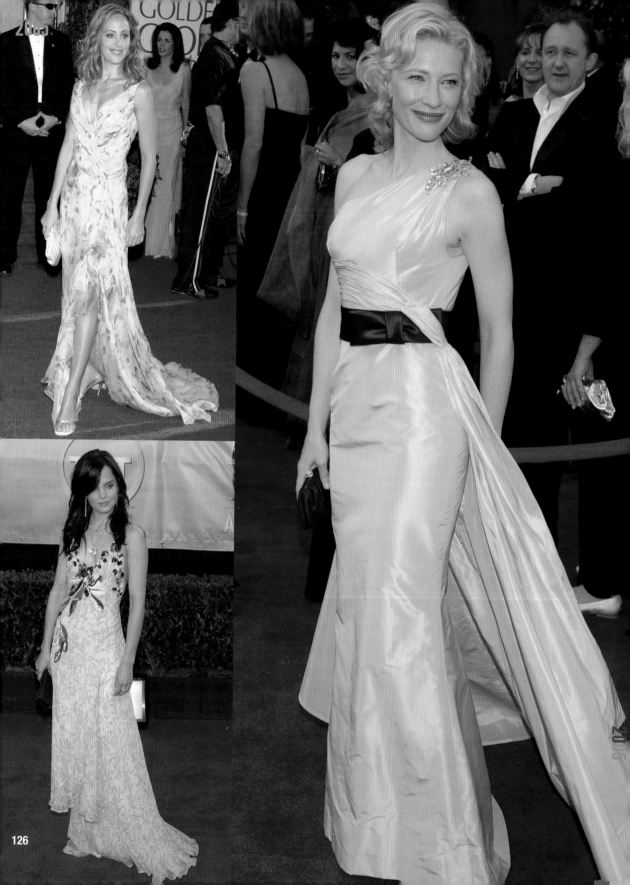

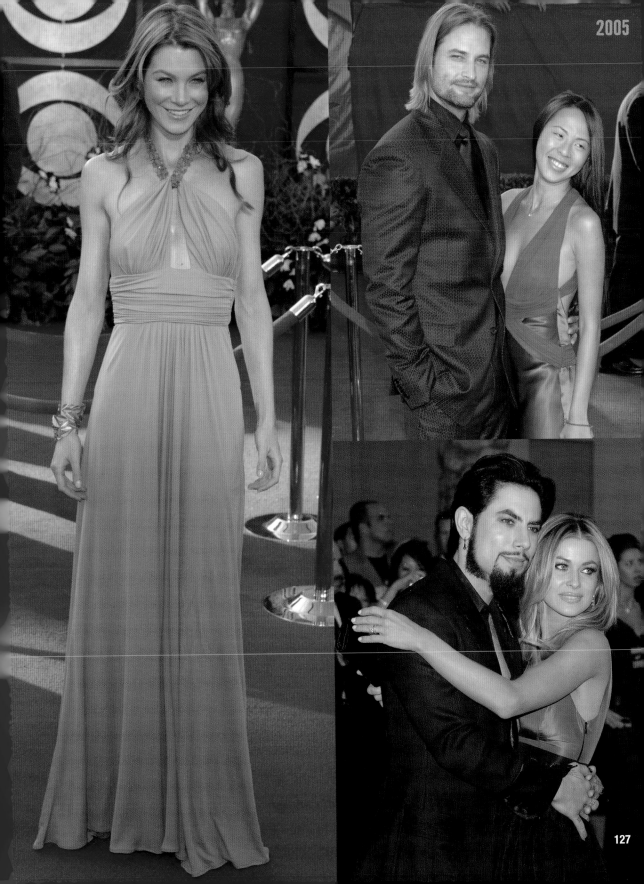

2006

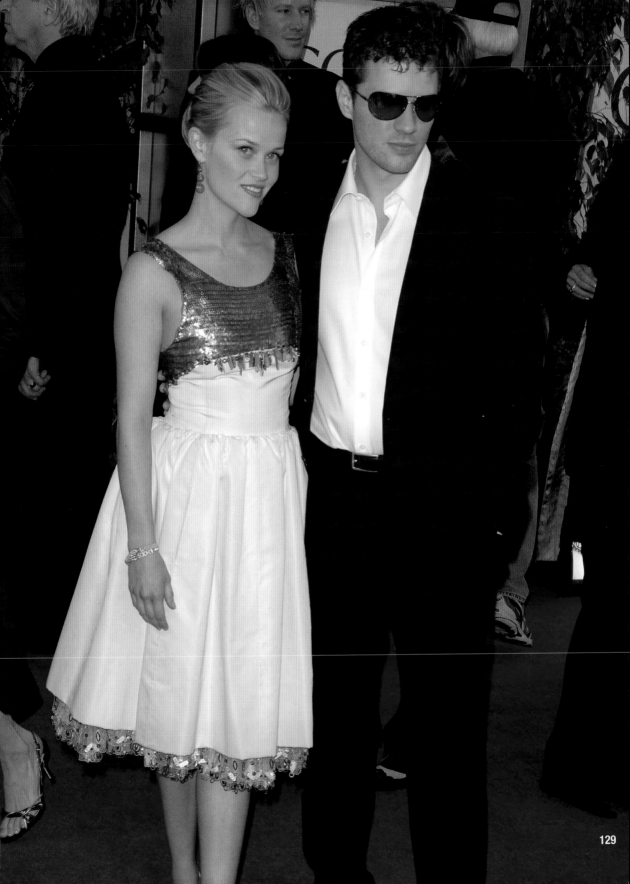

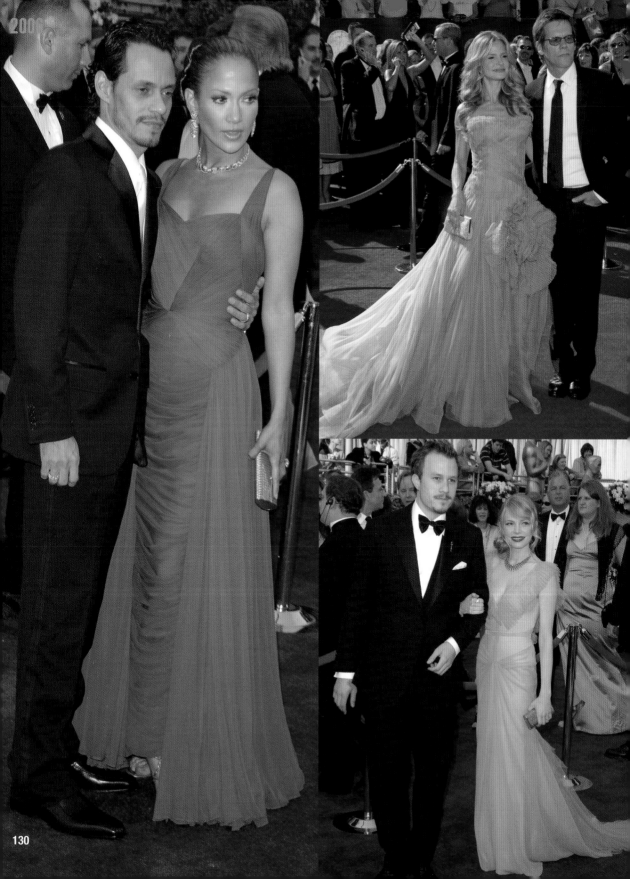

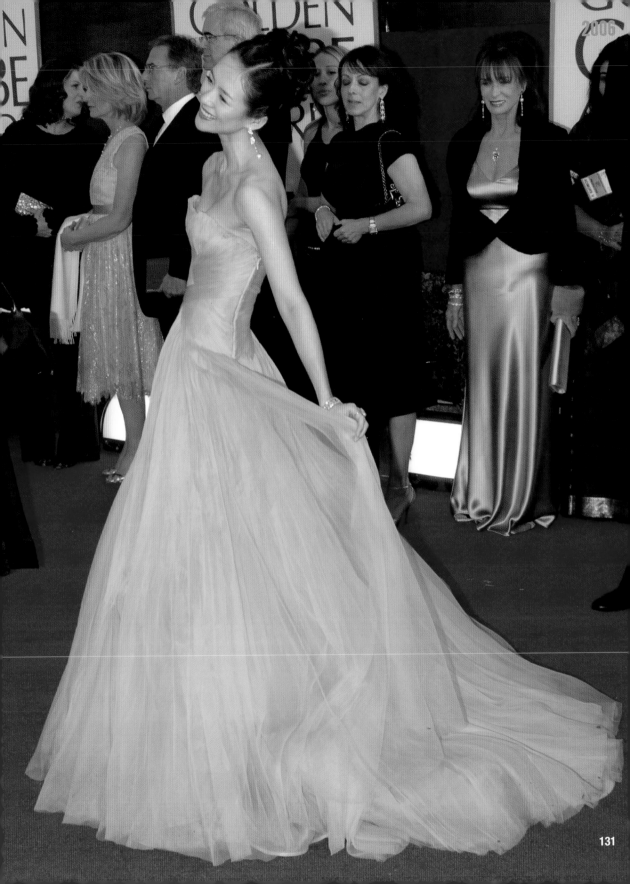

131

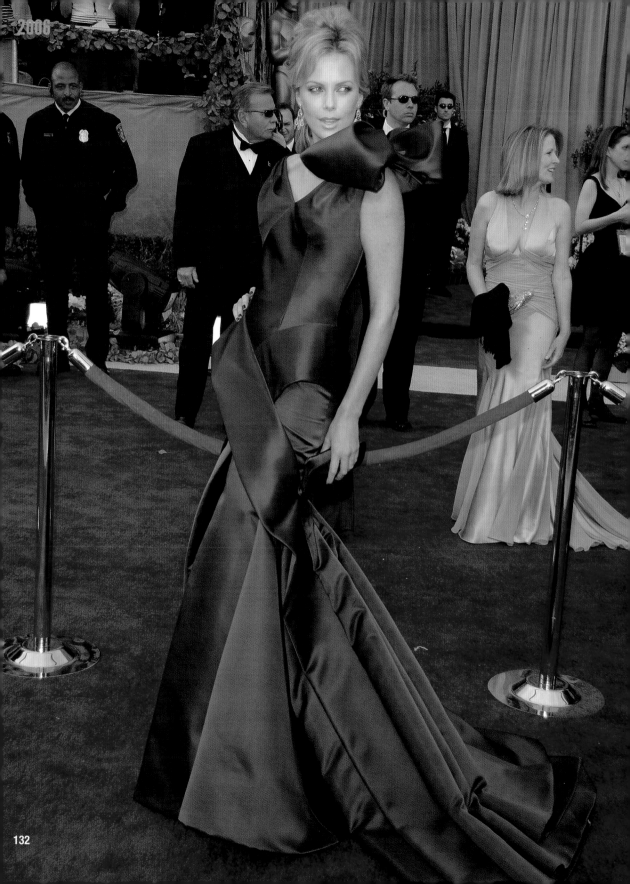

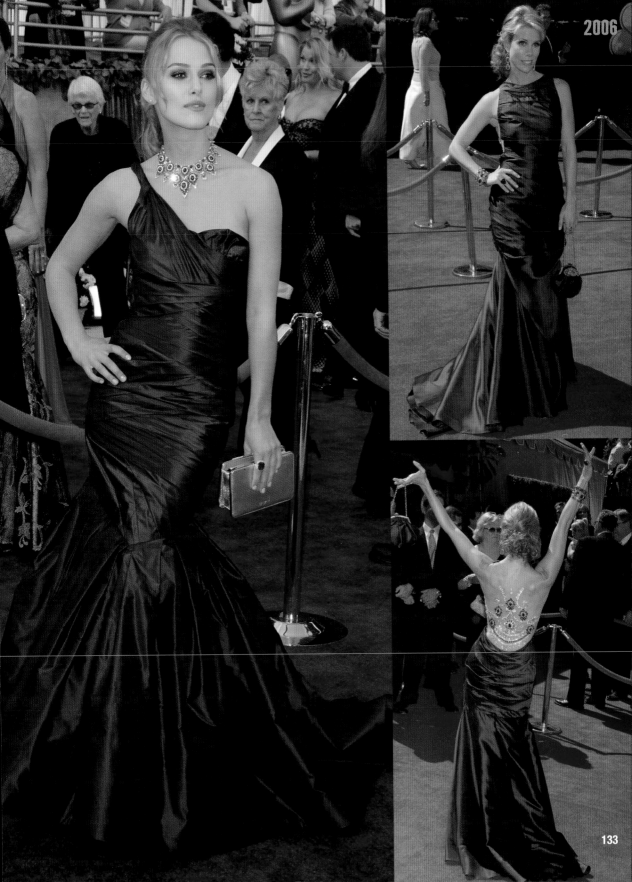

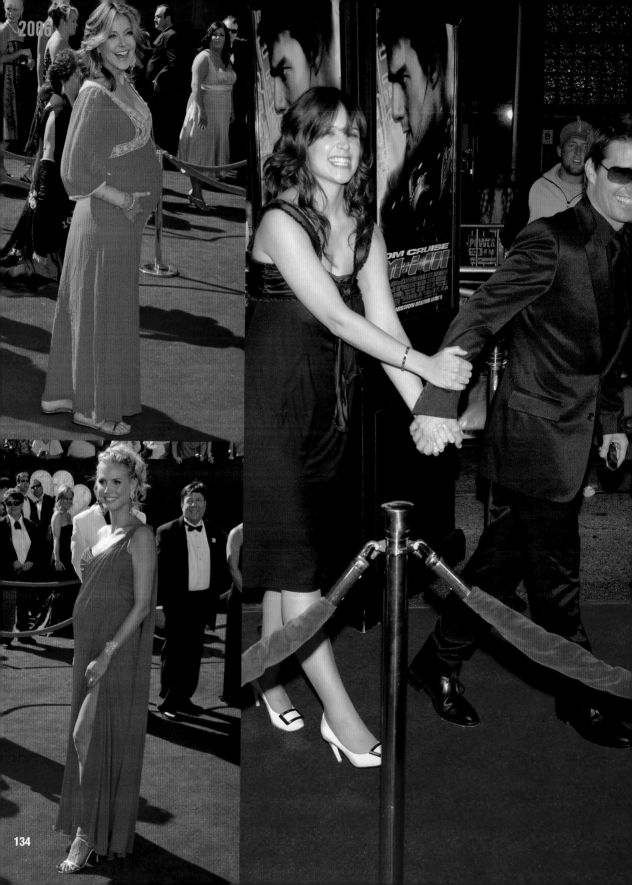

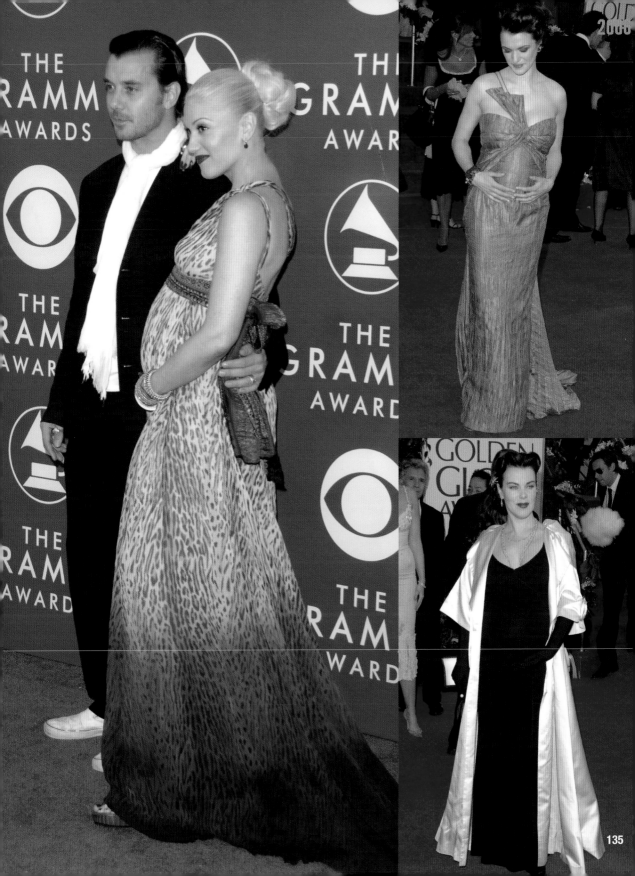

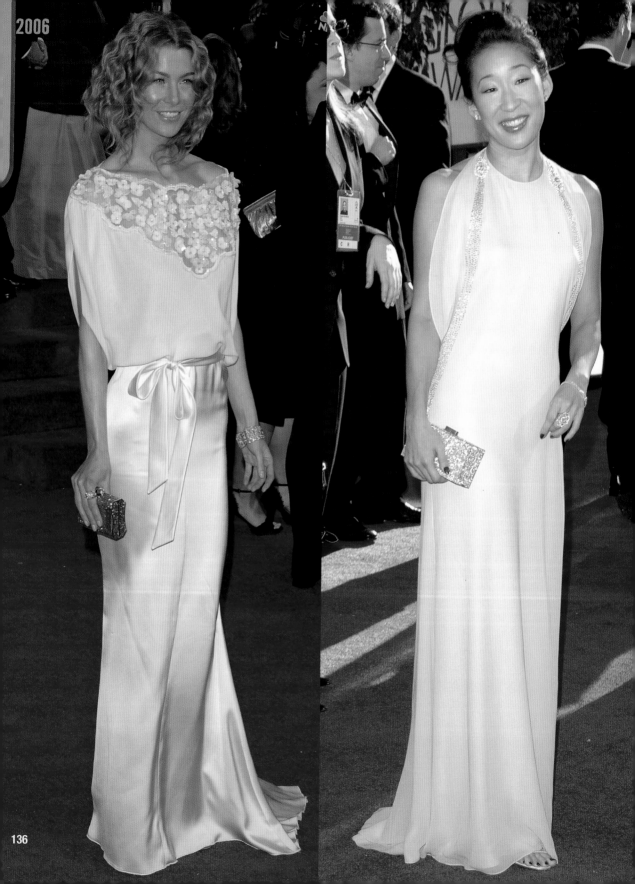

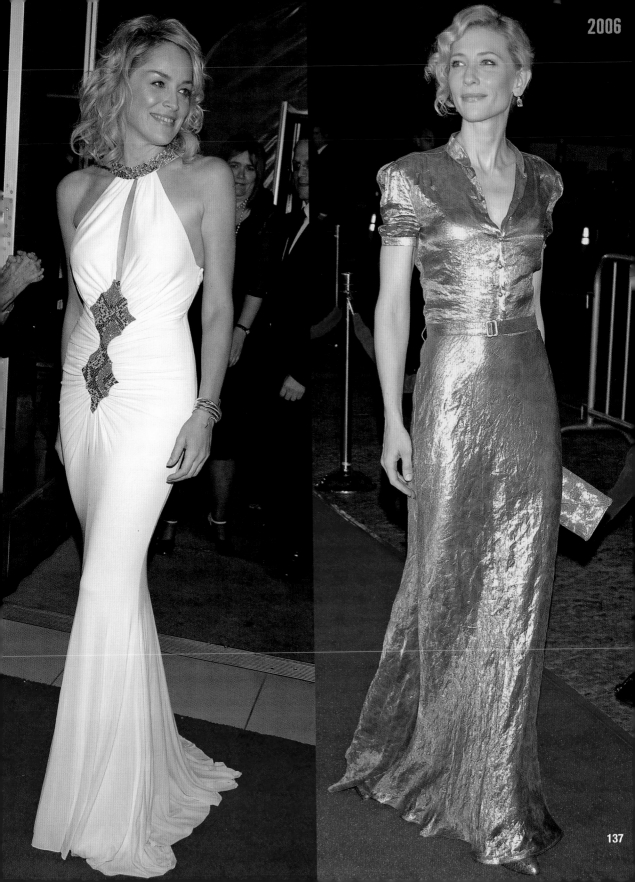

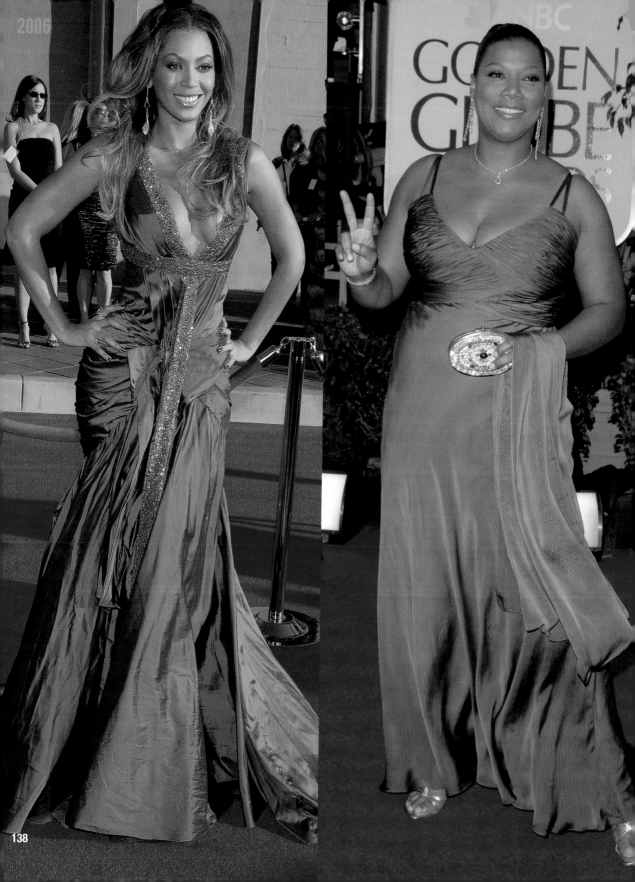

2006

138

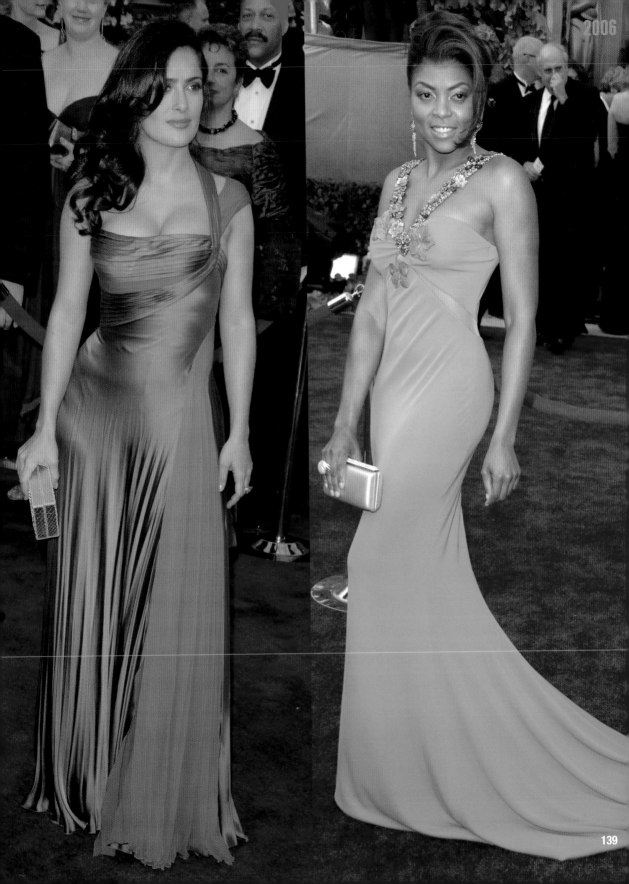

2007

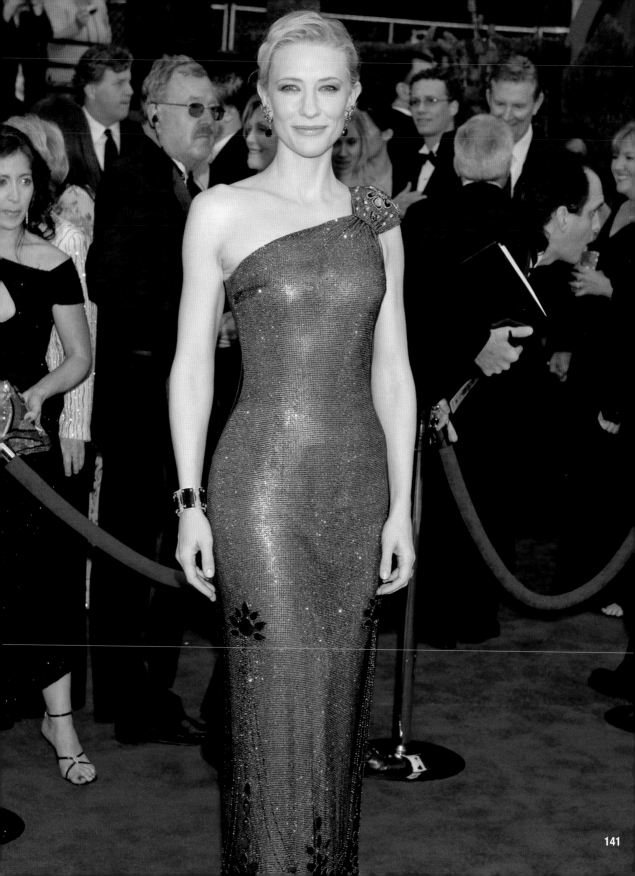

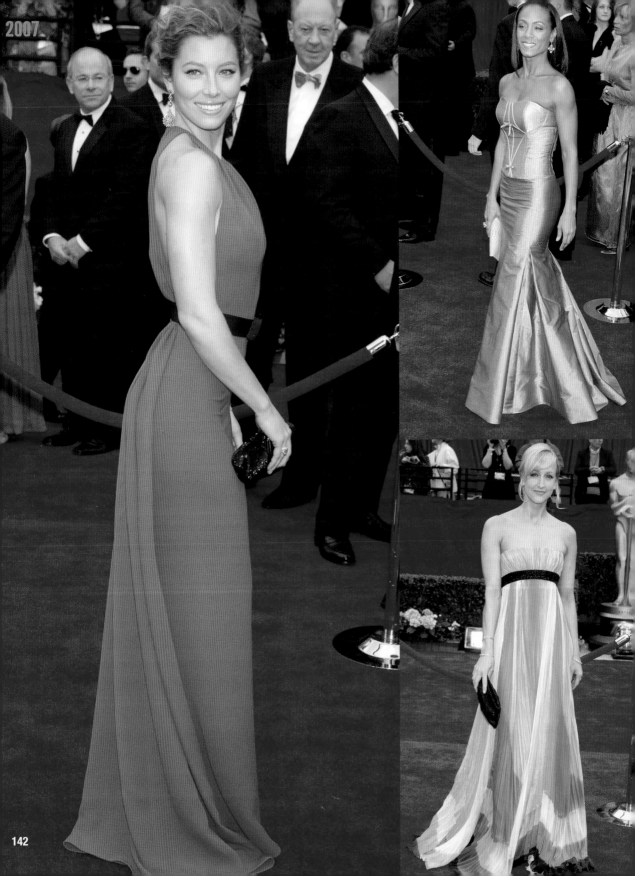

BE GOLDEN
AWA

RODEO DRIVE
WALK OF STYLE
BEVERLY HILLS

VERSACE

RSACE

RODEO DRIVE
WALK OF STYLE
BEVERLY HILLS

RSACE

RODEO DRIVE
WALK OF STYLE
BEVERLY HILLS

VER

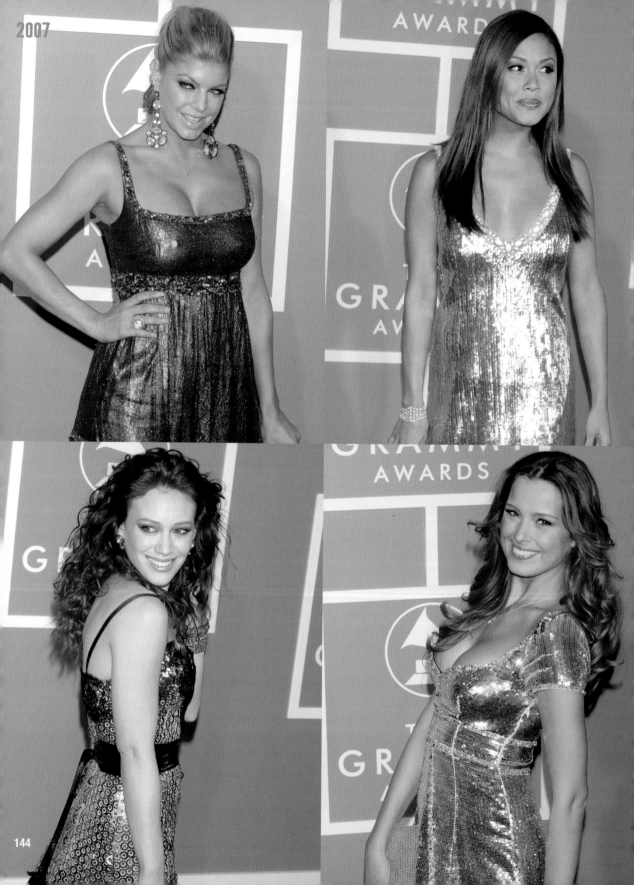

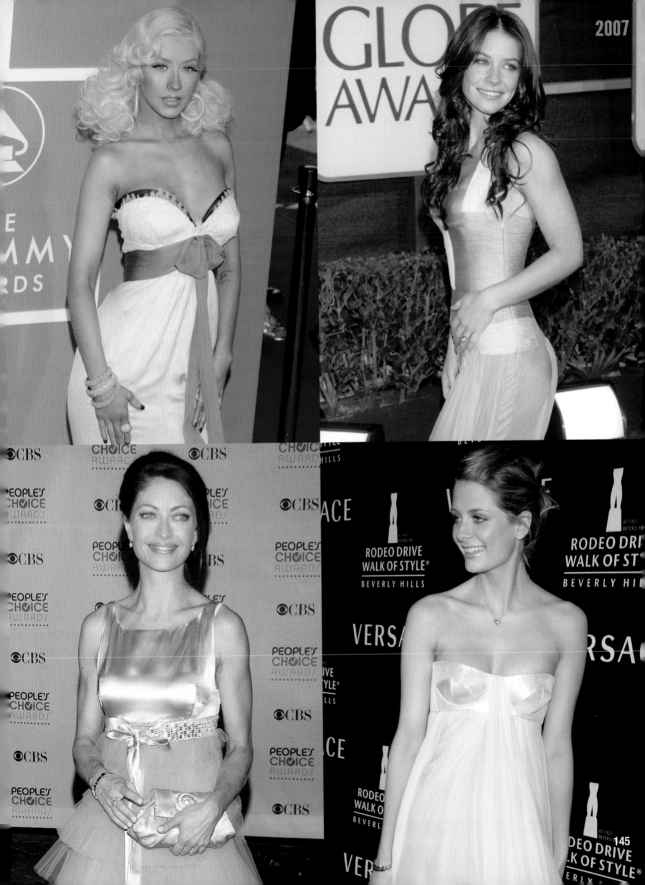

145

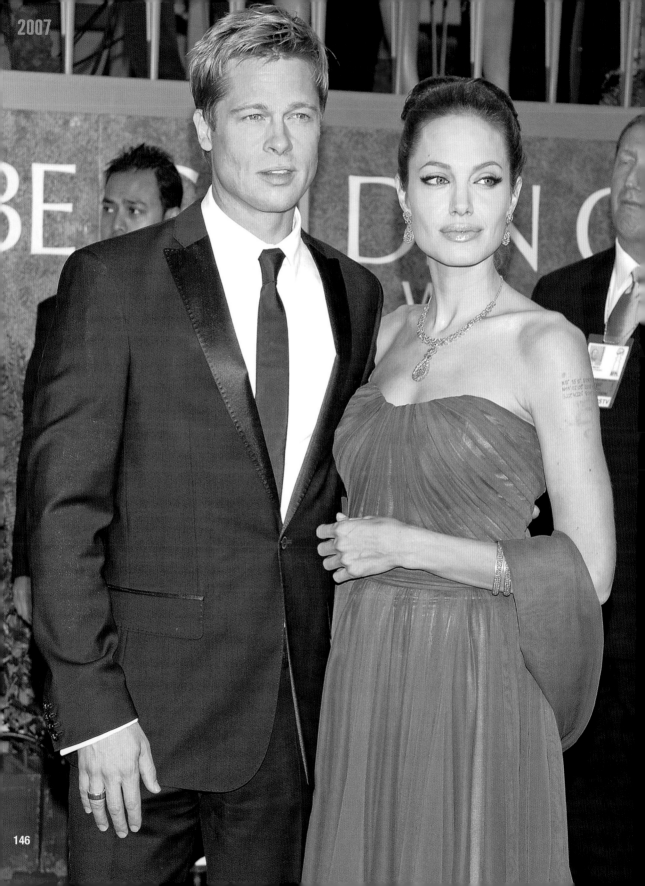

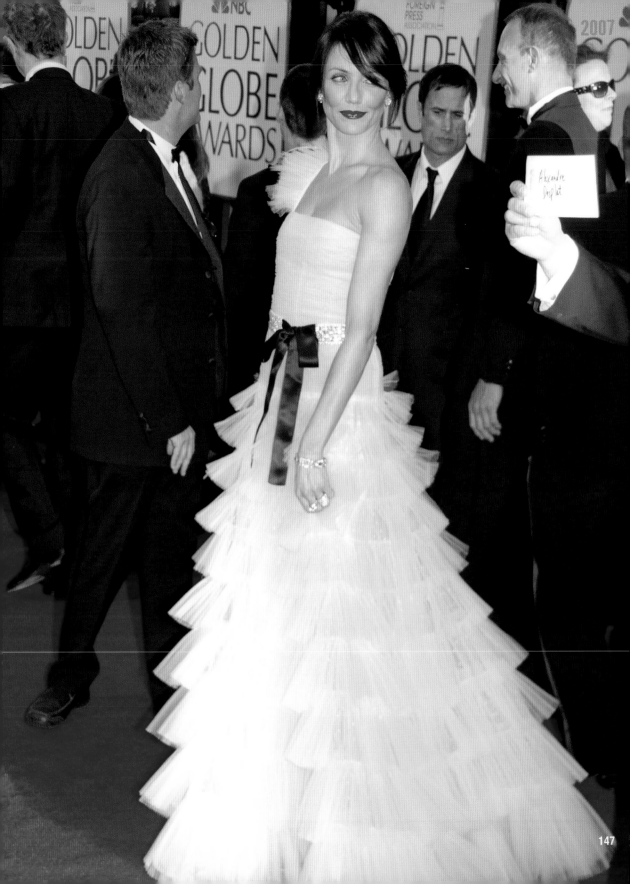

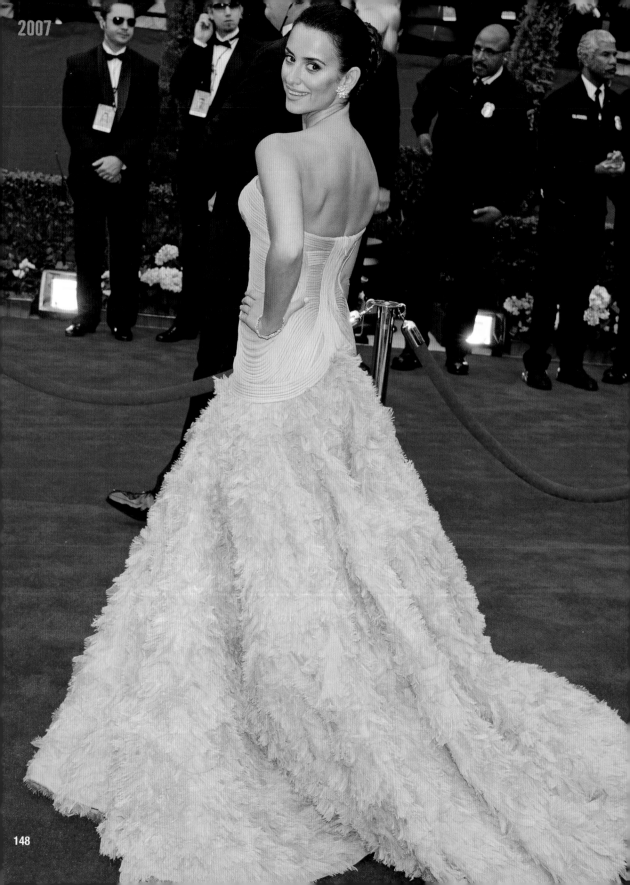

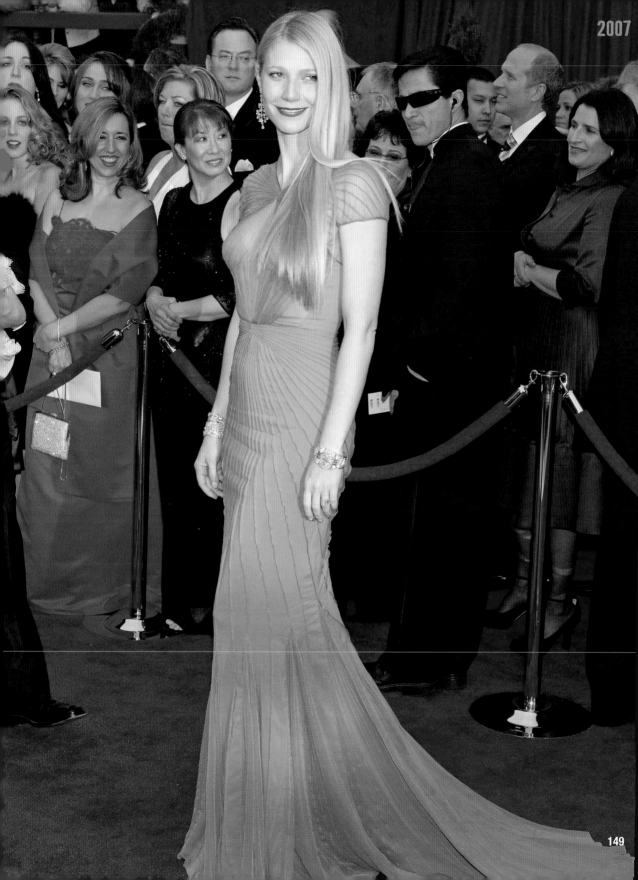

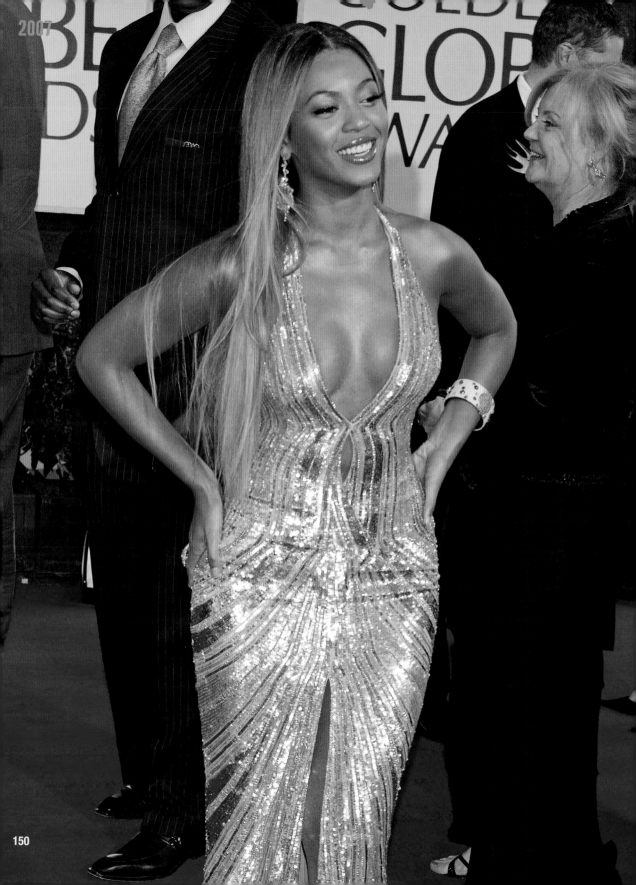

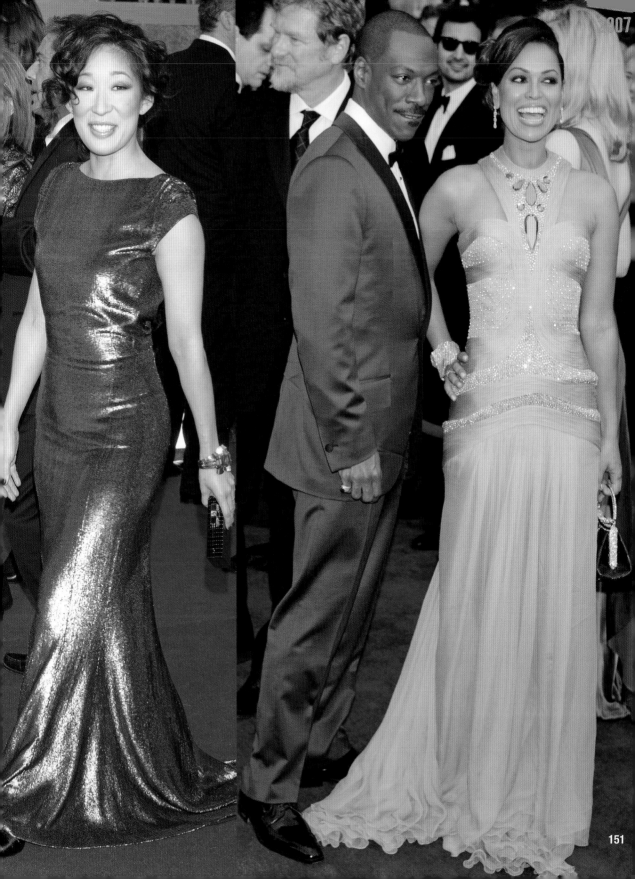

2008

153　**Ellen Pompeo** (in Nina Ricci by Olivier Theyskens), Screen Actors Guild Awards

154　**Christina Applegate** (in Elie Saab), Screen Actors Guild Awards; **Brittany Snow** (in Zuhair Muhad), Screen Actors Guild Awards; **Debra Messing** (in Oscar de la Renta), Screen Actors Guild Awards

155　**Teri Hatcher** (in Badgley Mischka), Screen Actors Guild Awards; **Eva Longoria** (in Naeem Kahn), Screen Actors Guild Awards; **Renée Zellweger** (in Carolina Herrera), Academy Awards

156　**Amy Adams** (in Proenza Schouler gown and Fred Leighton purse), Academy Awards

157　**Marion Cotillard** (in Jean Paul Gaultier Couture), Academy Awards

158　**Johnny Depp** (in Giorgio Armani) and **Vanessa Paradis** (in Chanel Haute Couture), Academy Awards; **Ellen Page** (in vintage Jean-Louis Scherrer), Academy Awards

159　**Emily Deschanel**, Critics Choice Awards; **Nicole Kidman** (in Balenciaga gown and L'Wren Scott necklace), Academy Awards; **Élodie Bouchez**, Grammy Awards

160　**Rihanna** (in Zac Posen); **Miley Cyrus** (in Celine); **Beyoncé** (in Elie Saab), Grammy Awards

161　**Spike Lee** and **Wesley Snipes**, Academy Awards; **John Travolta** and **Olivia Newton-John** (in Ralph Lauren), G'Day USA ball; **Colin Farrell** (in Dunhill) and mother **Rita**, Academy Awards; **Chris Brown** and **Fergie** (in Calvin Klein), Grammy Awards

162　**Taraji P. Henson** (in Bradley Bayou), Screen Actors Guild Awards; **Ashley Tisdale** (in Badgley Mischka Couture), Screen Actors Guild Awards

163　**Kate Beckinsale** (in Alberta Ferretti), *Snow Angels* premiere; **Becky Newton** (in Elsie Katz Couture), Screen Actors Guild Awards

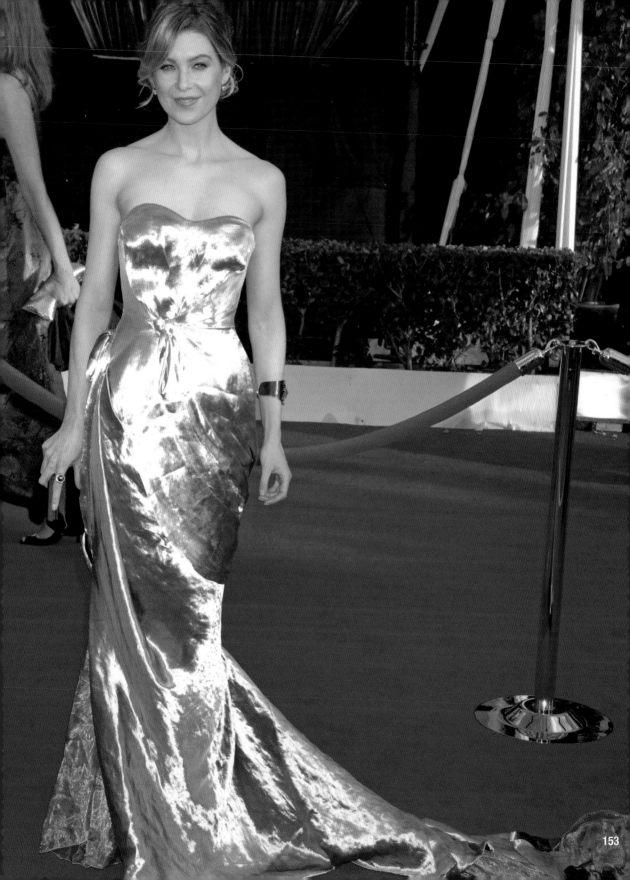

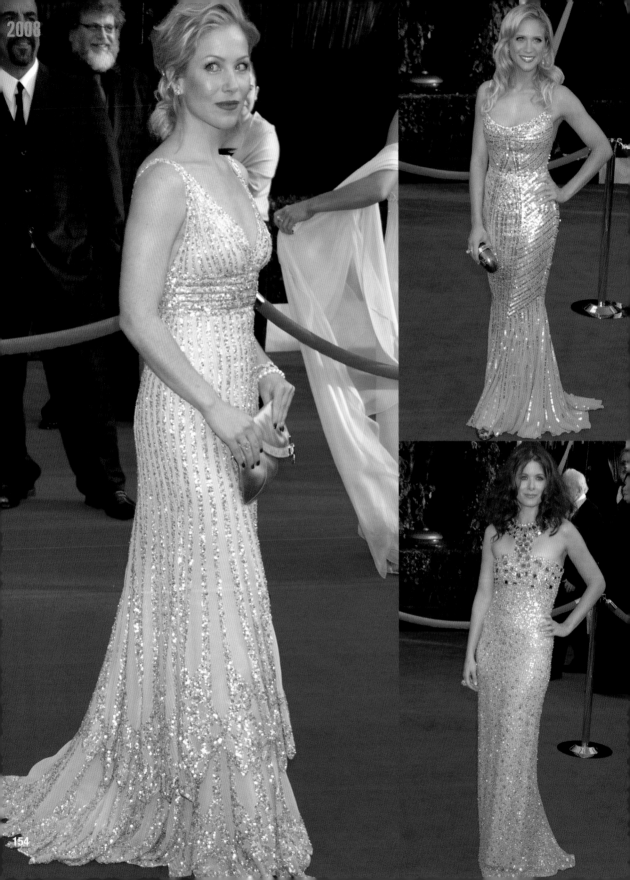

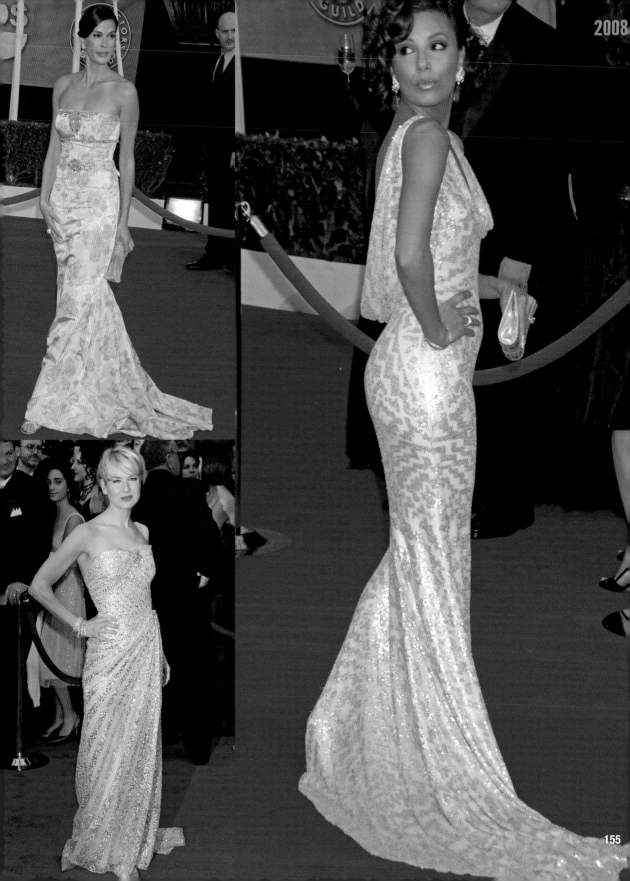

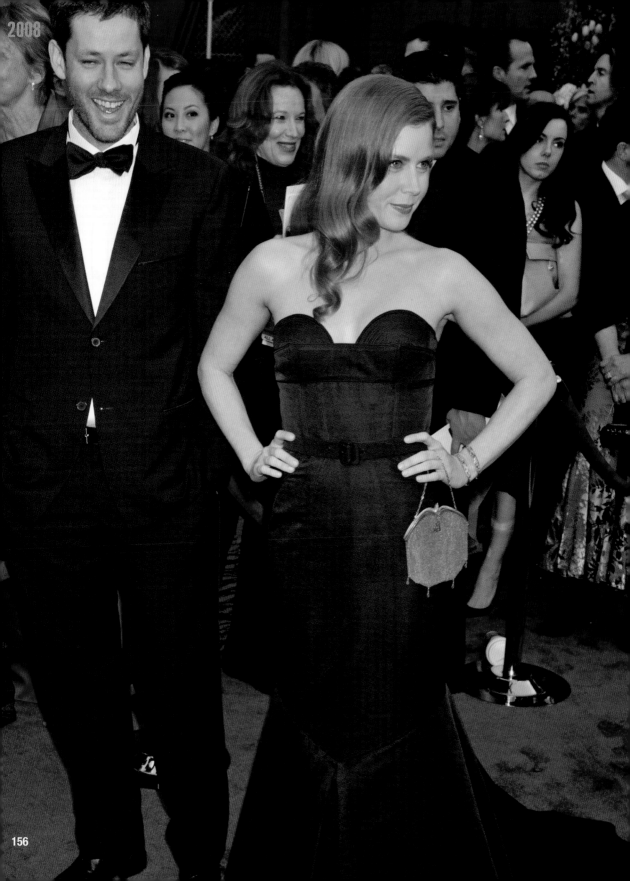

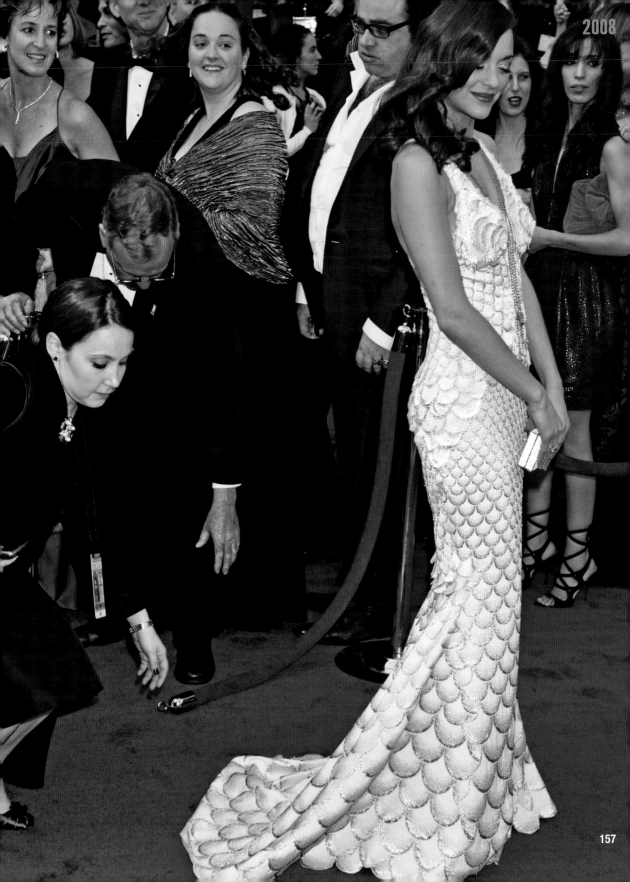

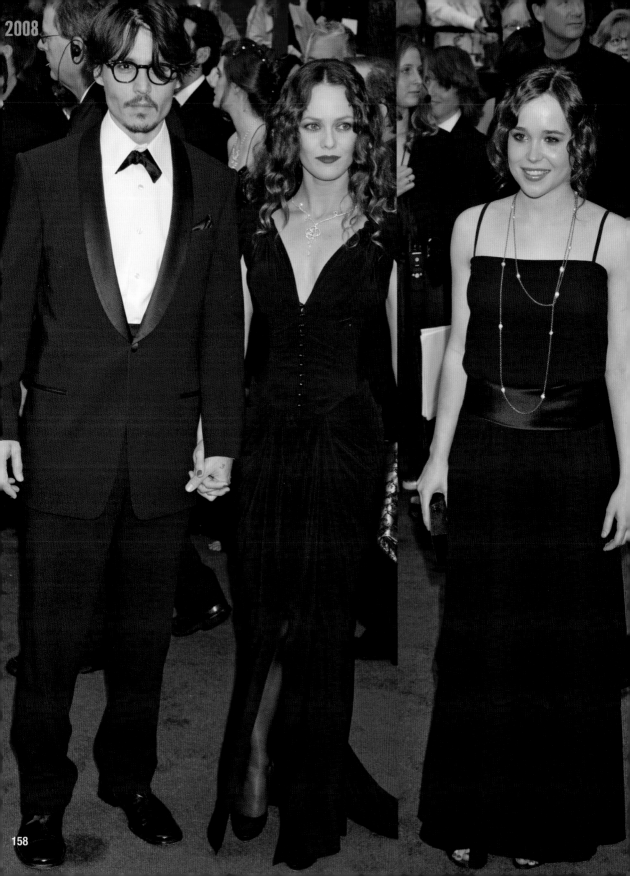

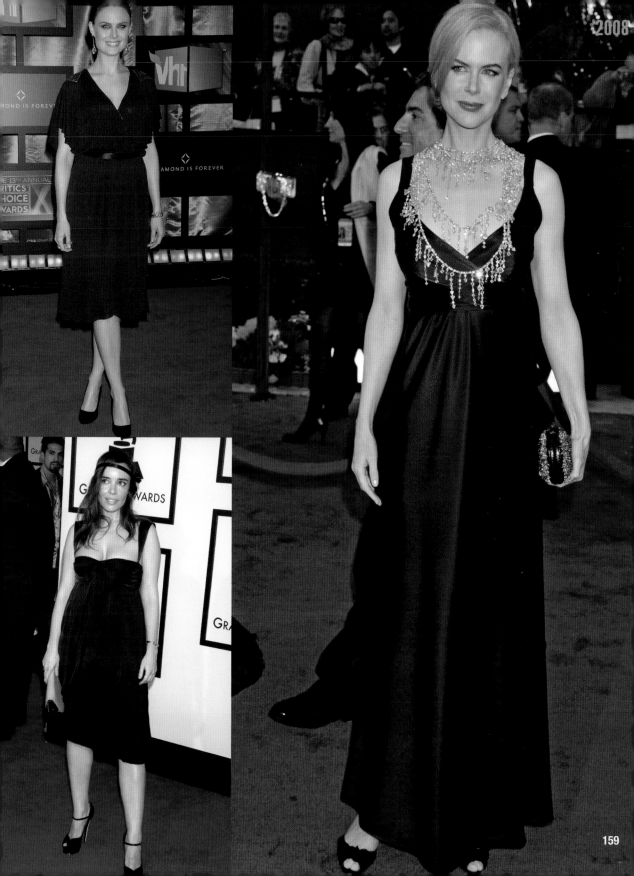

2008

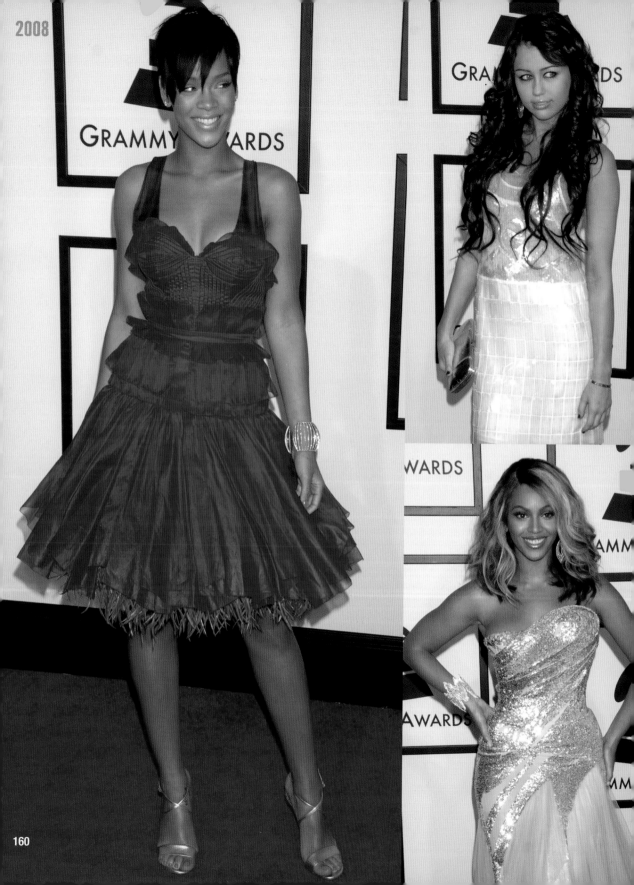

2008

GRAMMY AWARDS

160

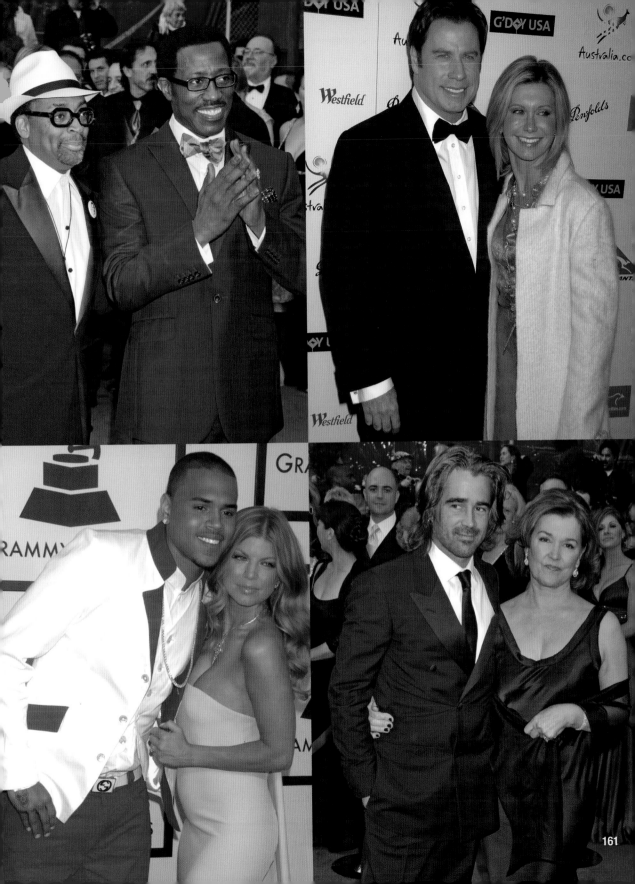

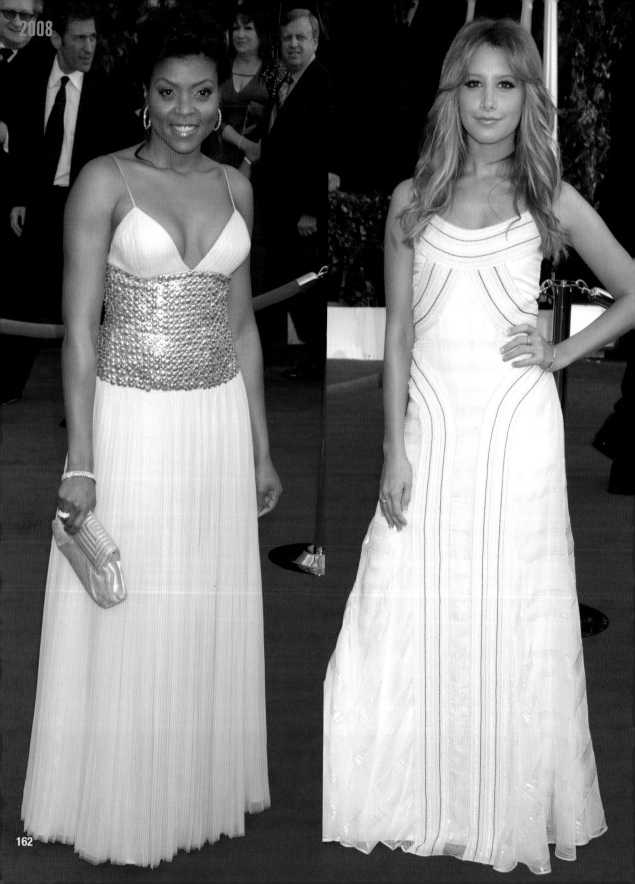

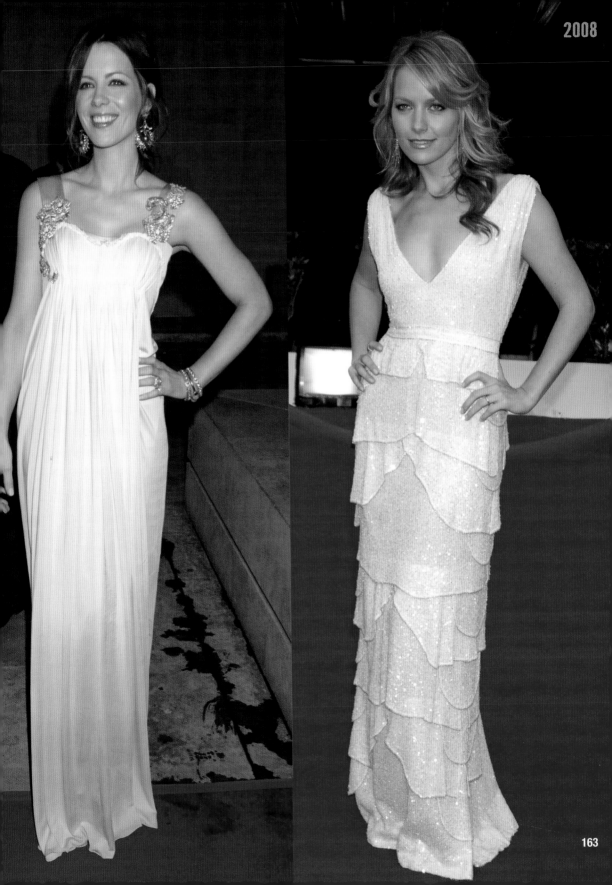

2009

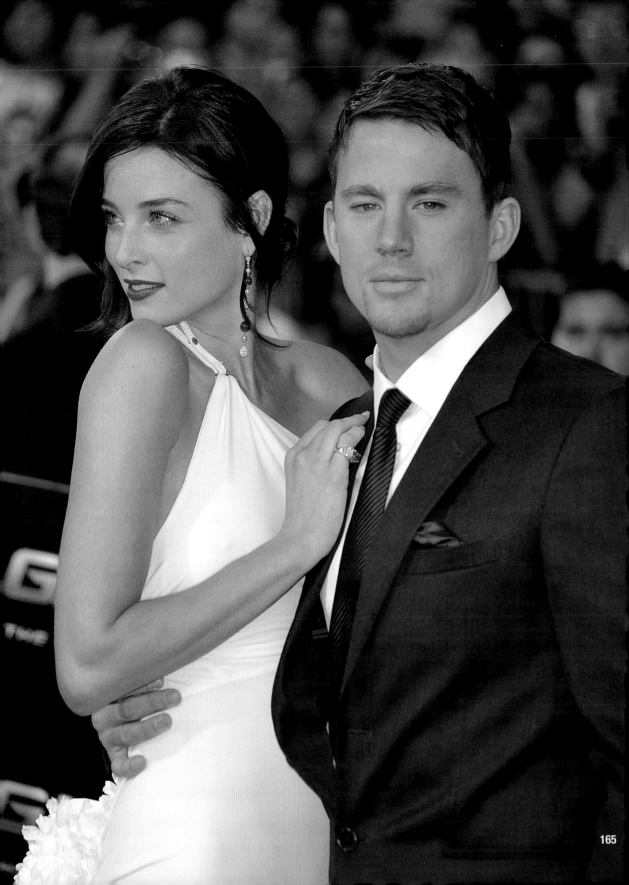

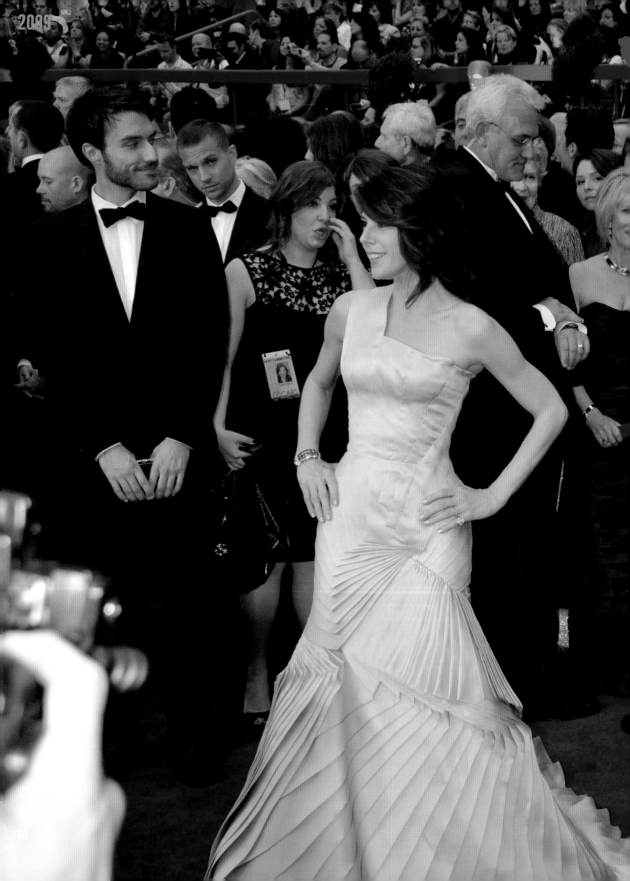

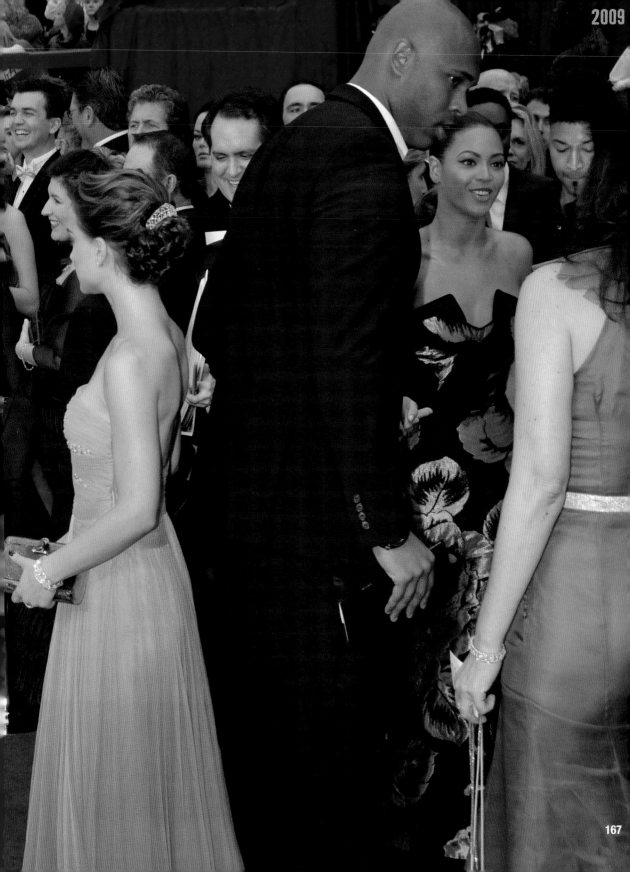

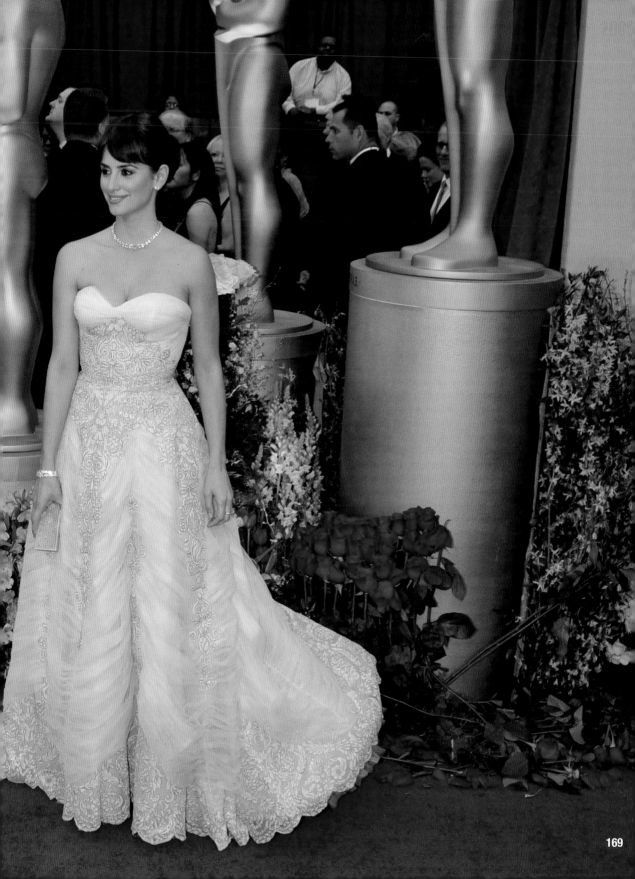

169

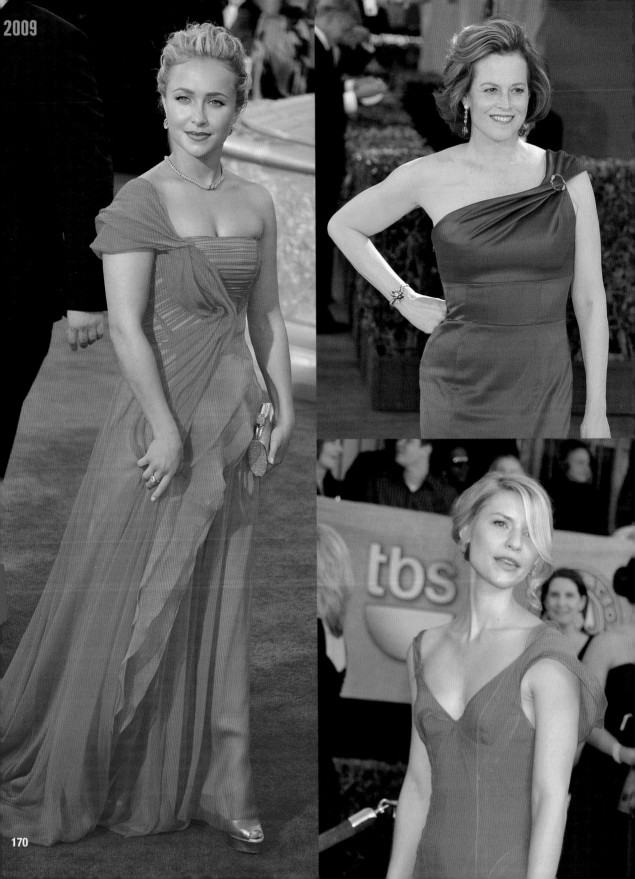

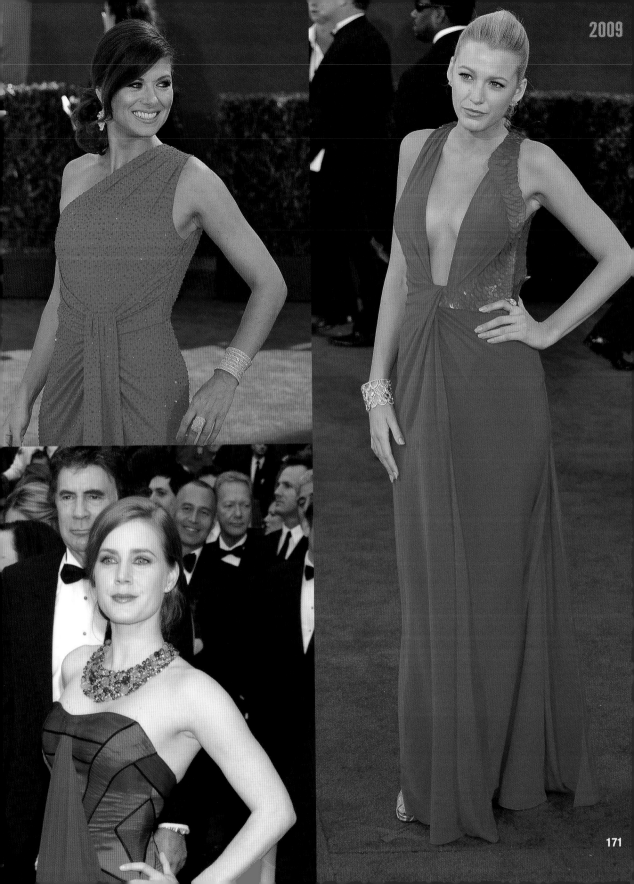

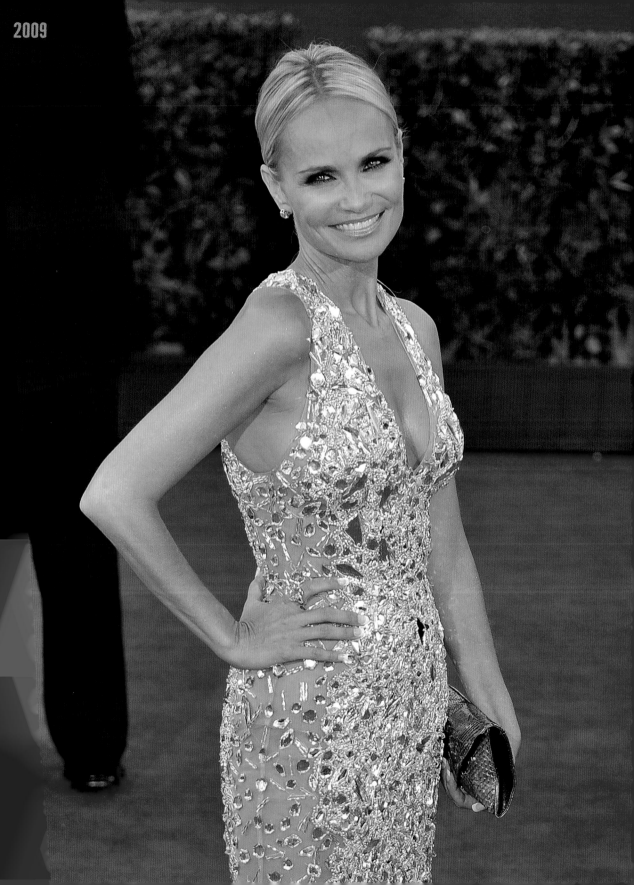

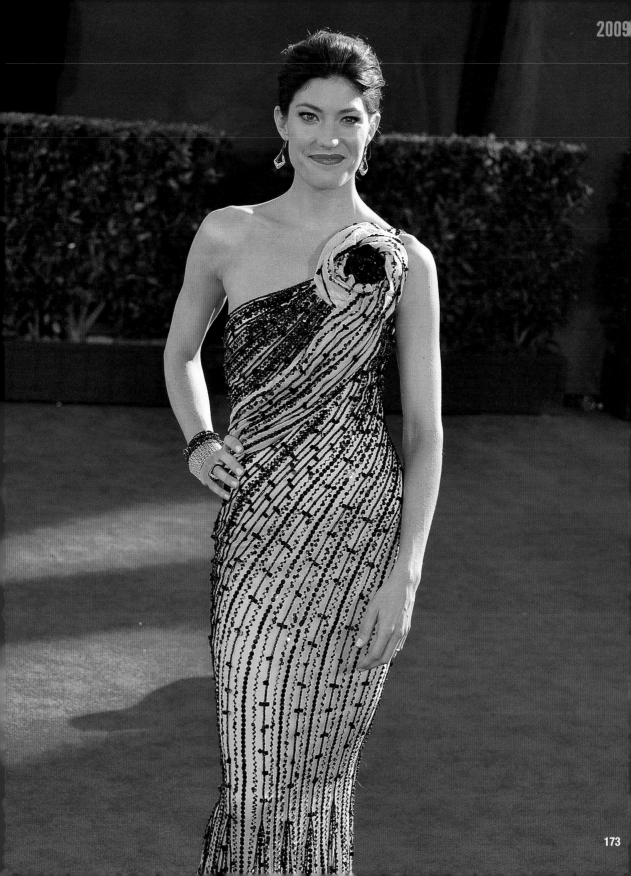

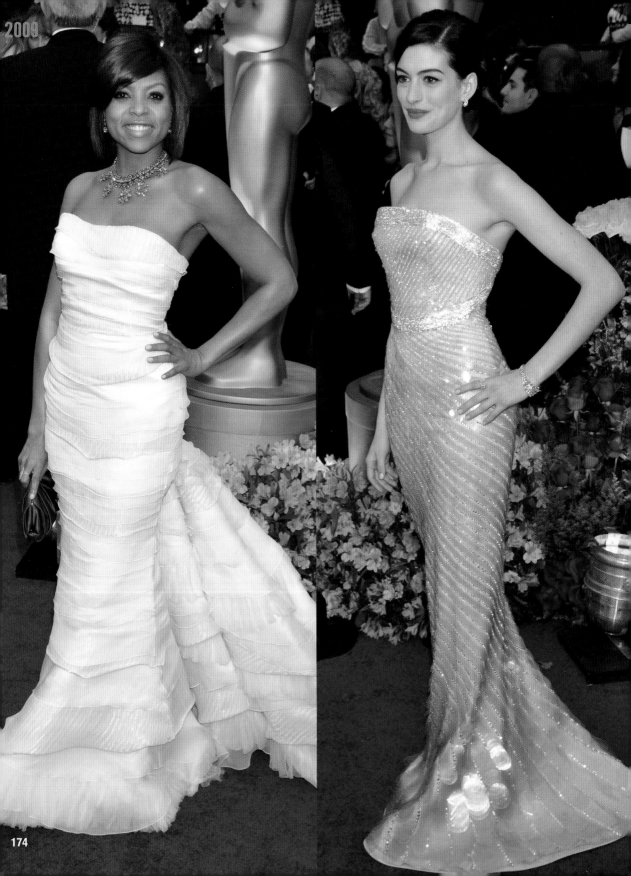

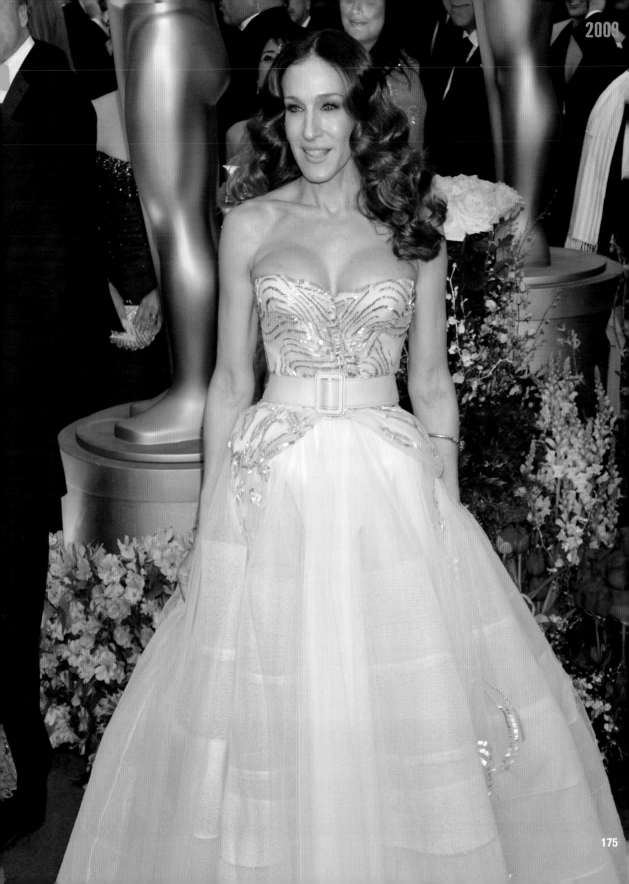

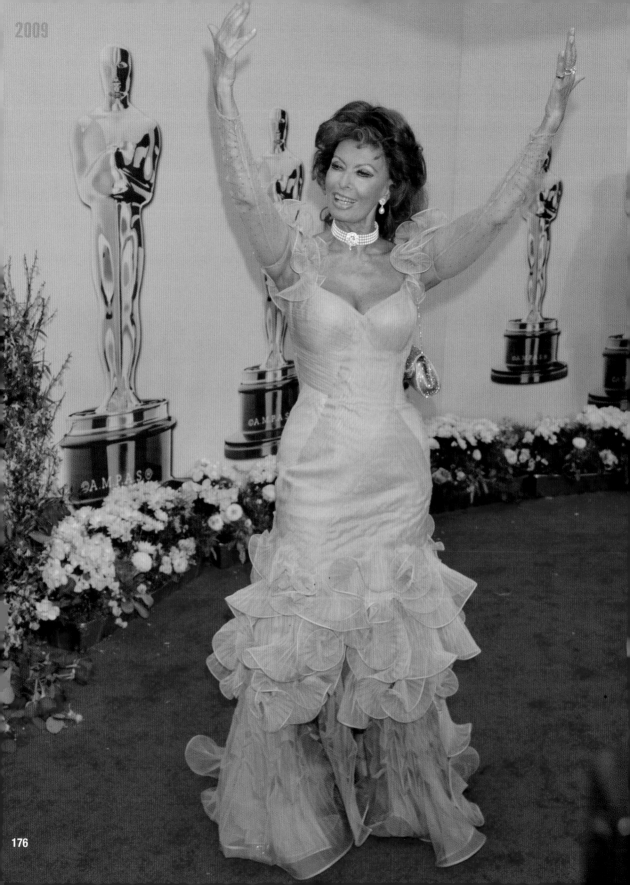

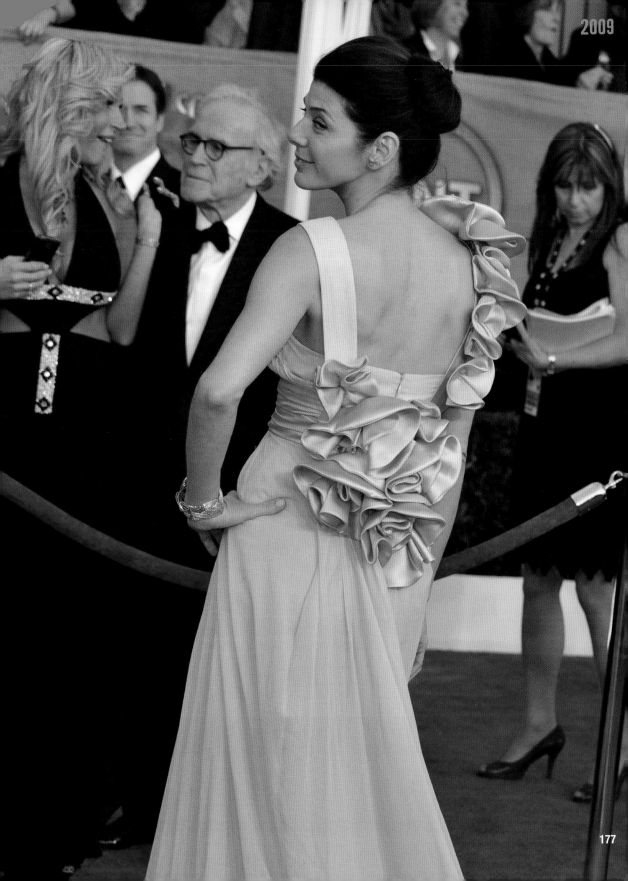

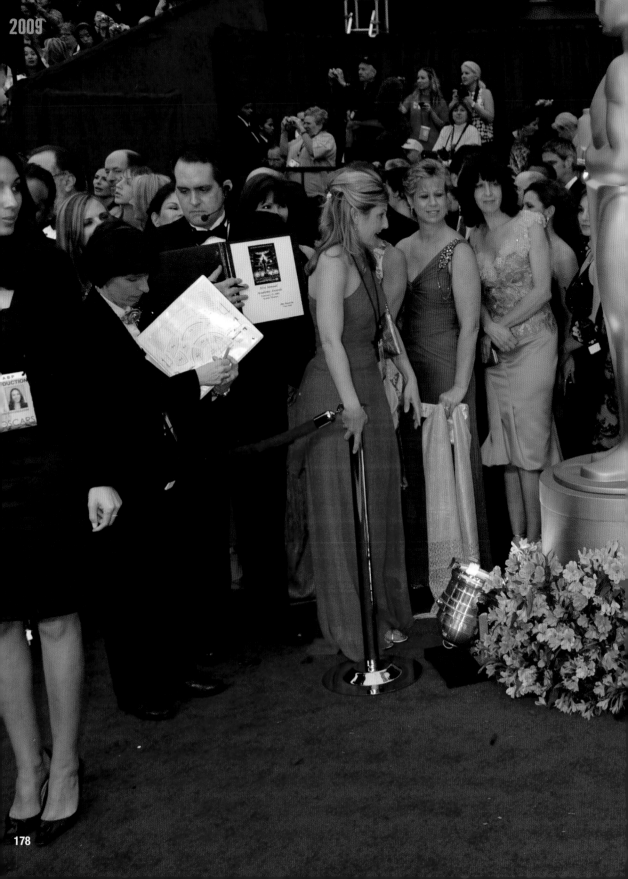

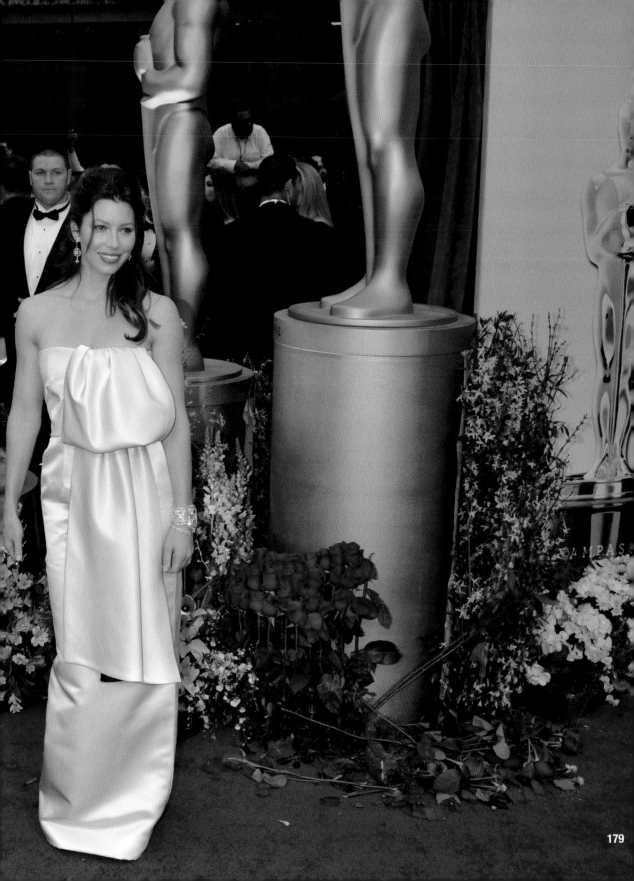

179

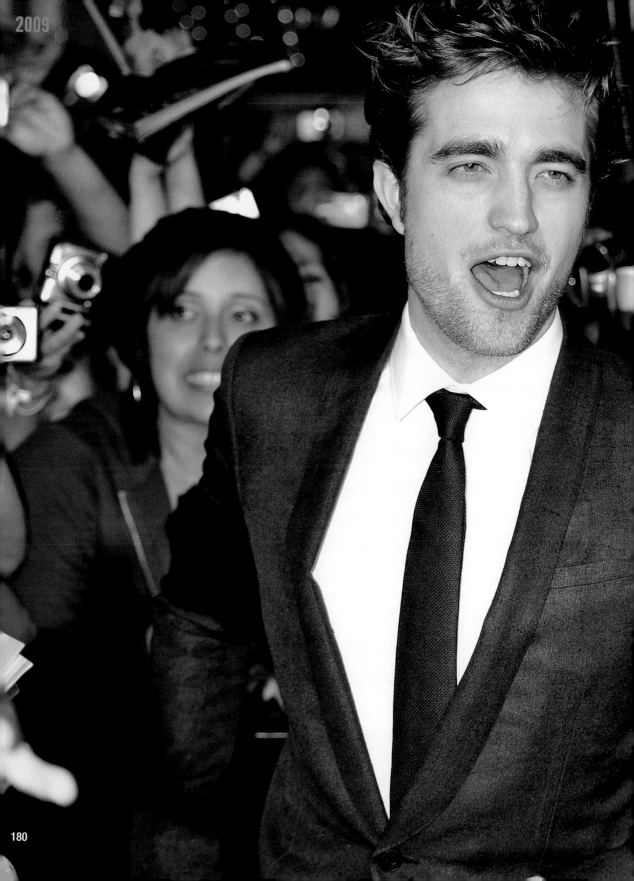

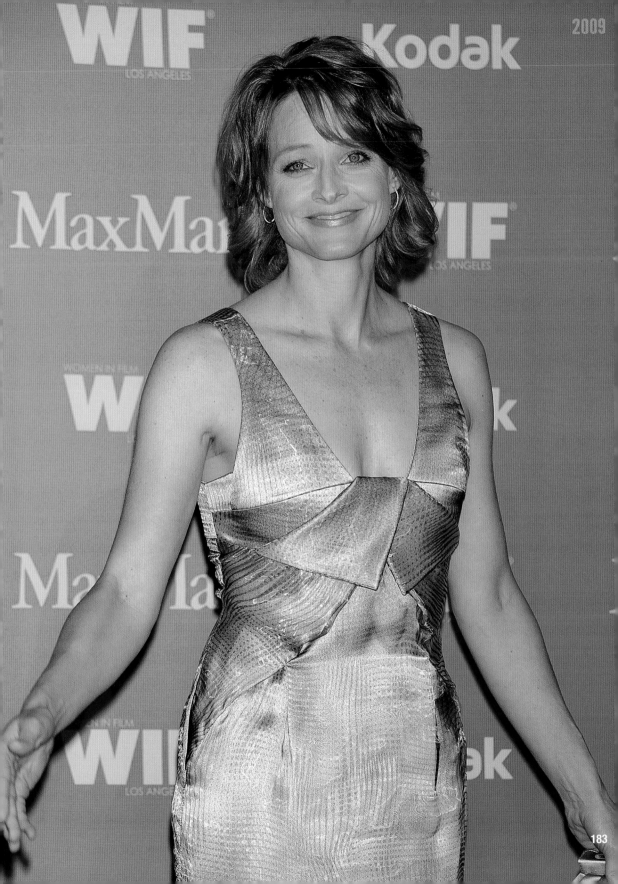

2010

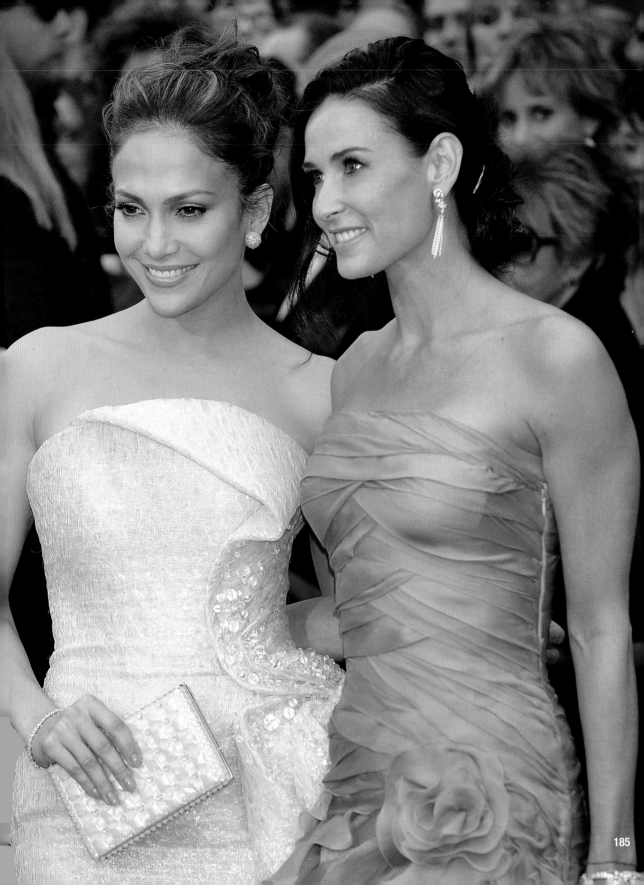

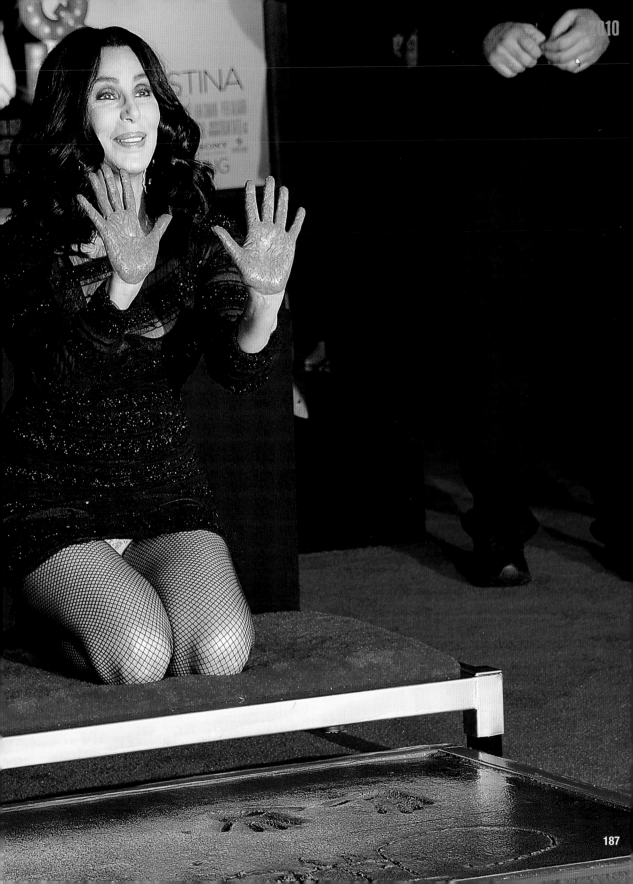

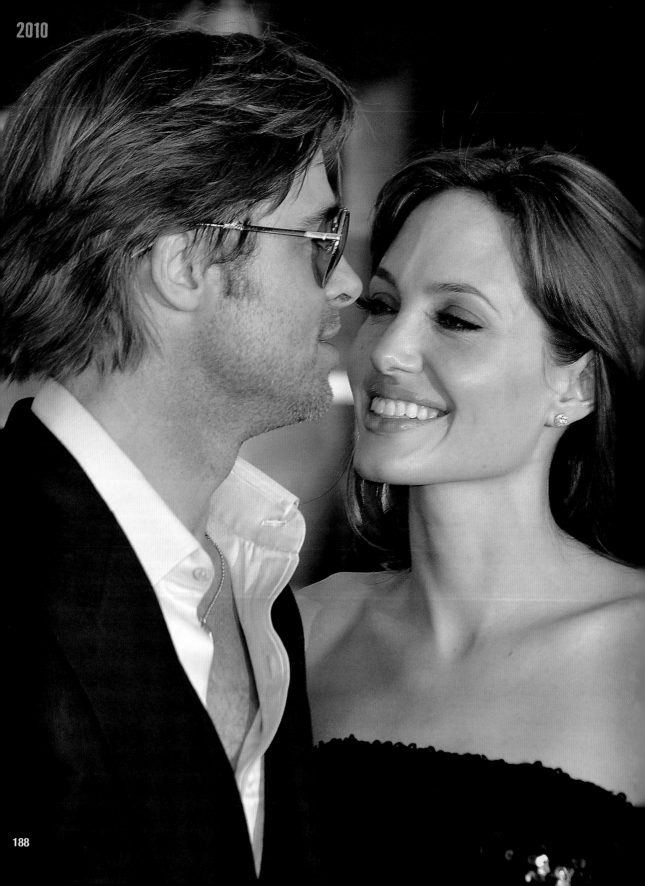

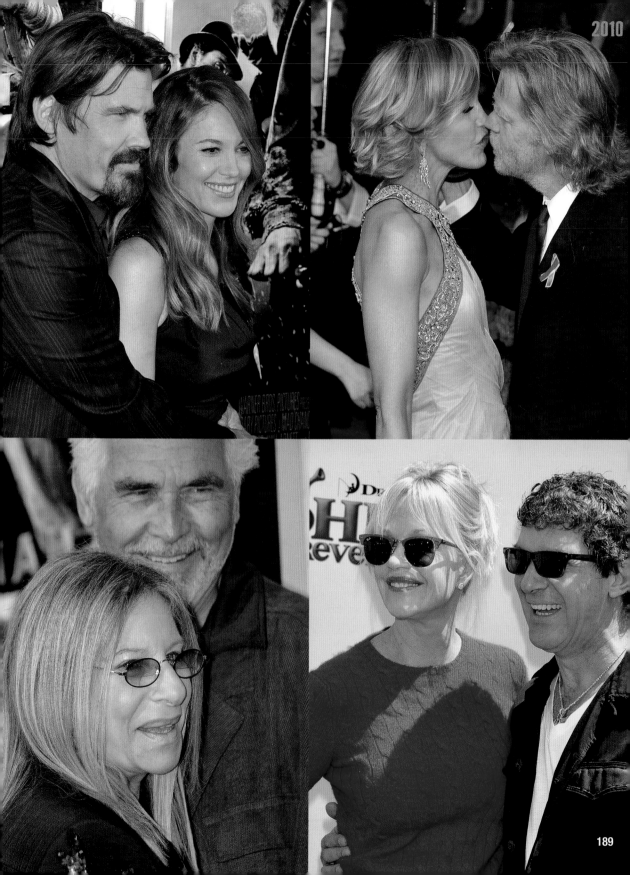

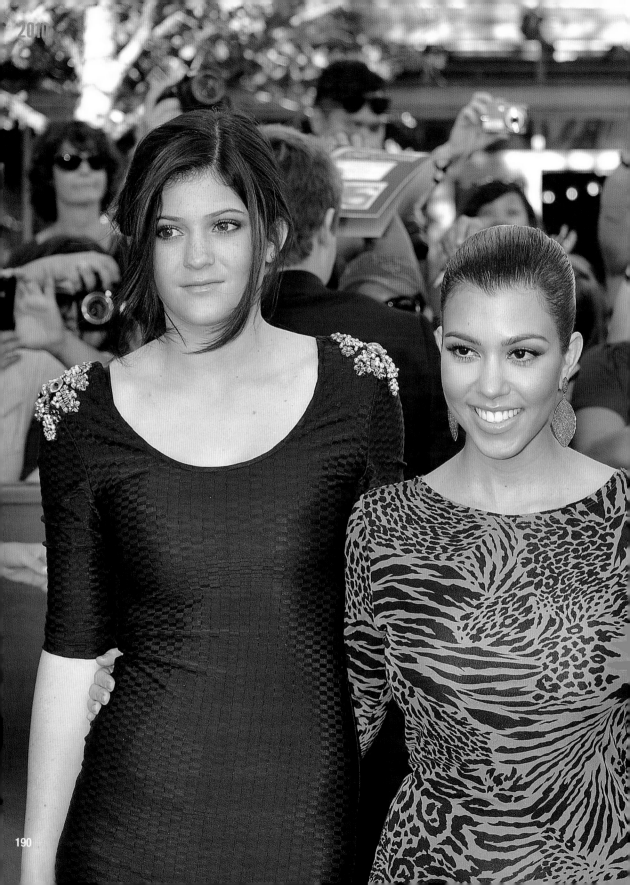

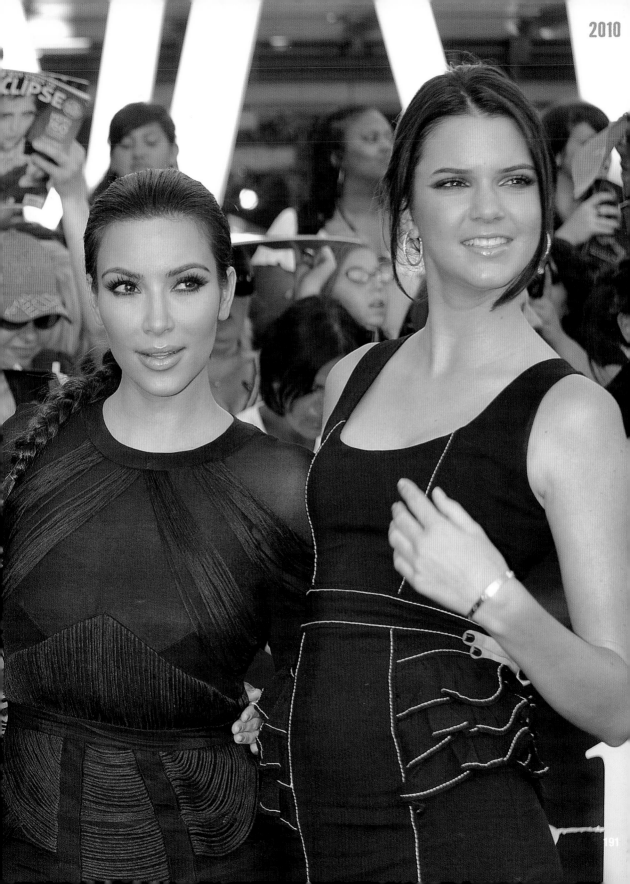

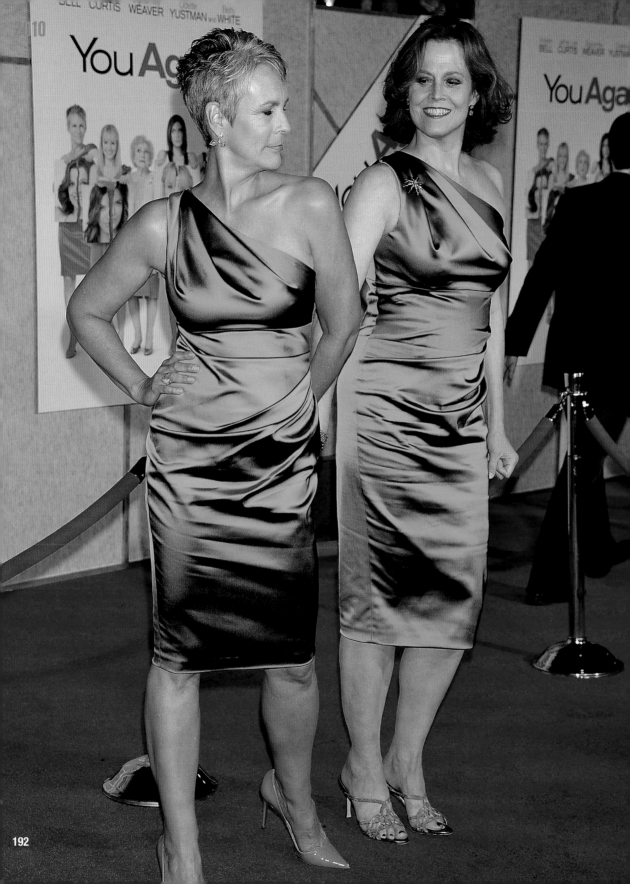

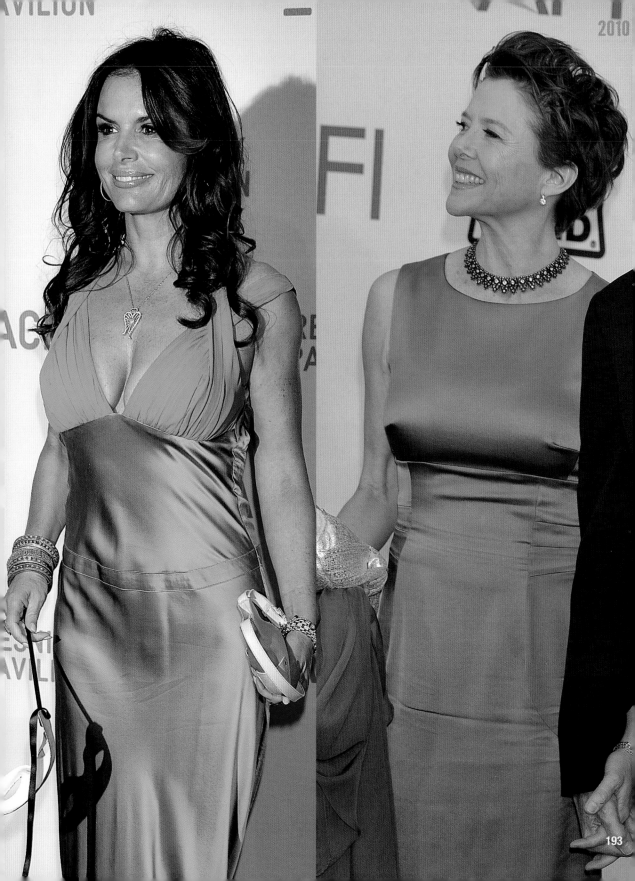

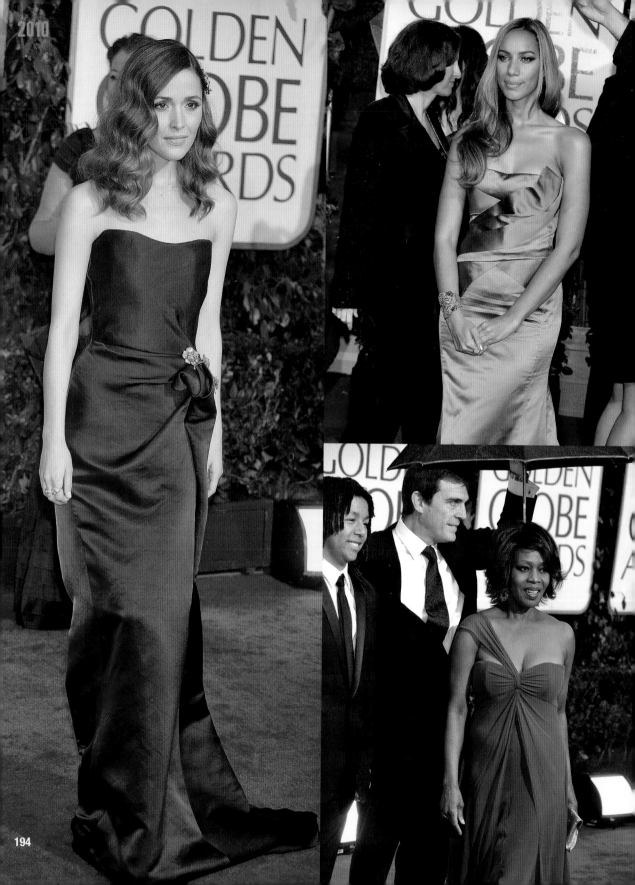

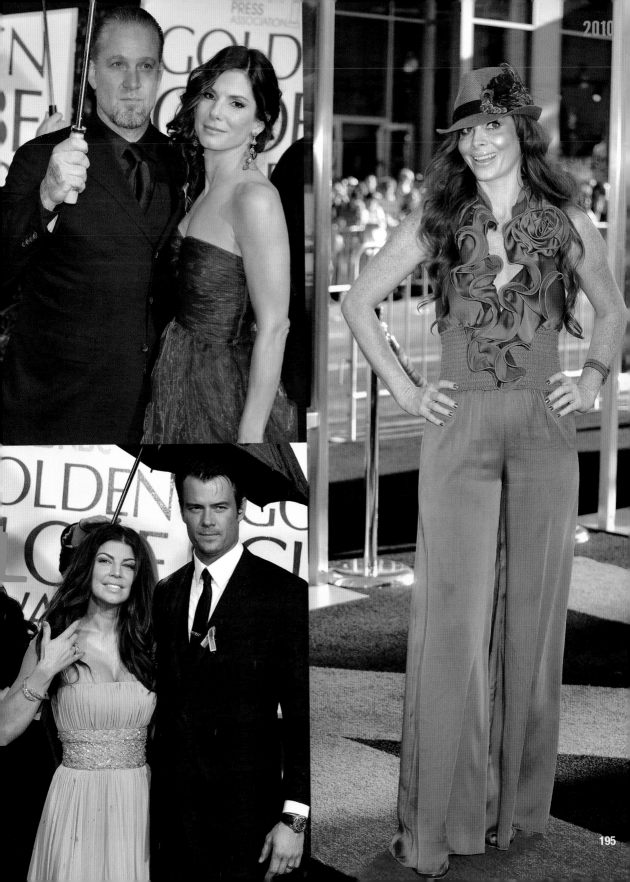

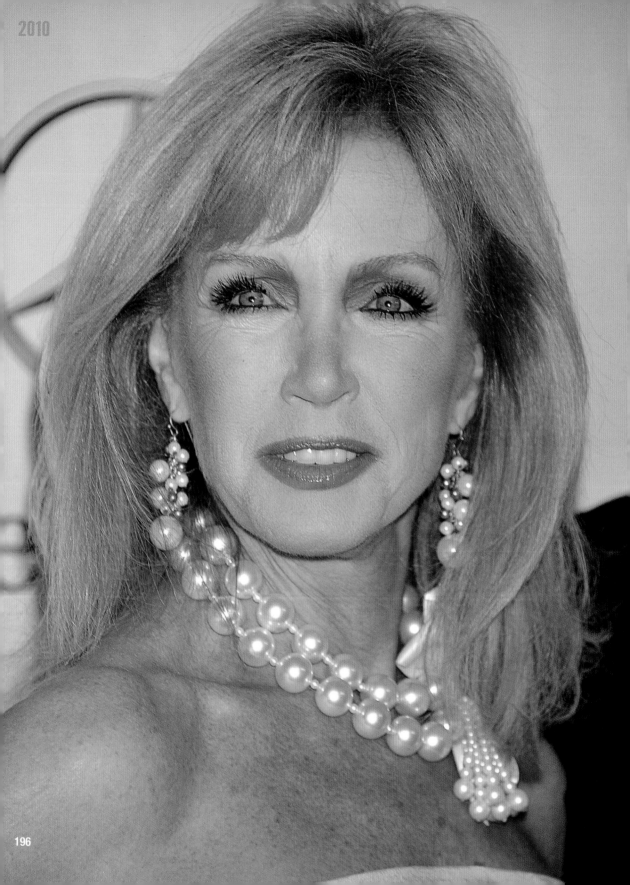

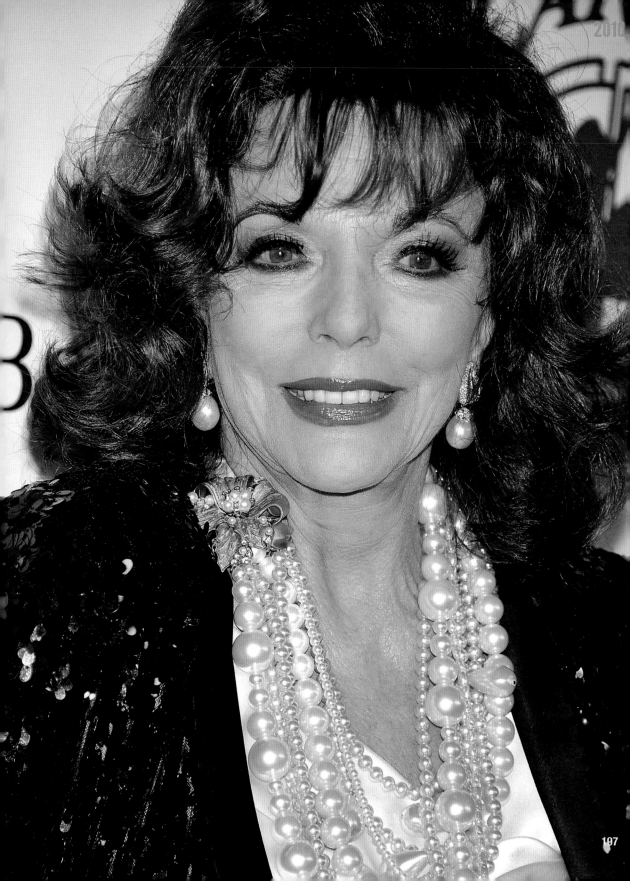

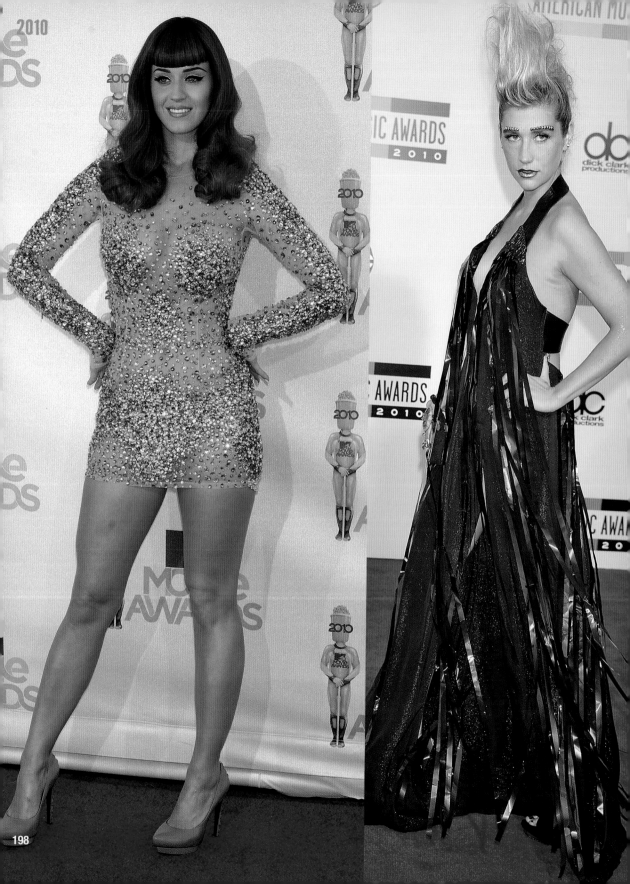

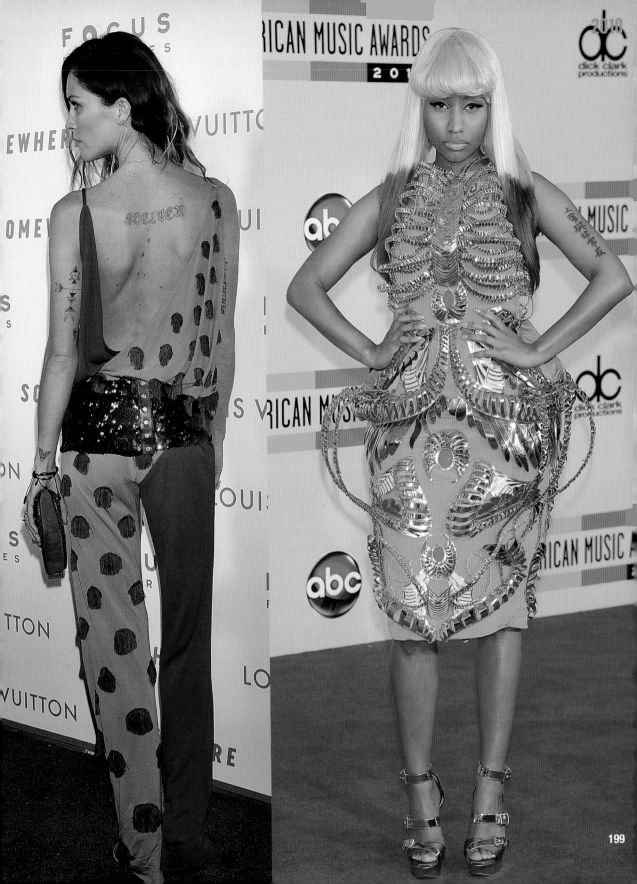

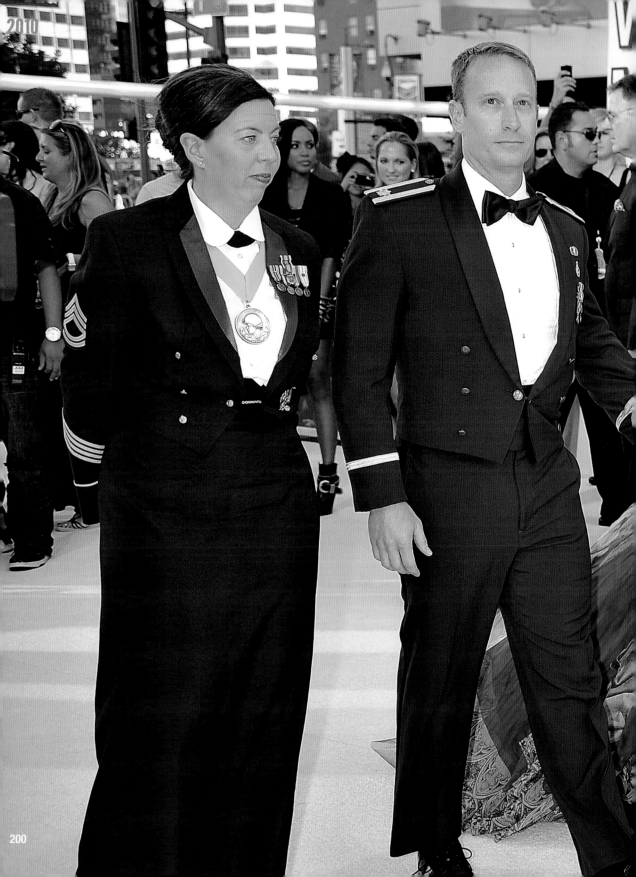

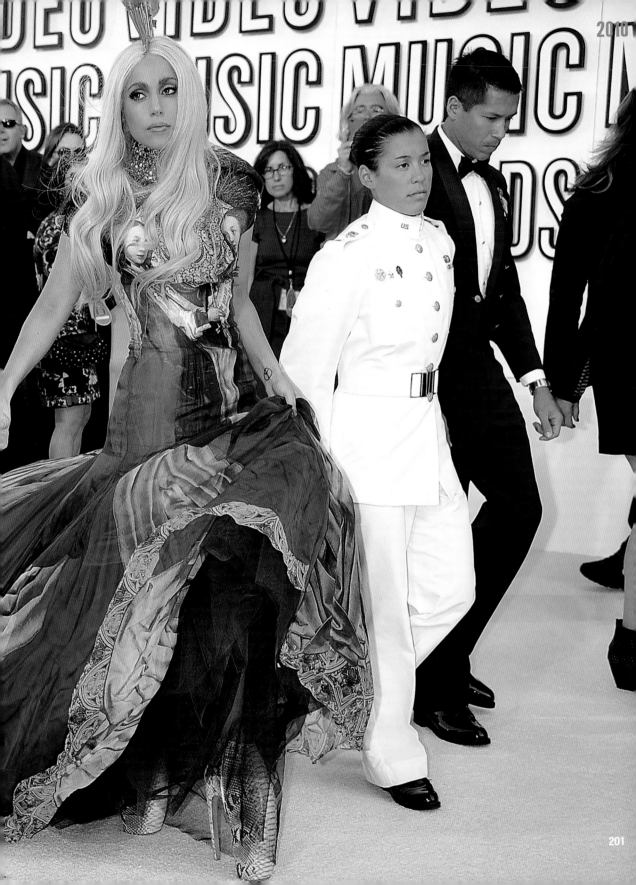

2011

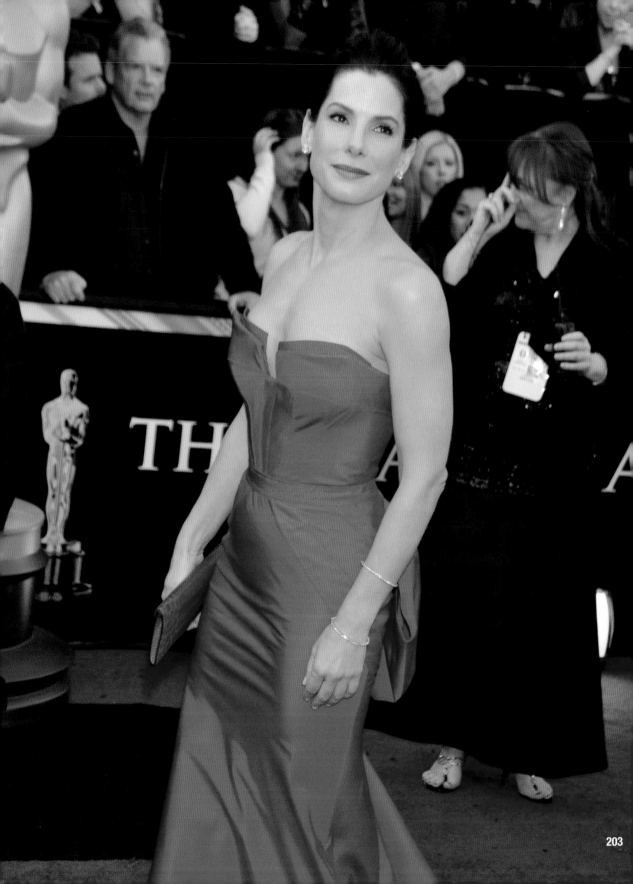

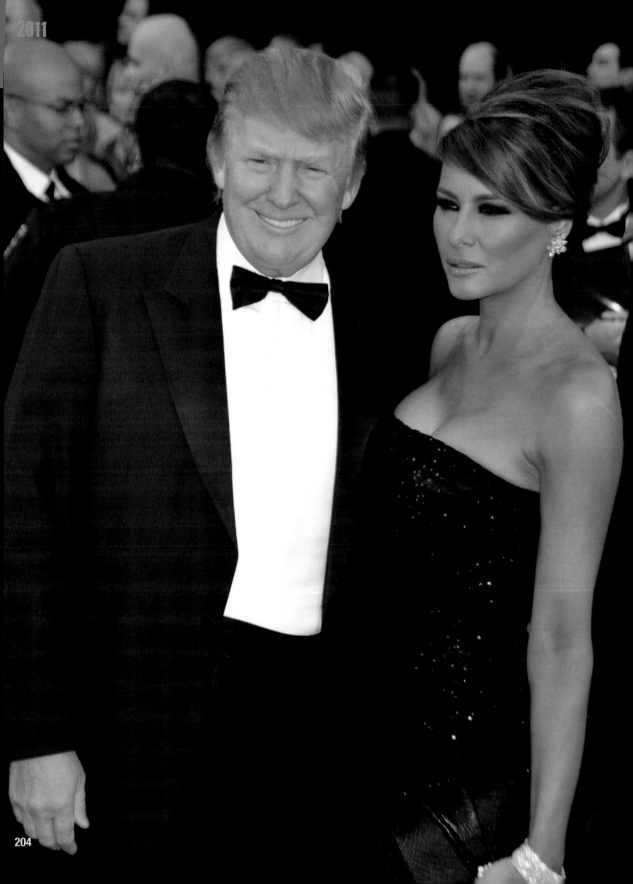

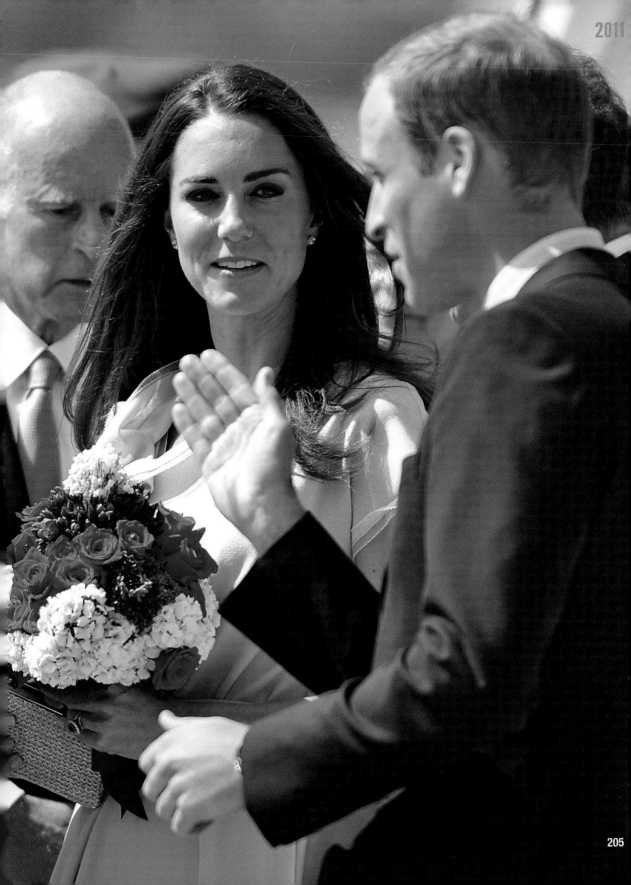

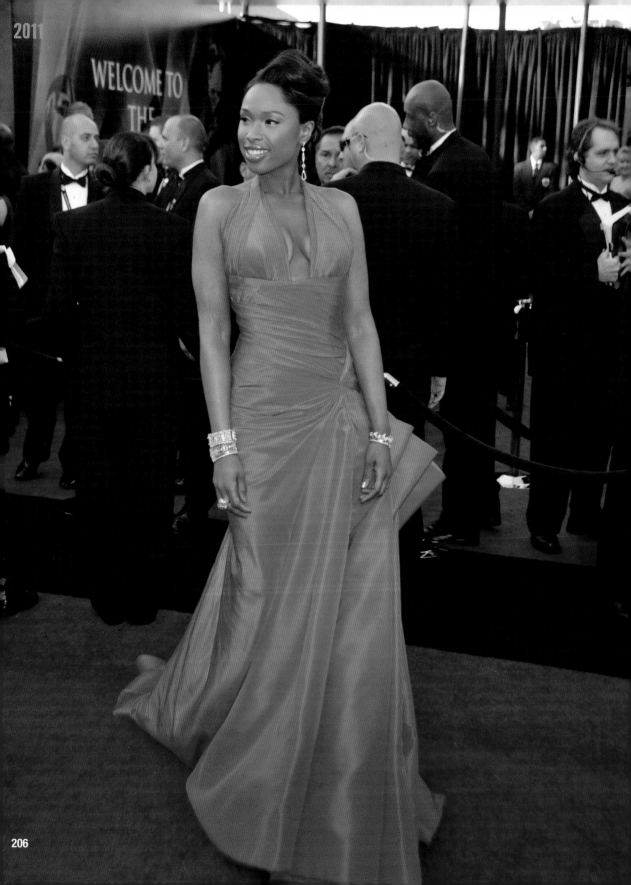

WELCOME TO
THE

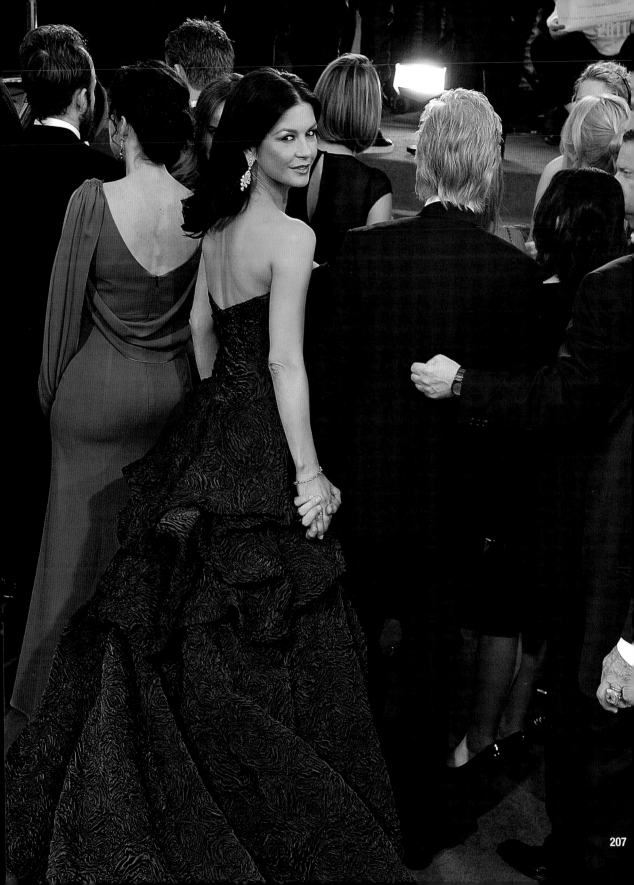

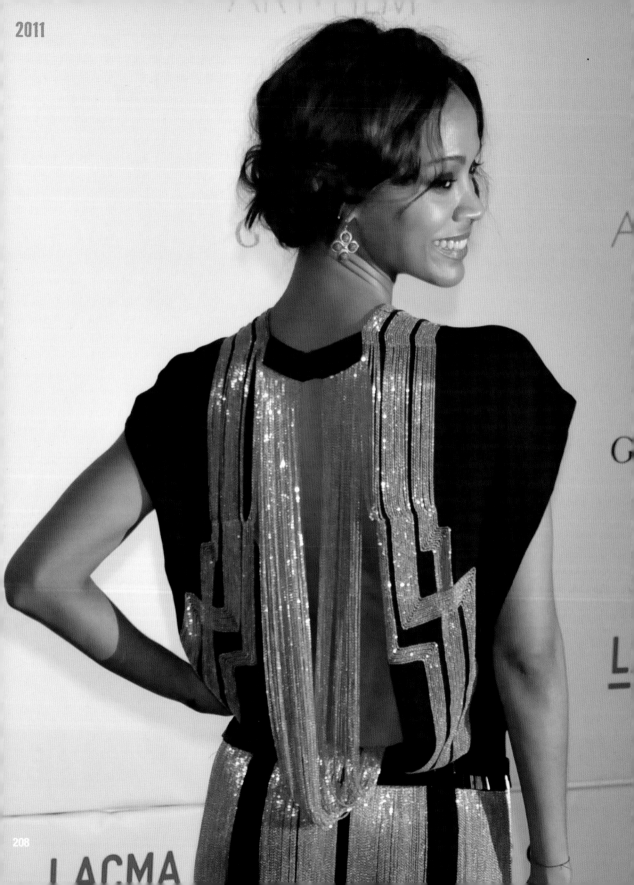

LACMA

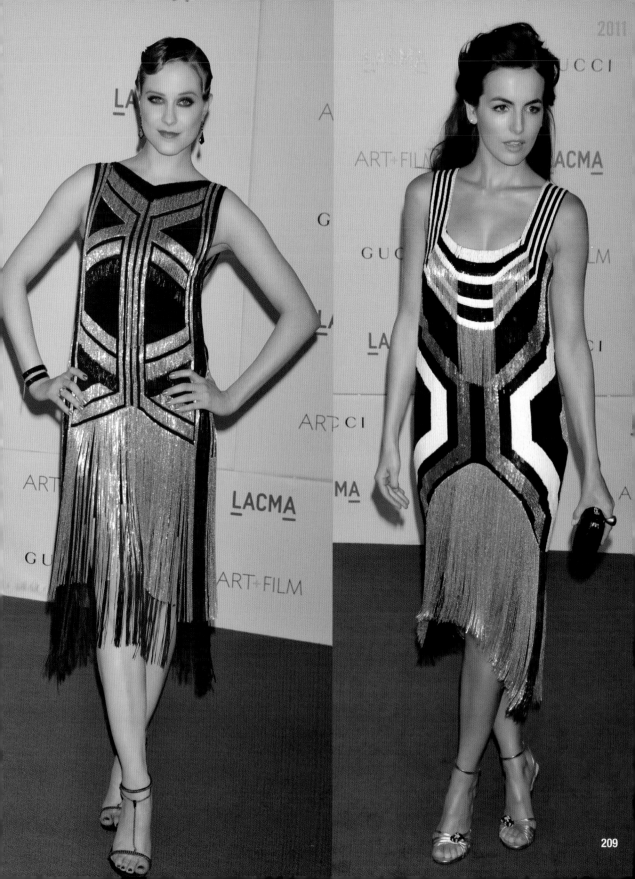

209

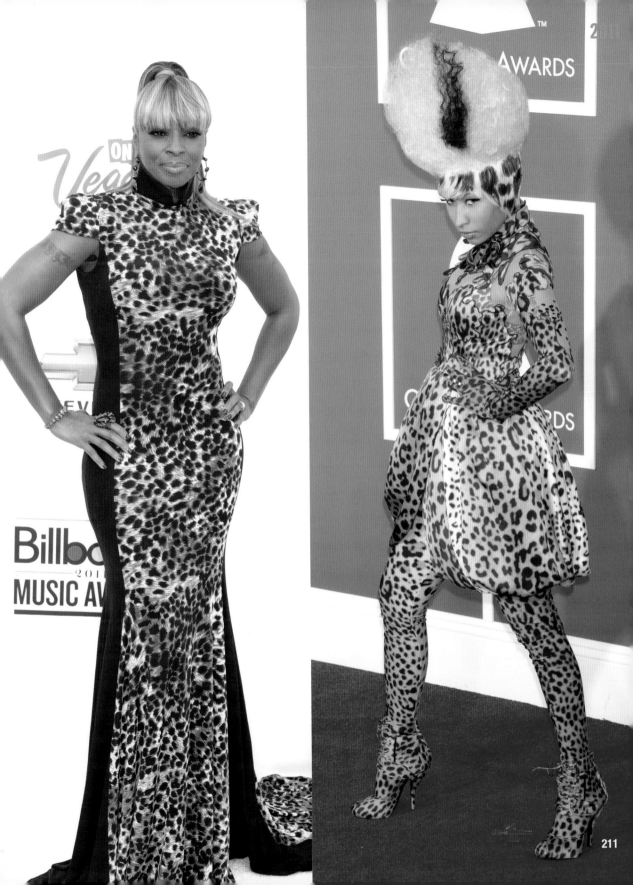

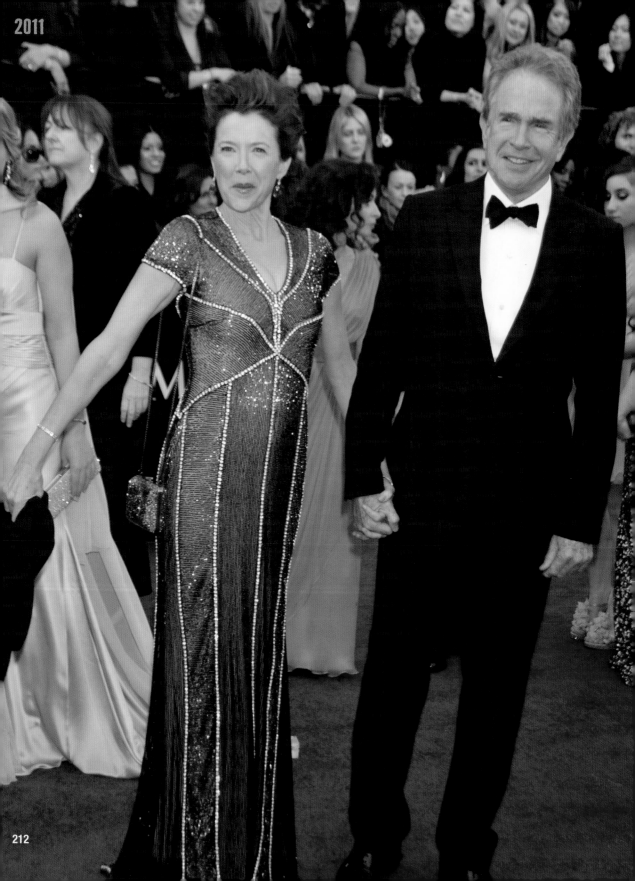

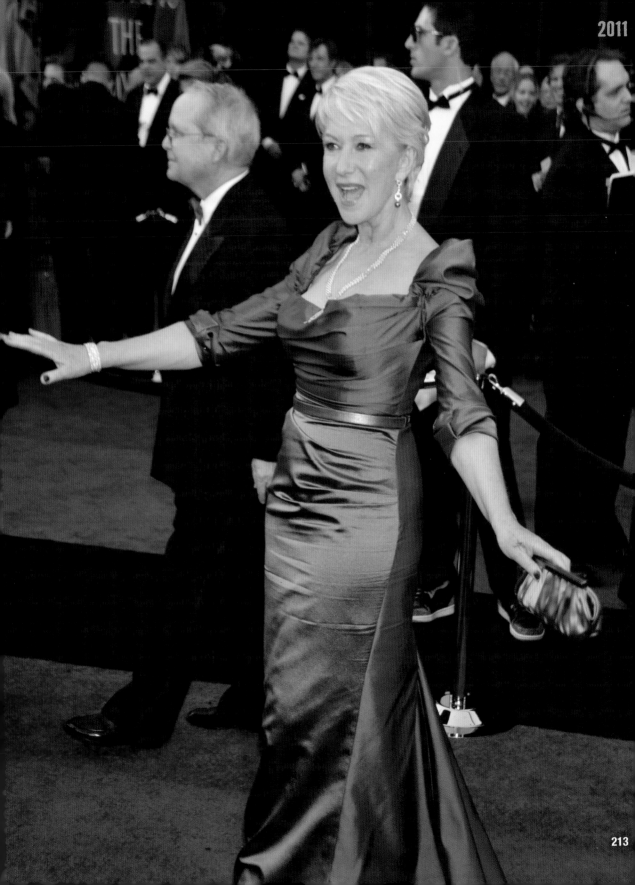

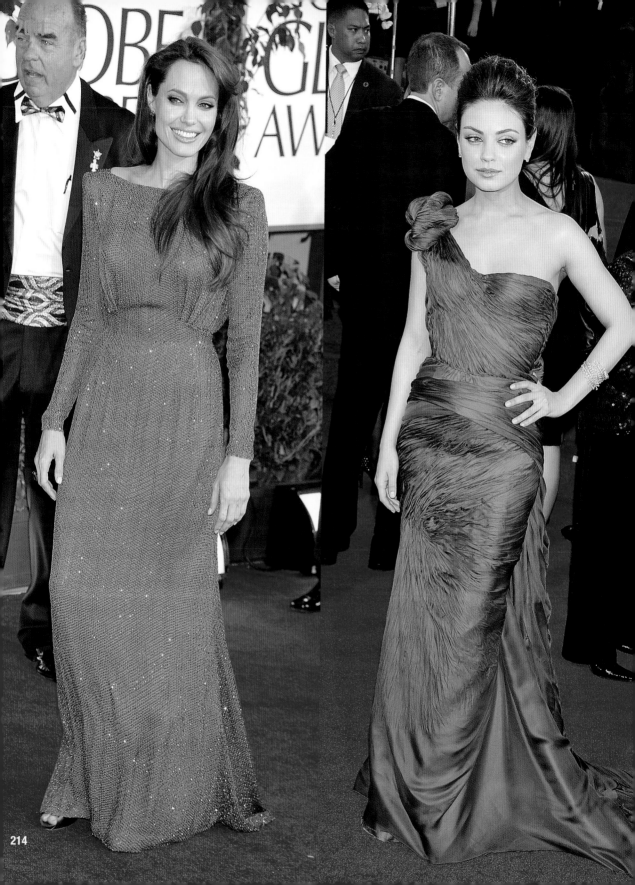

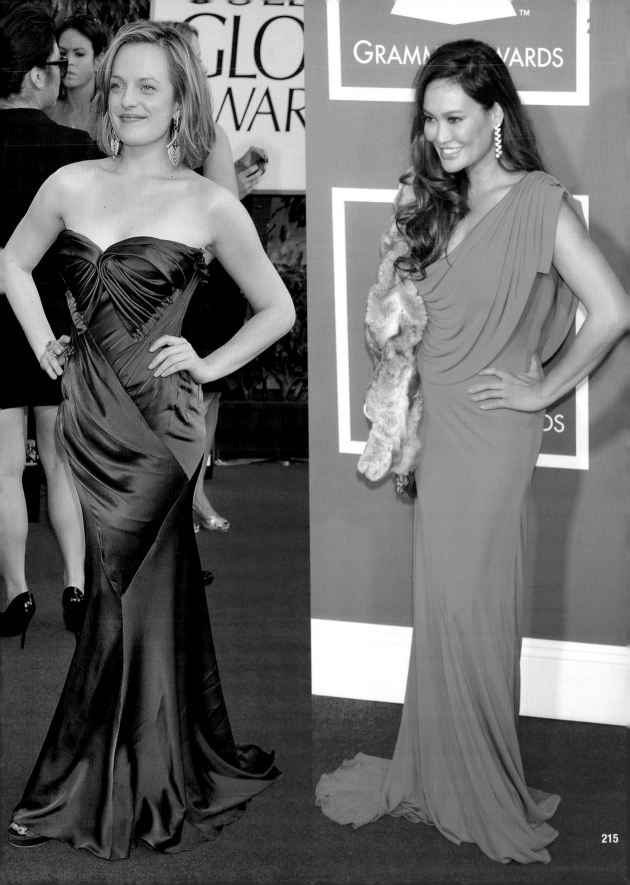

2012

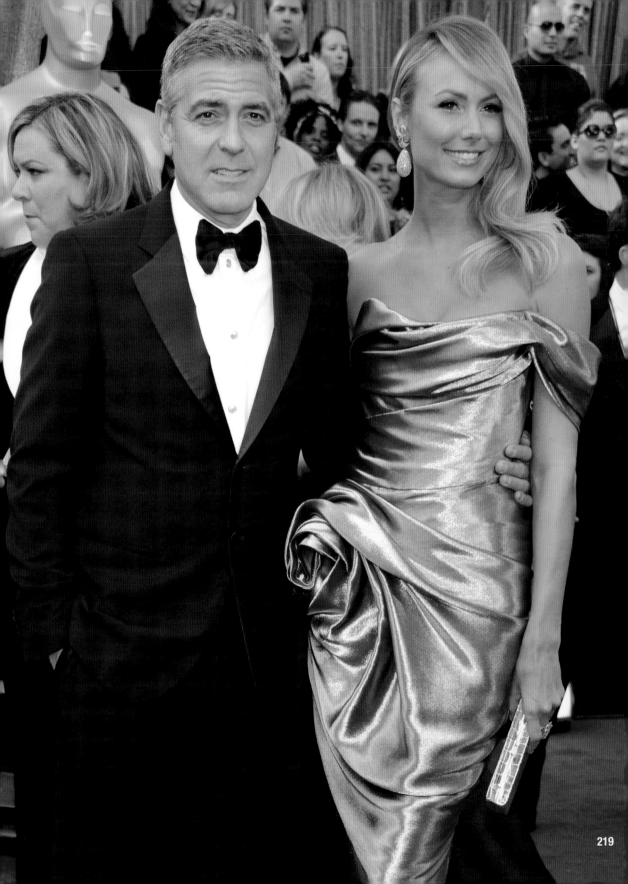

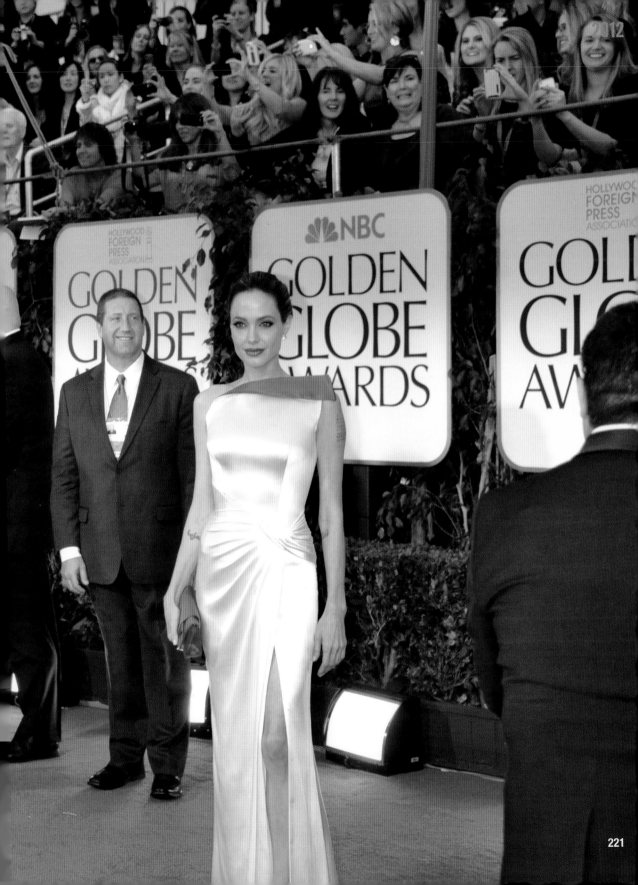

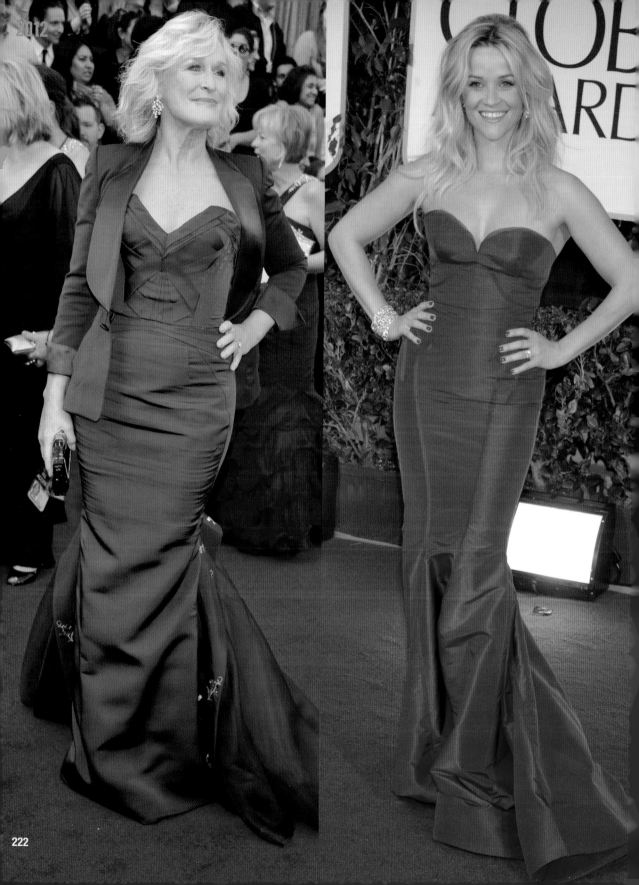

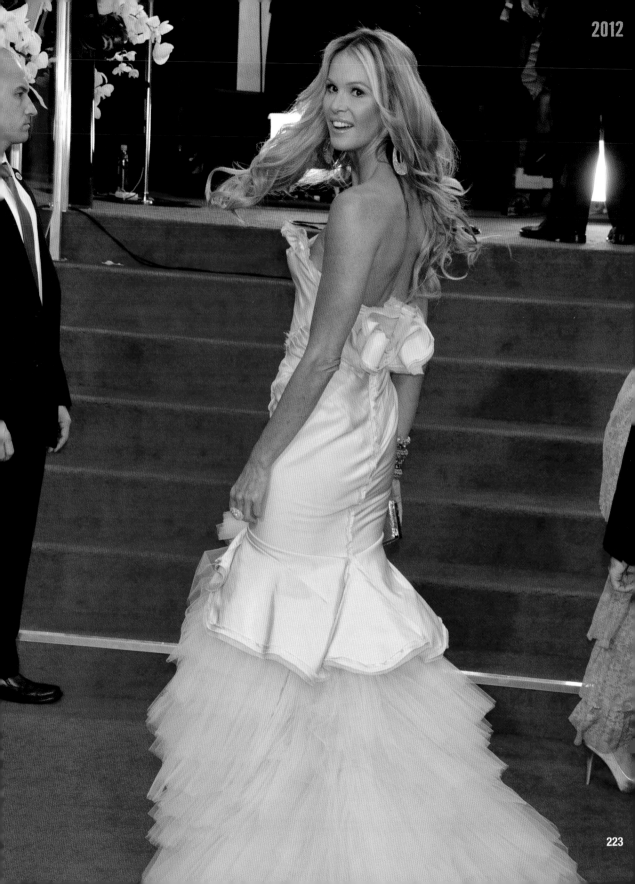

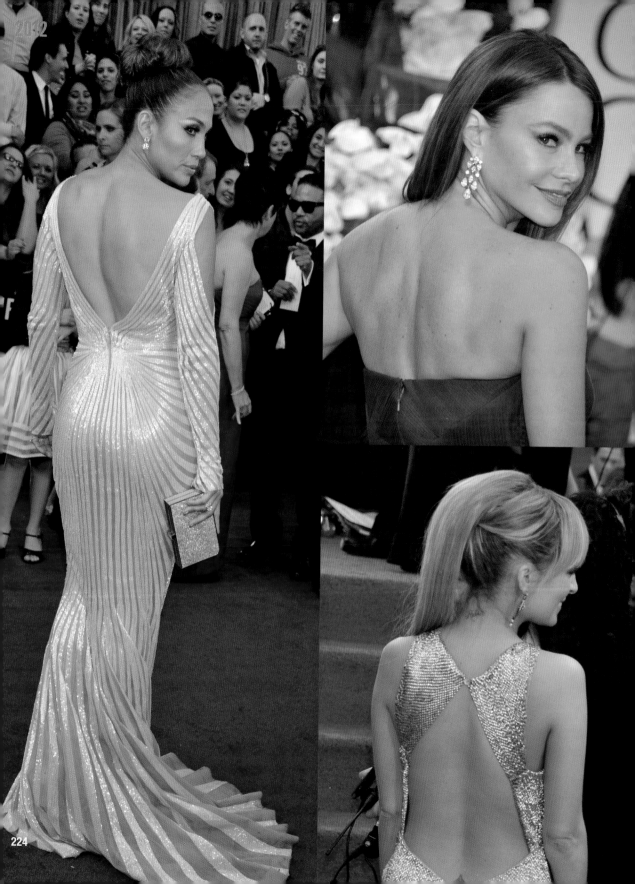

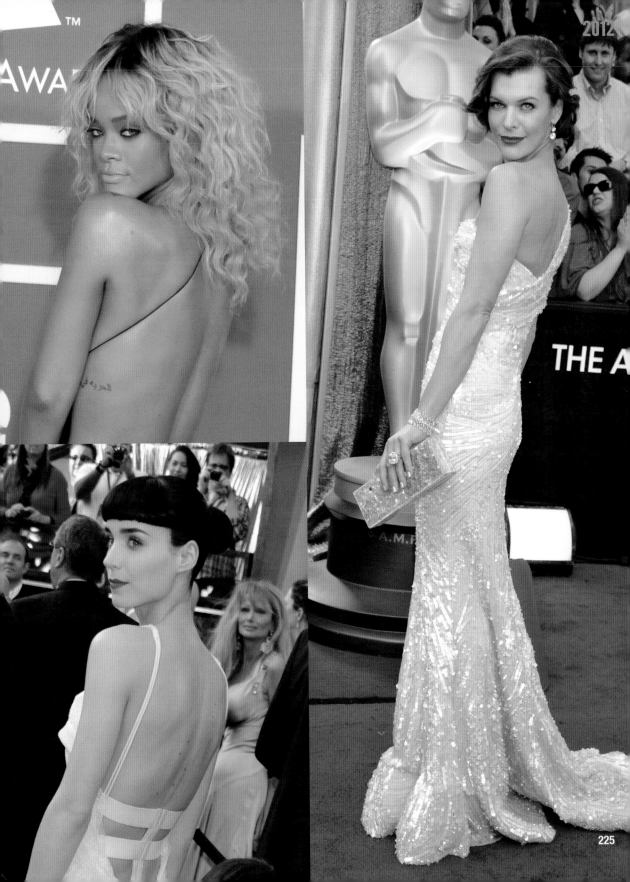

AWA

THE A

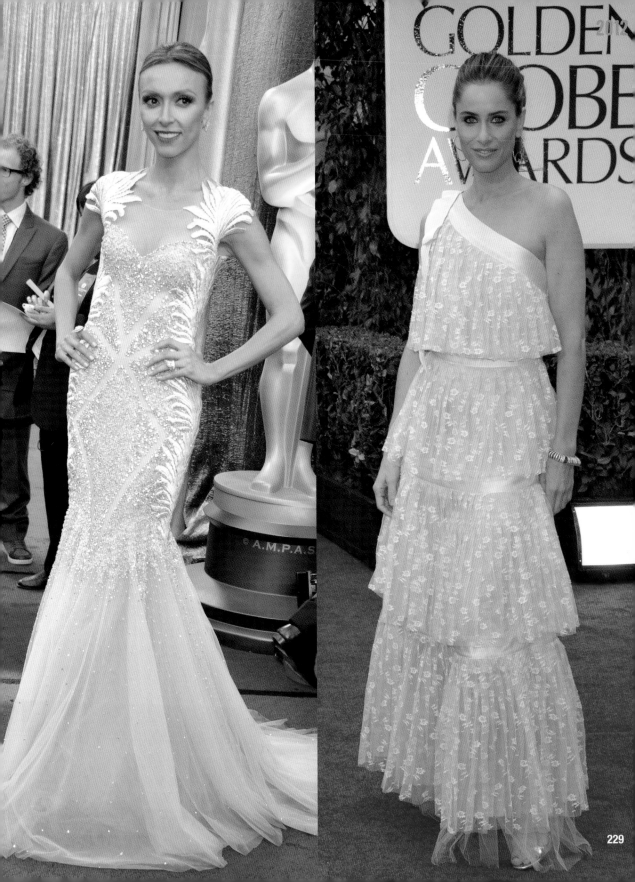

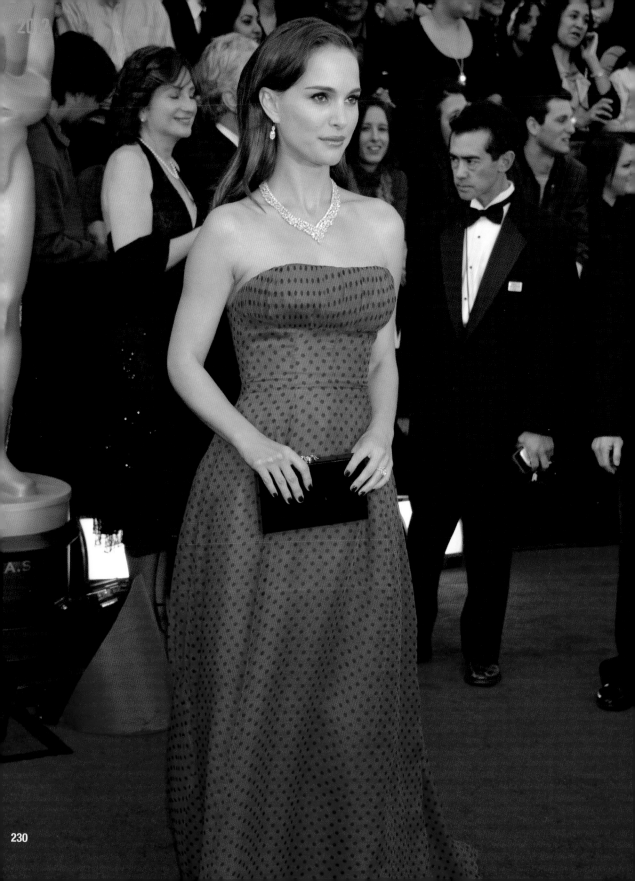

AWARDS

A.M.P.A.S.

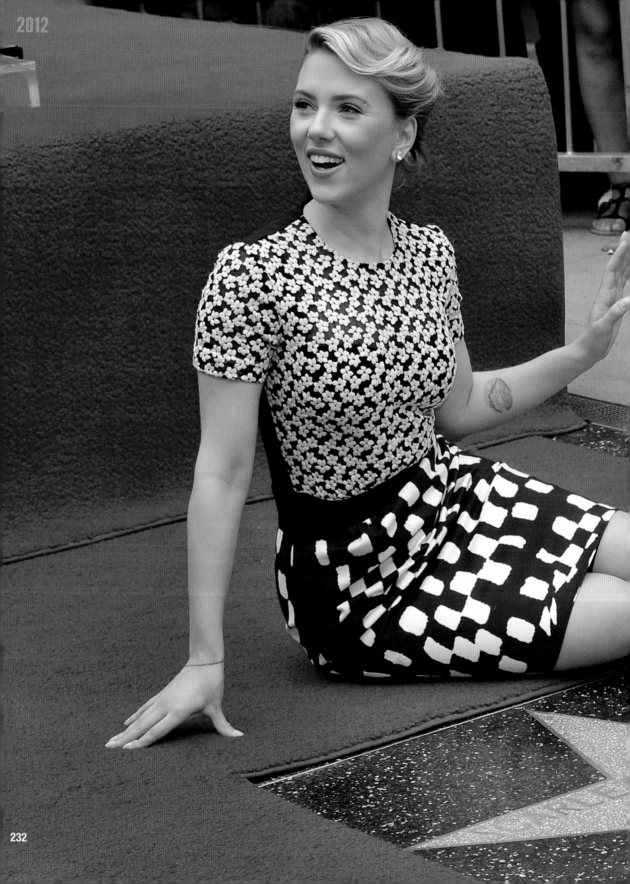

2013

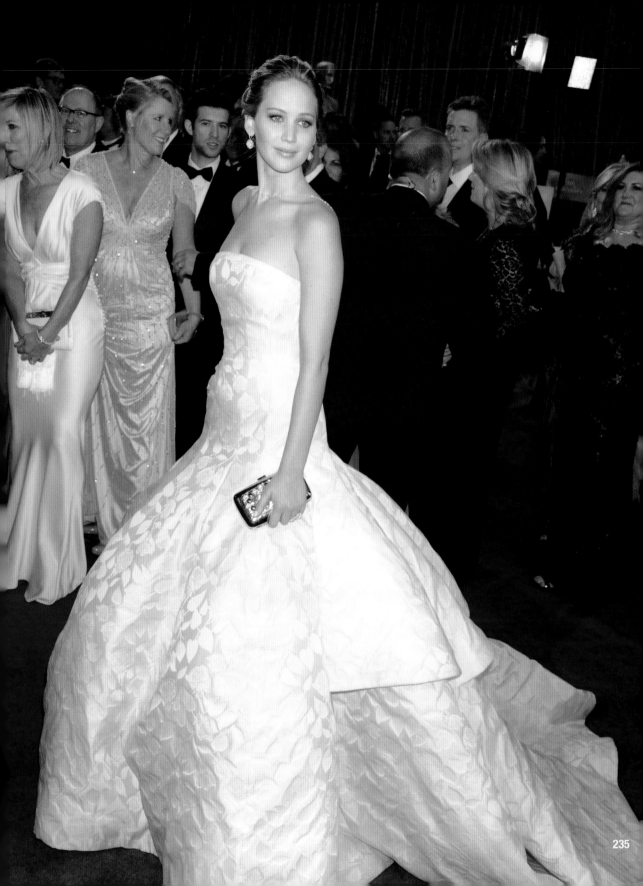

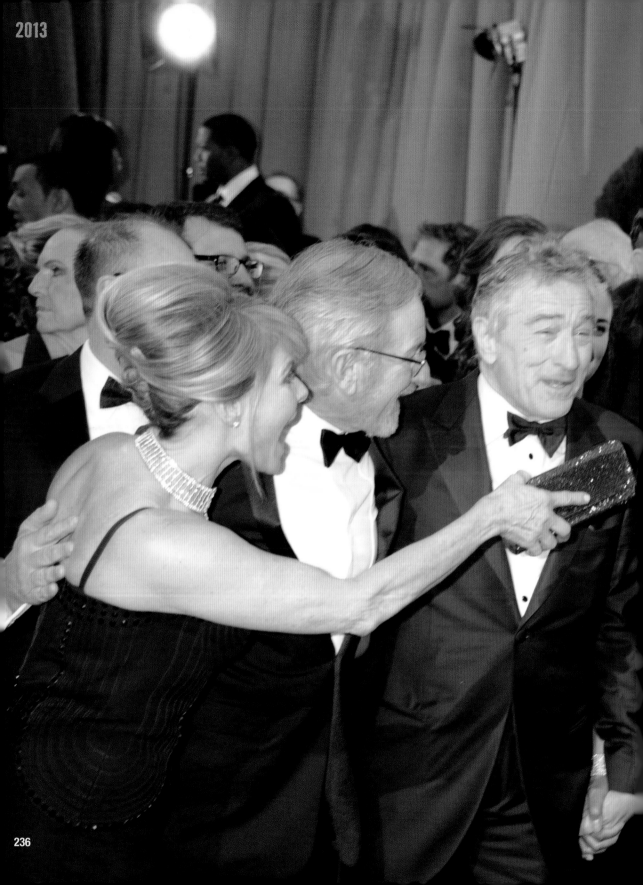

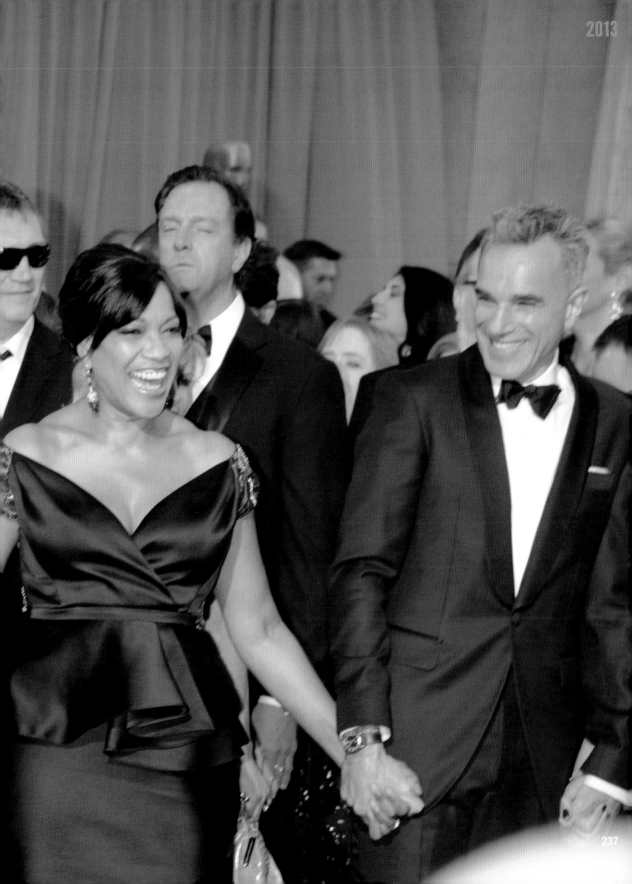

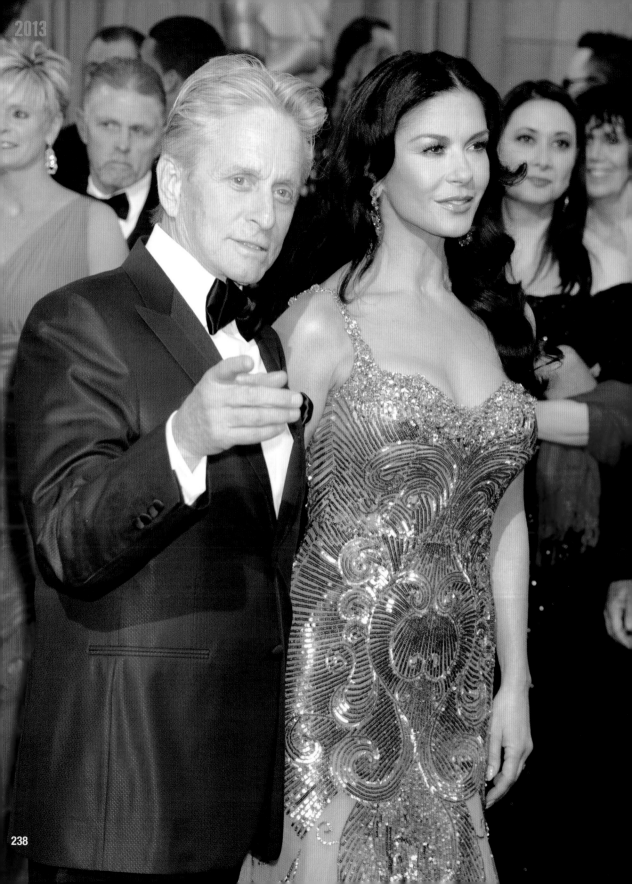

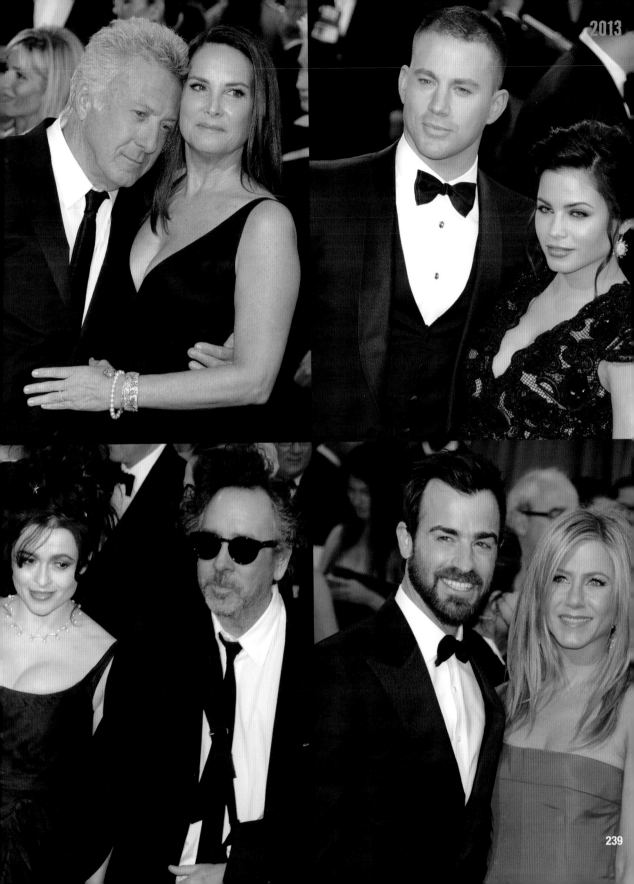

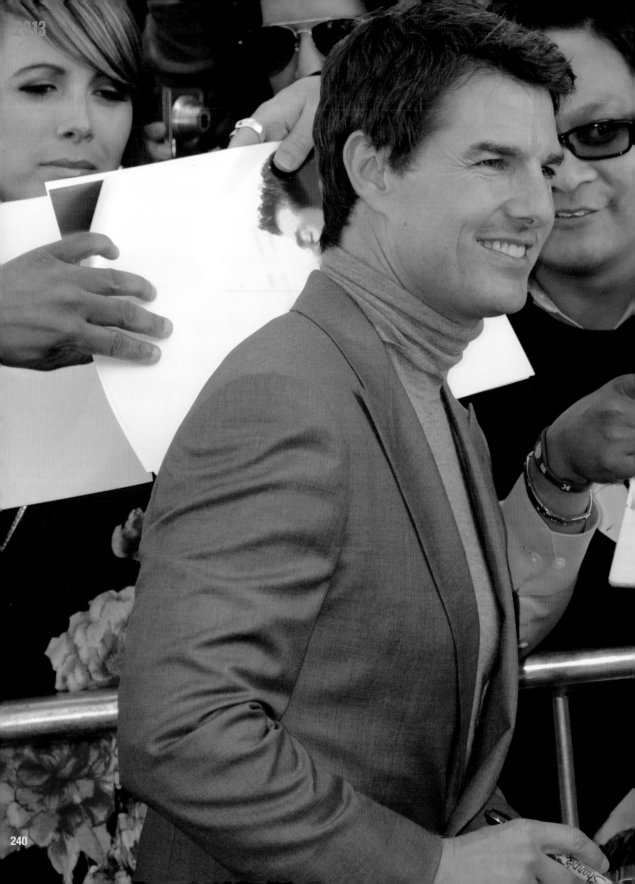

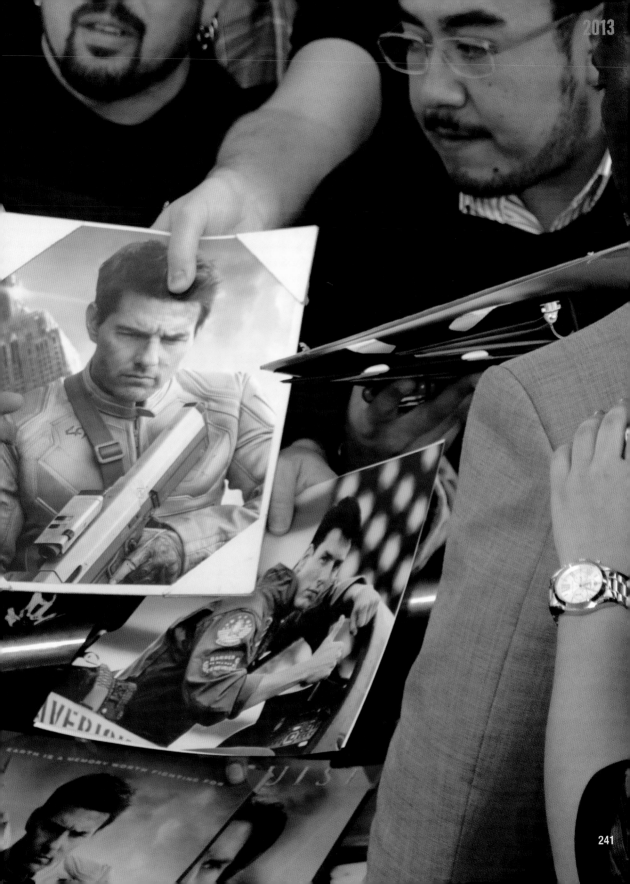

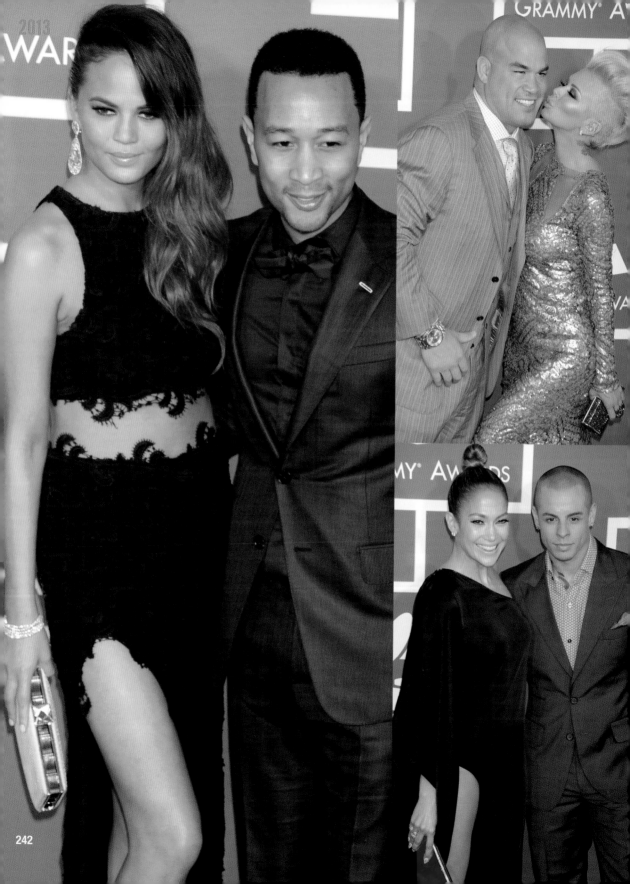

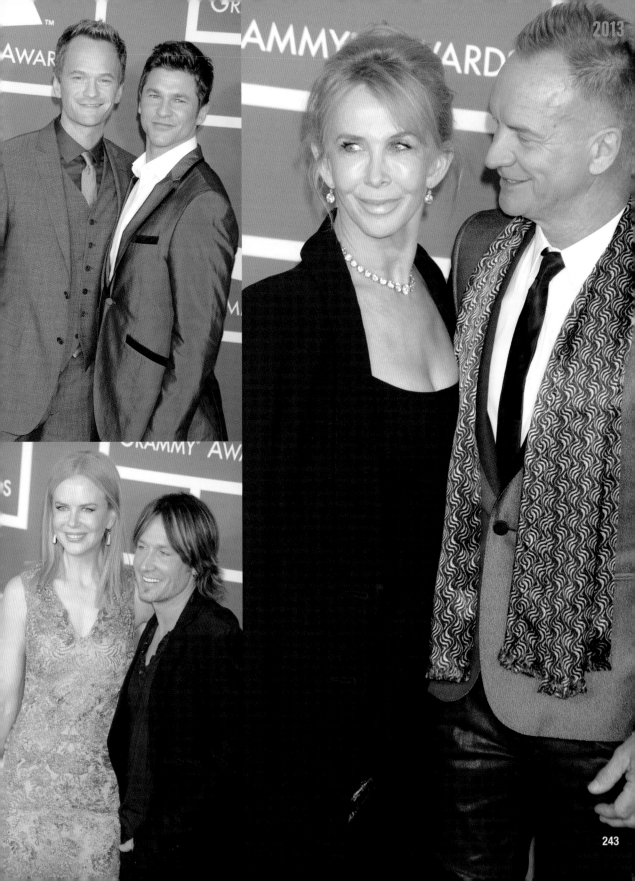

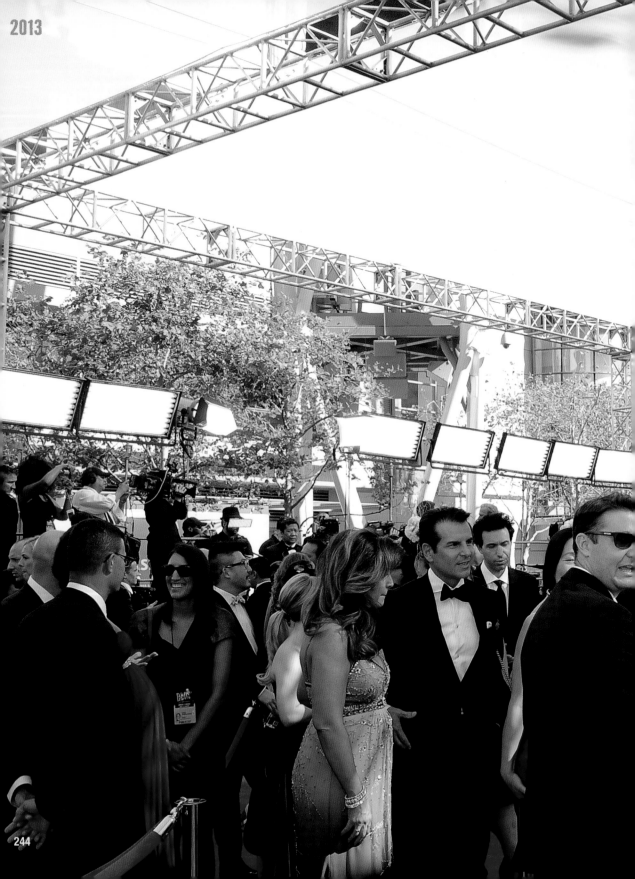

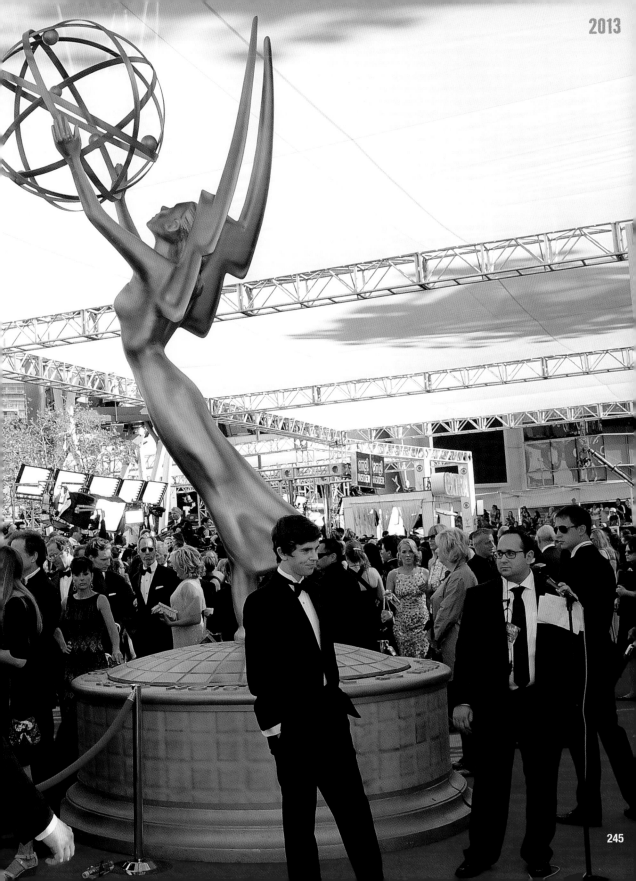

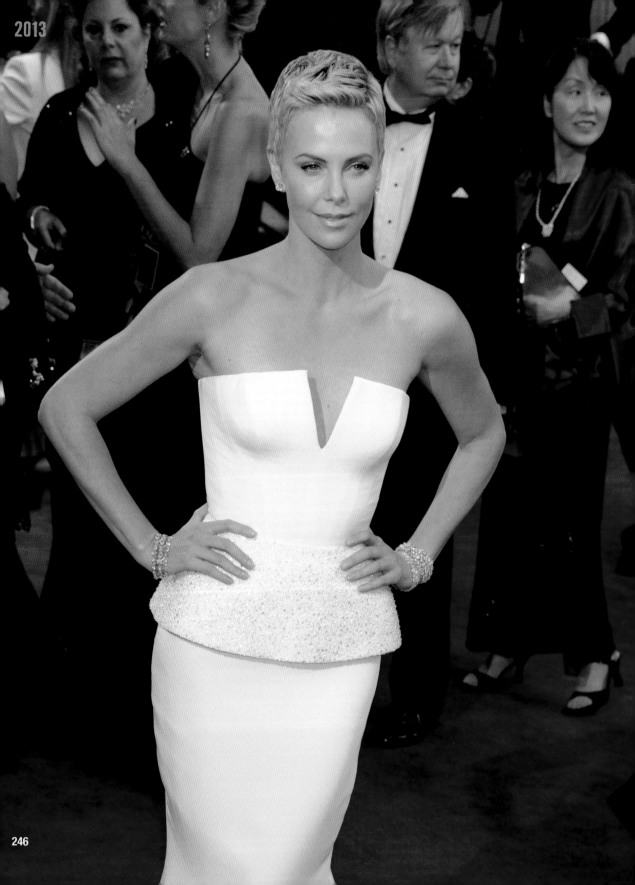

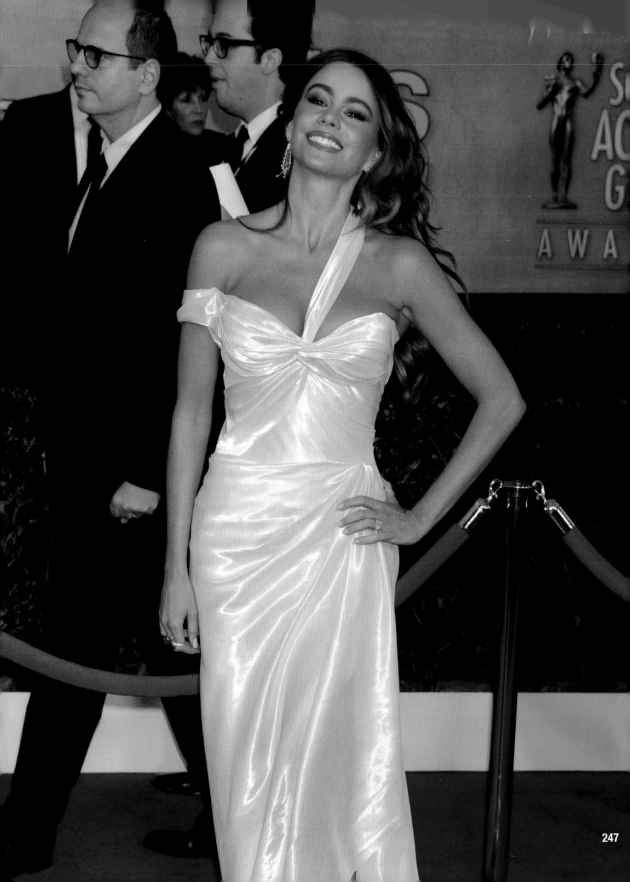

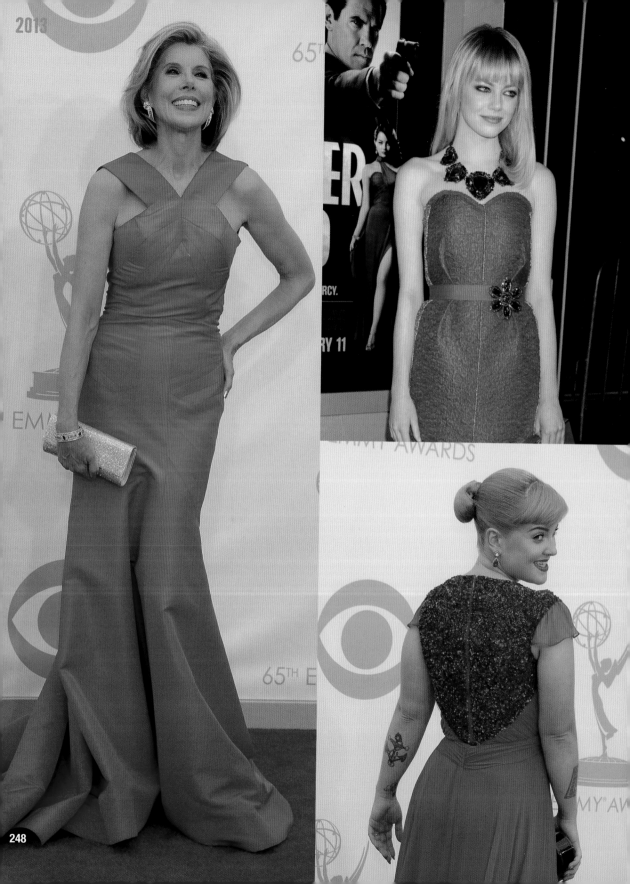

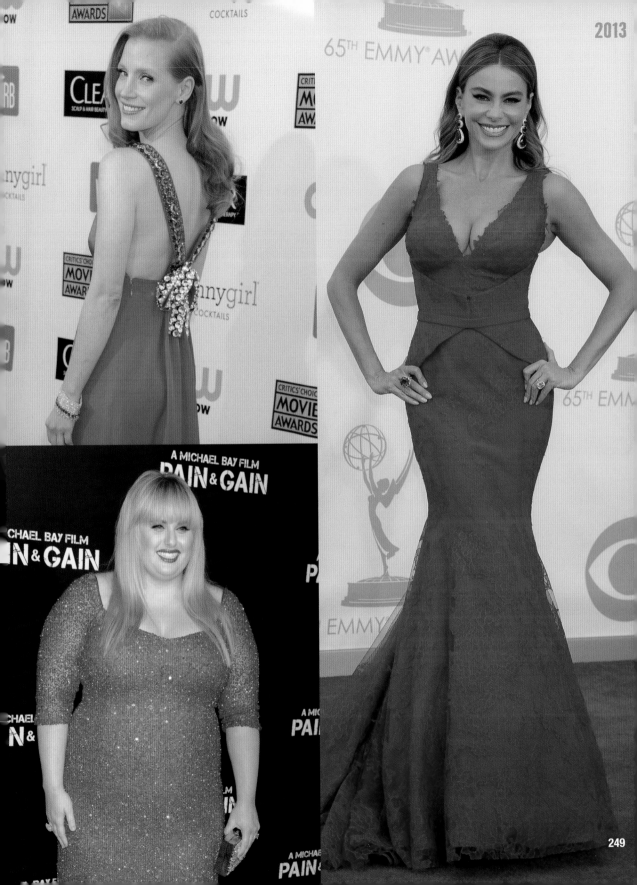

2014

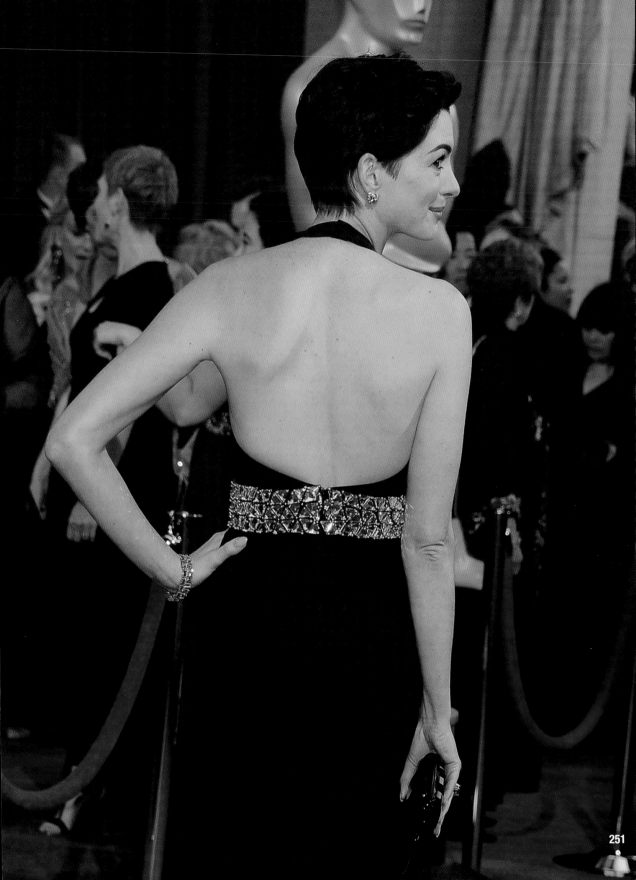

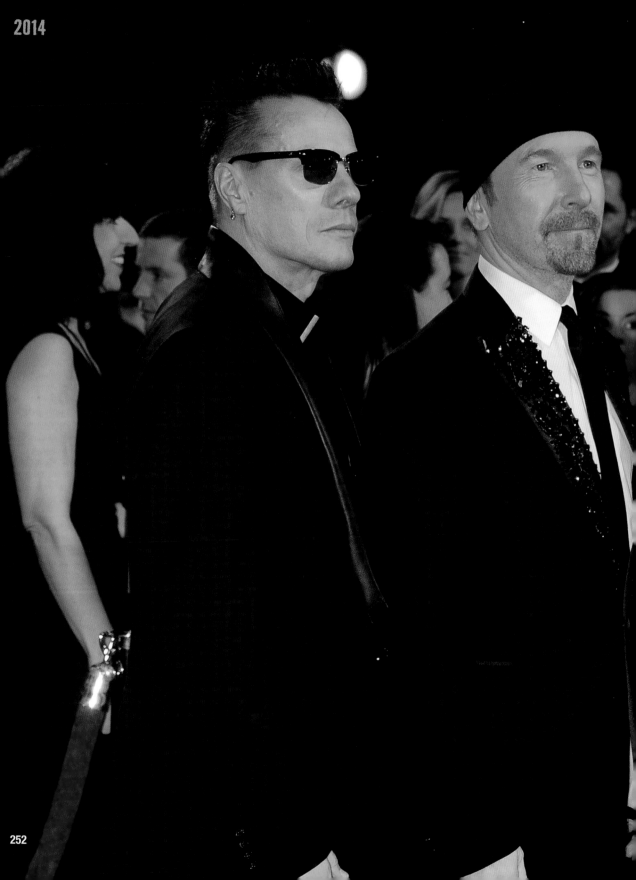

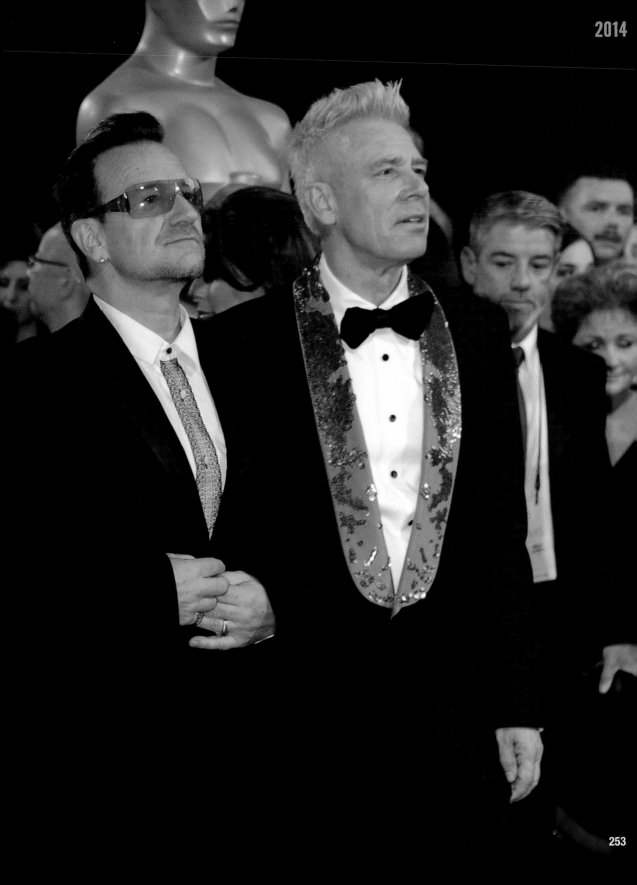

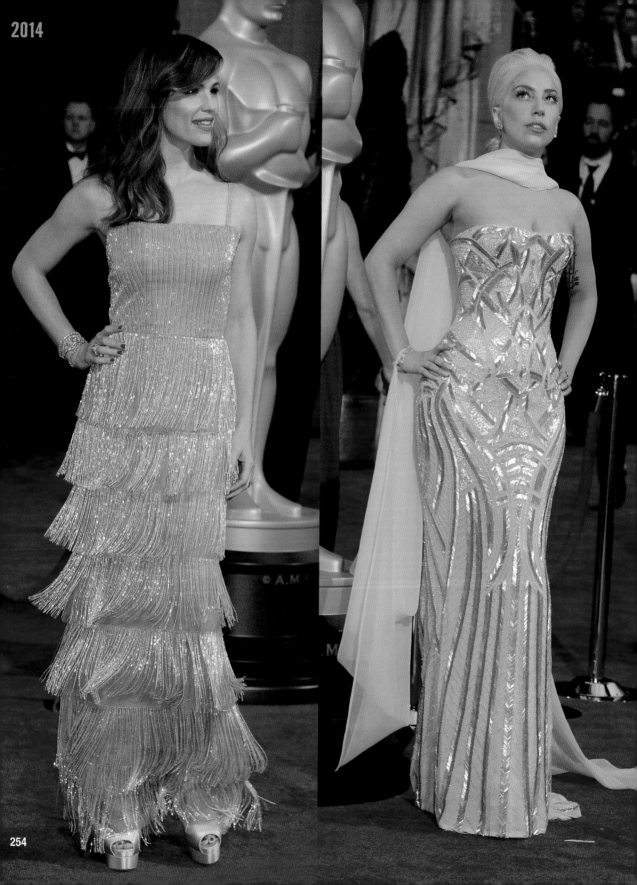

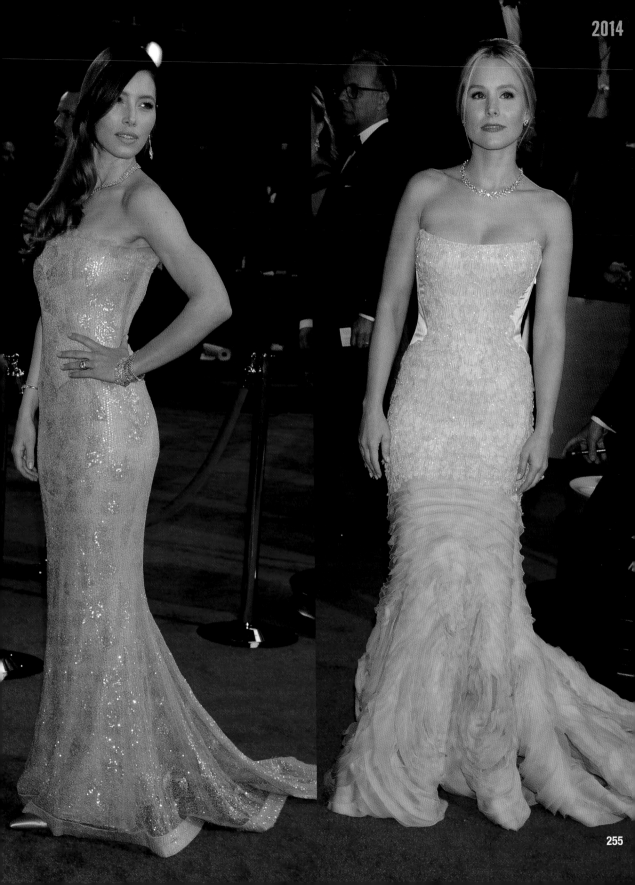

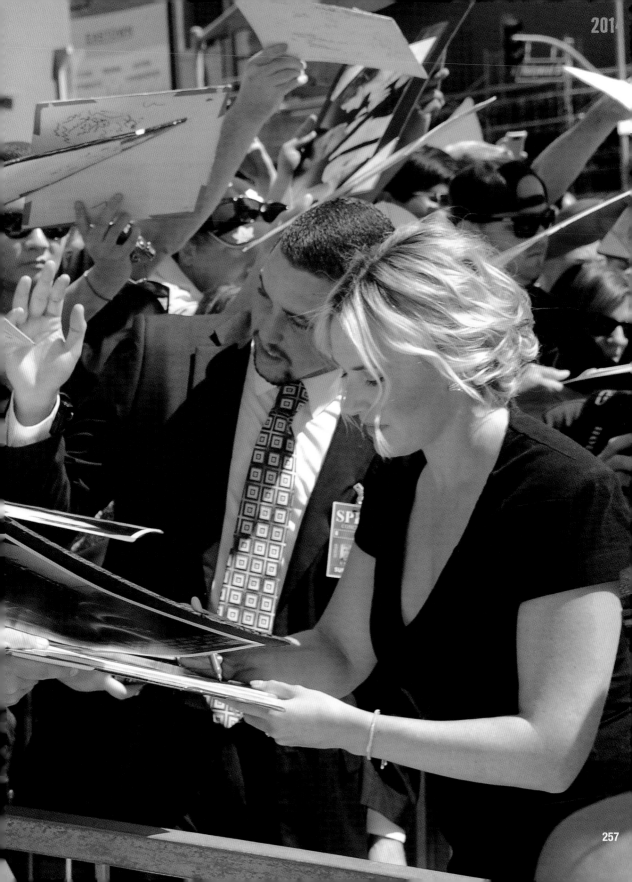

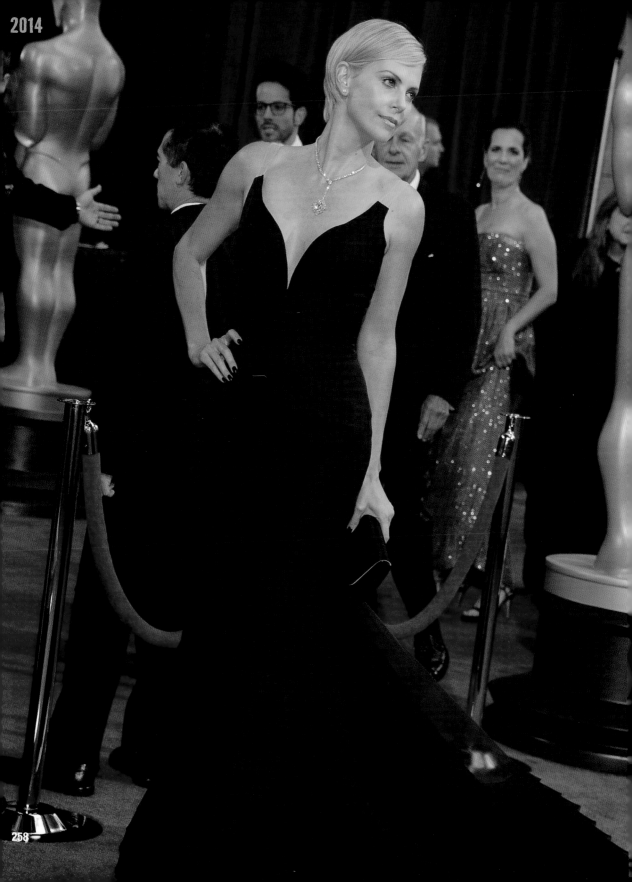

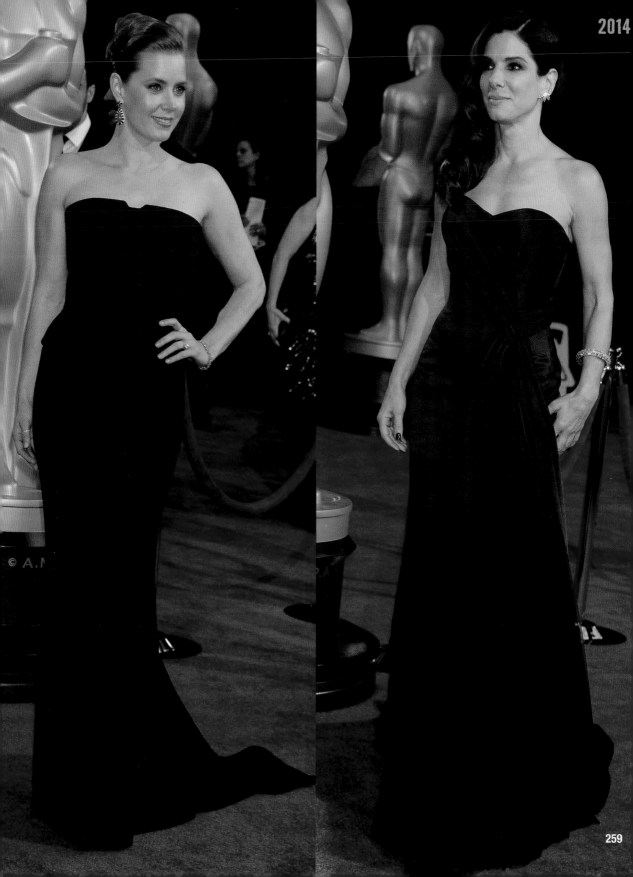

MGM

22 JUMP STREET

JUNE 13

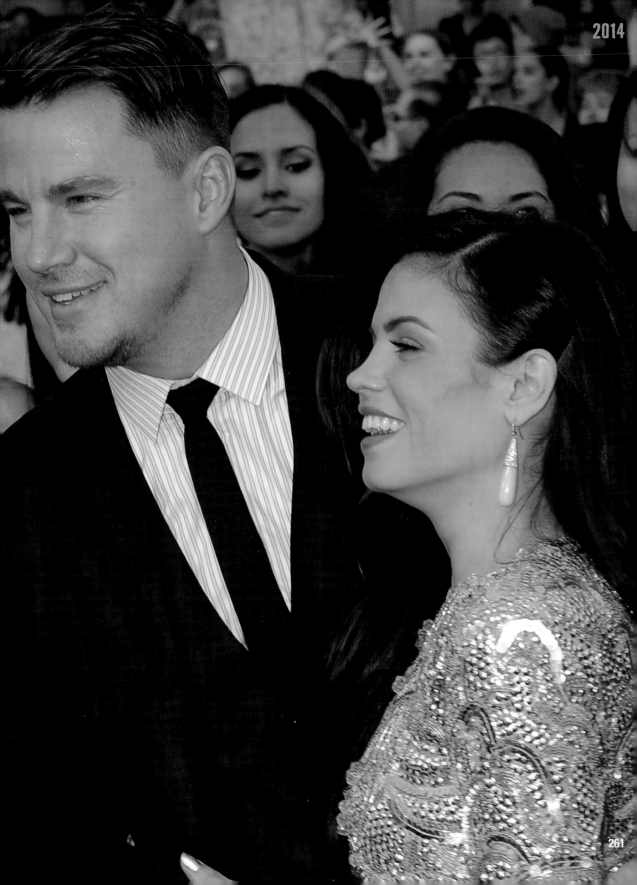

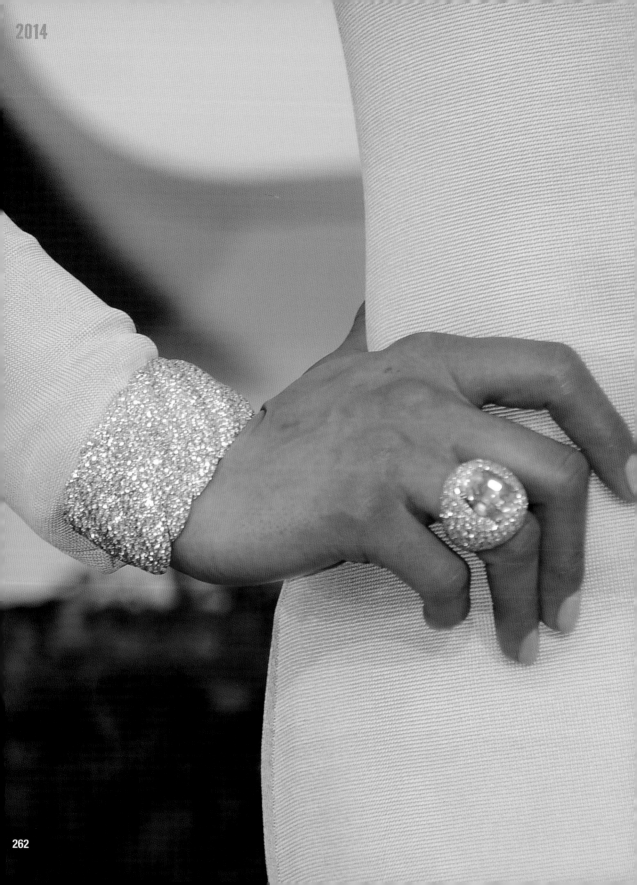

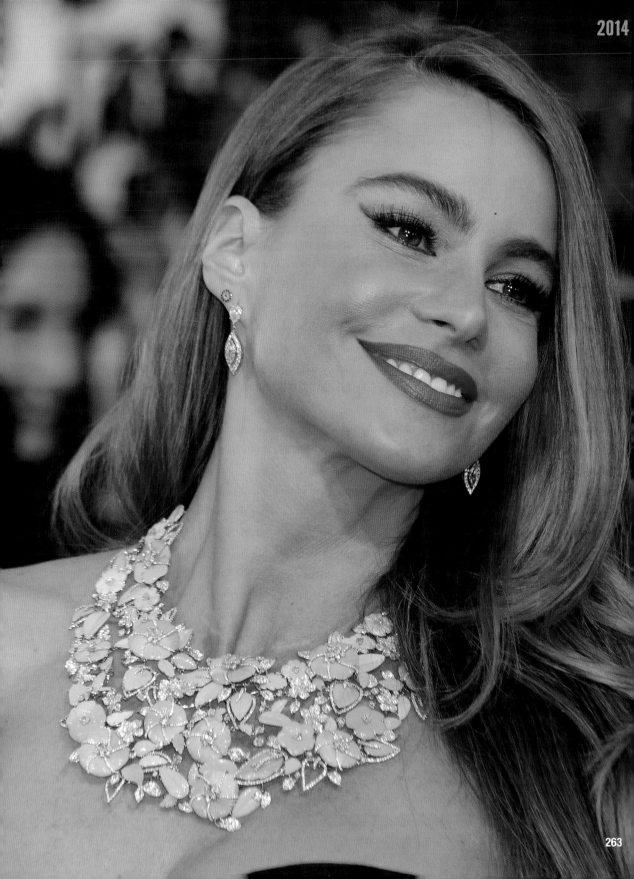

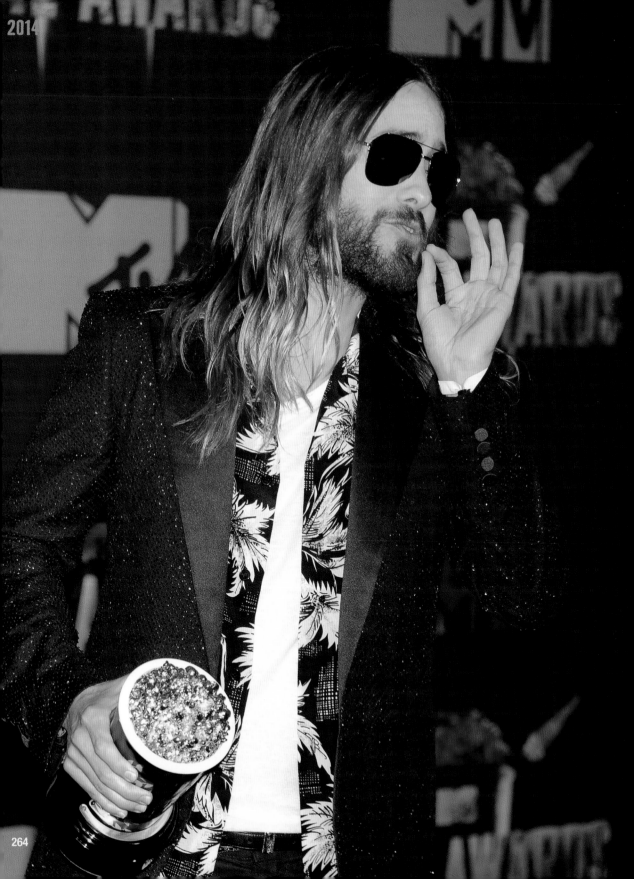

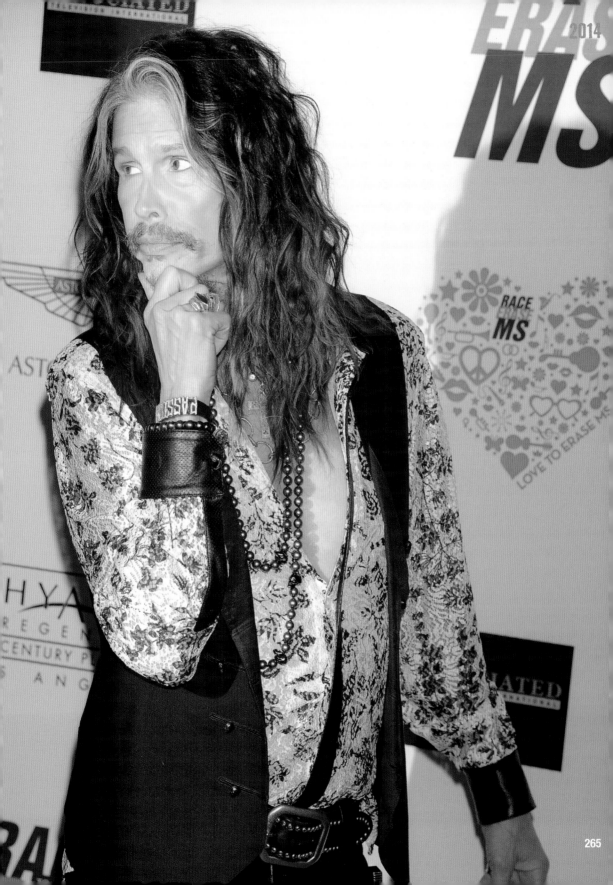

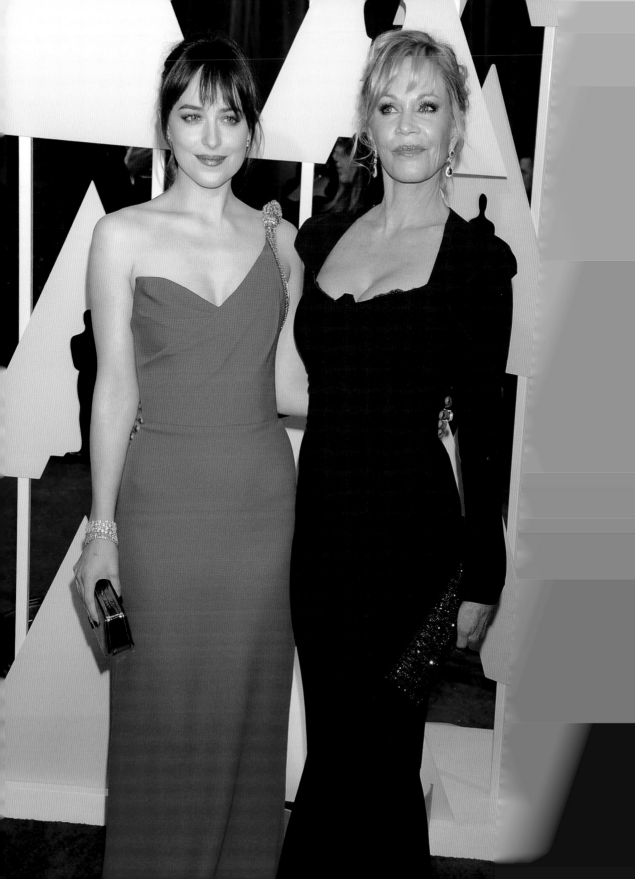

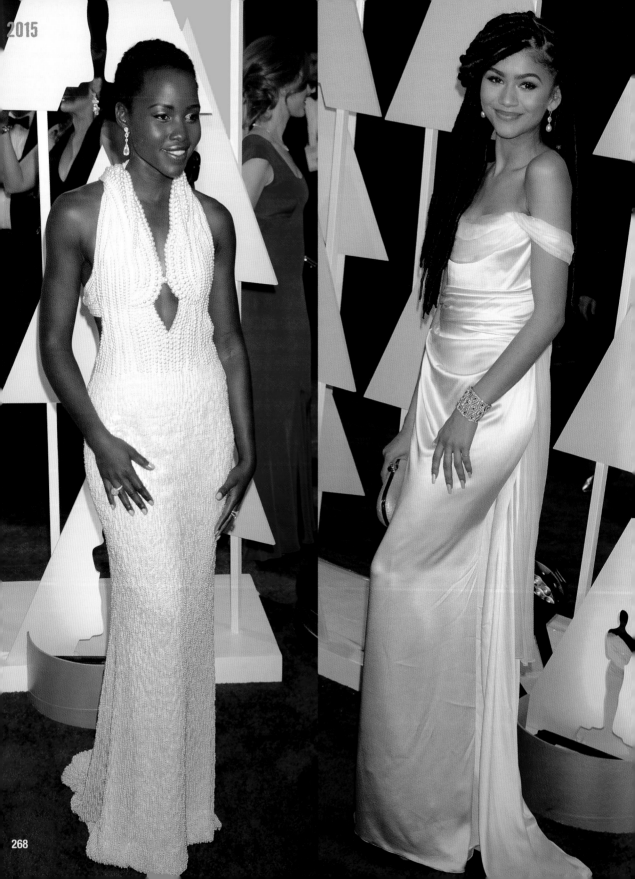

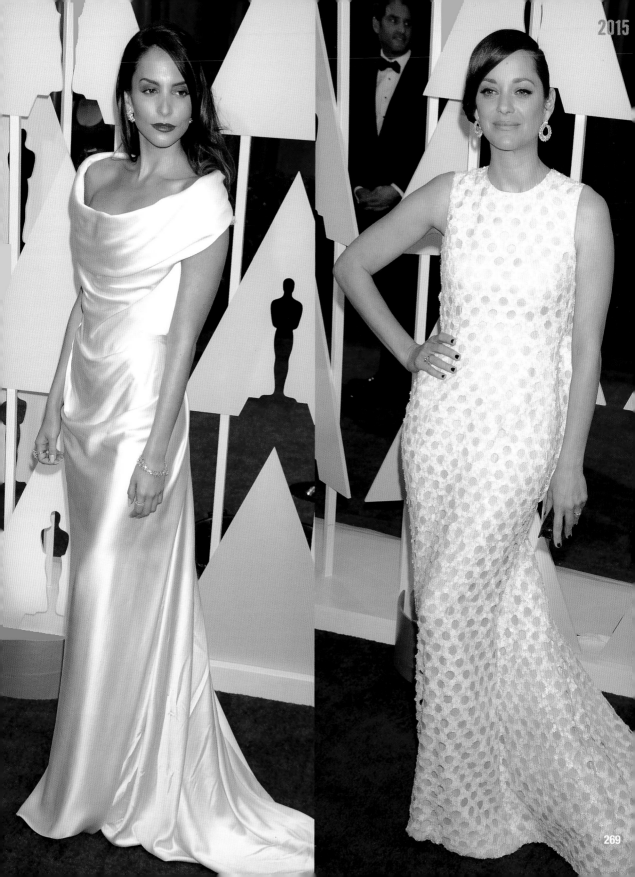

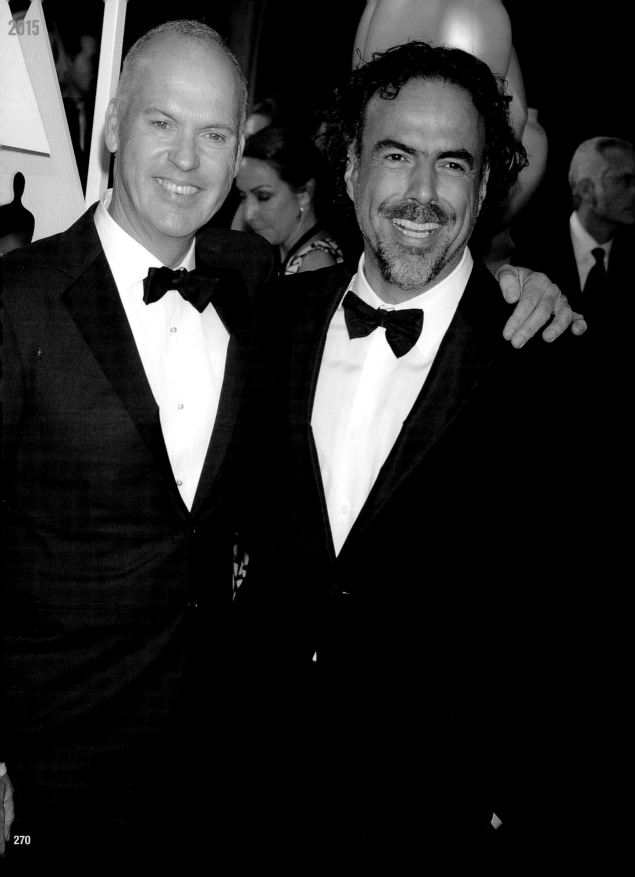

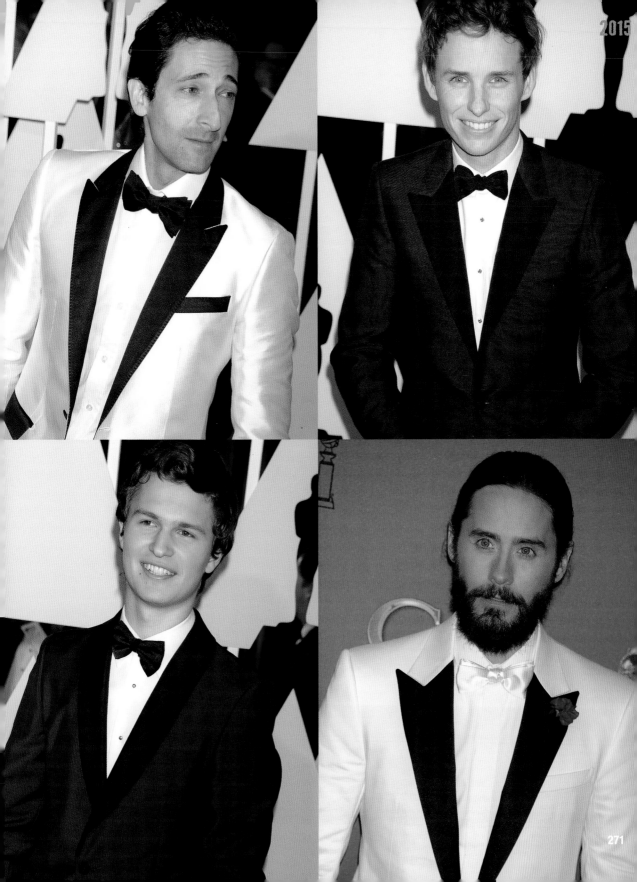

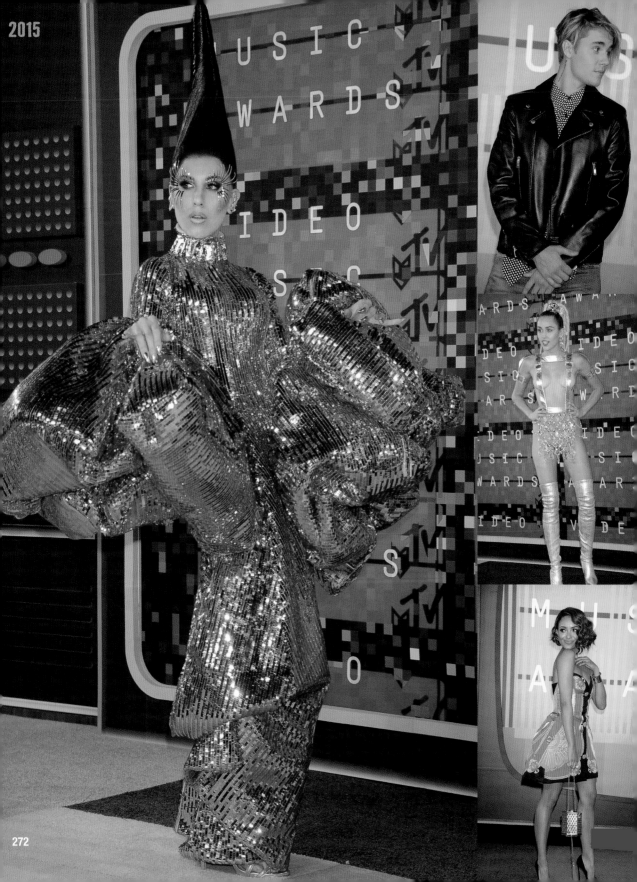

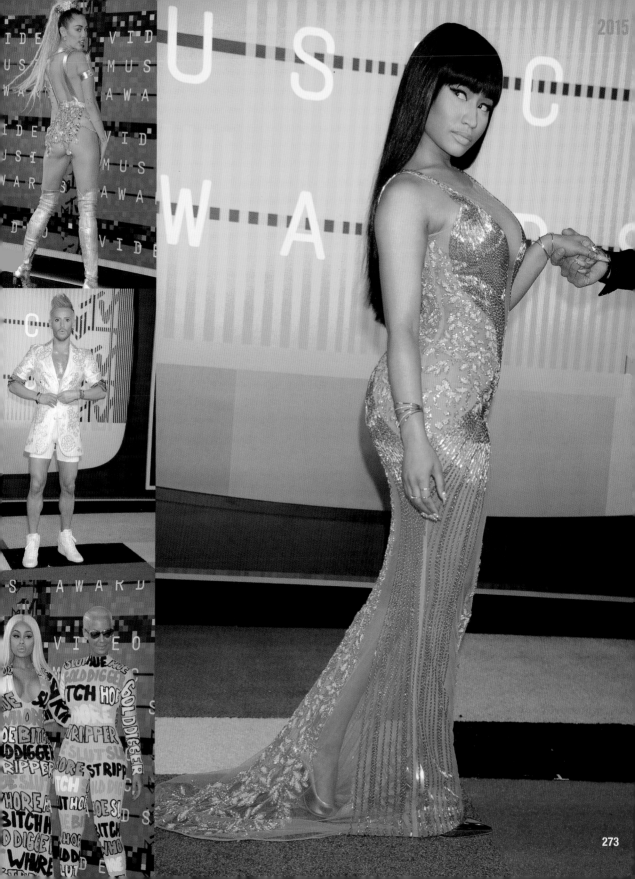

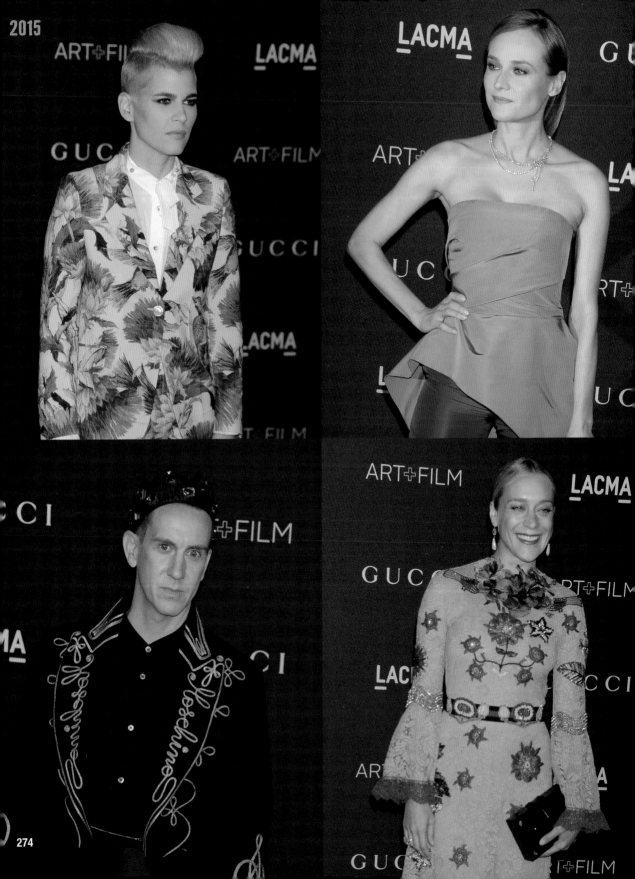

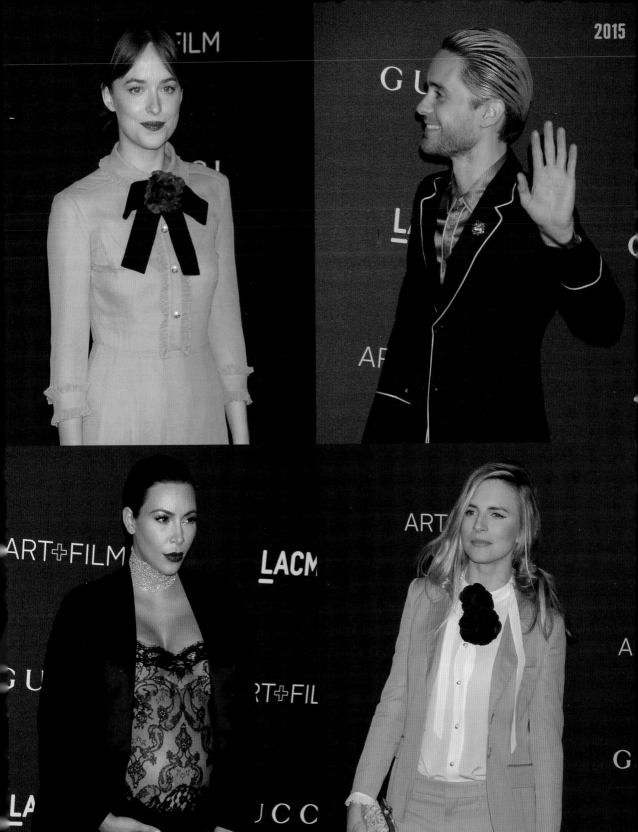

2015

275

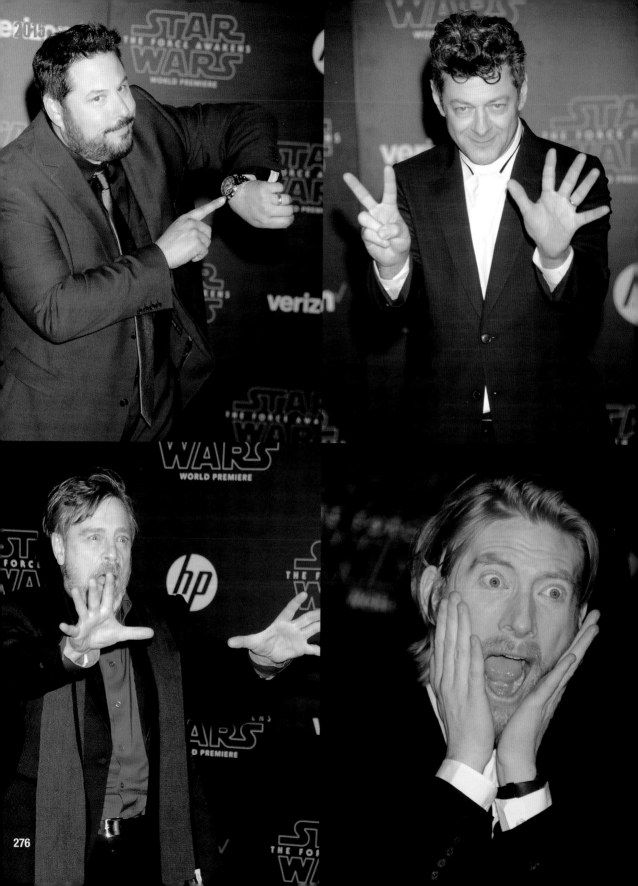

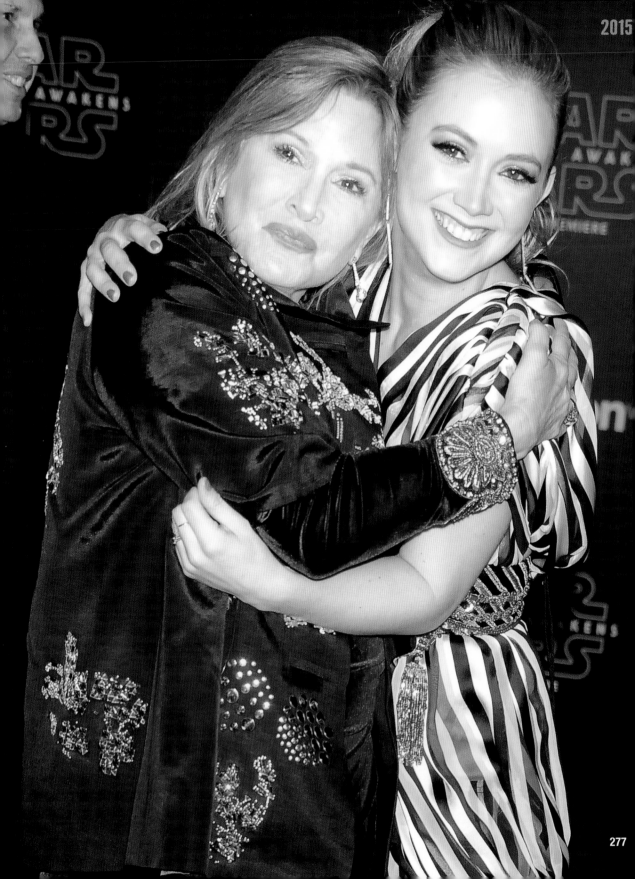

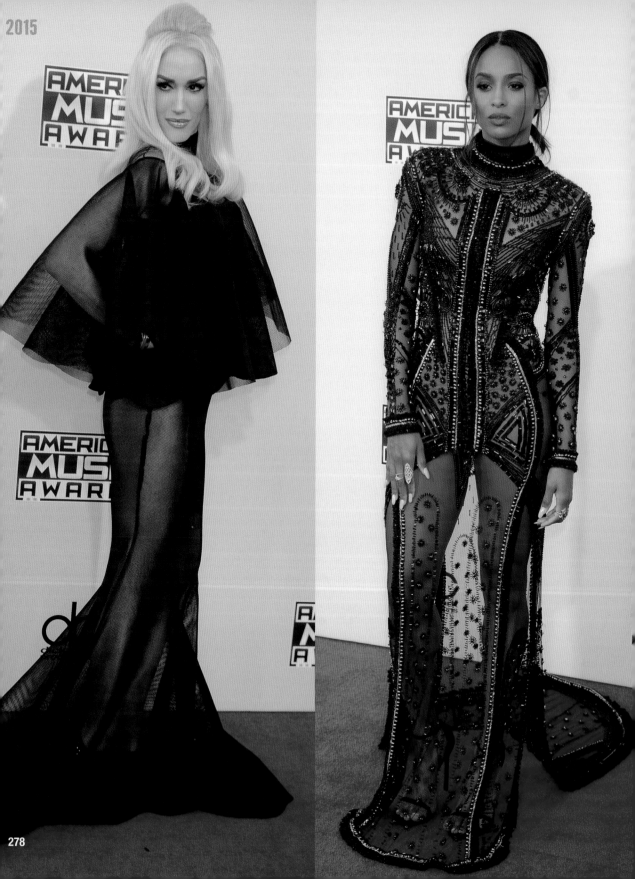

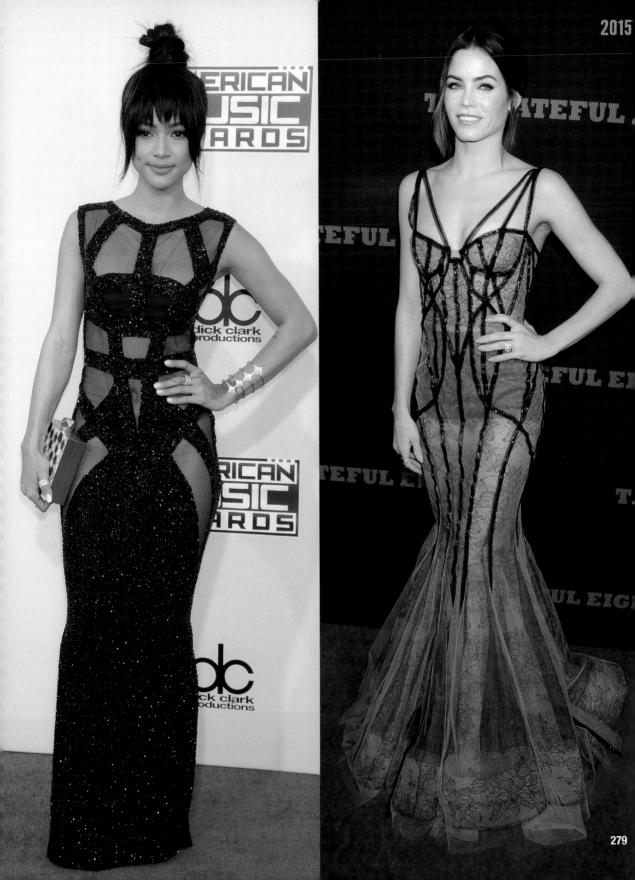

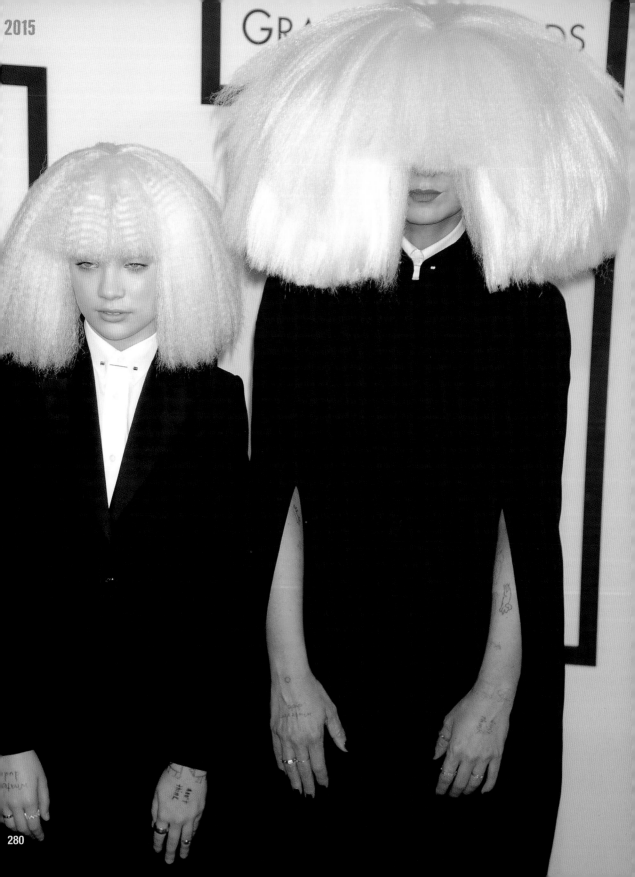

2015

GRA...DS

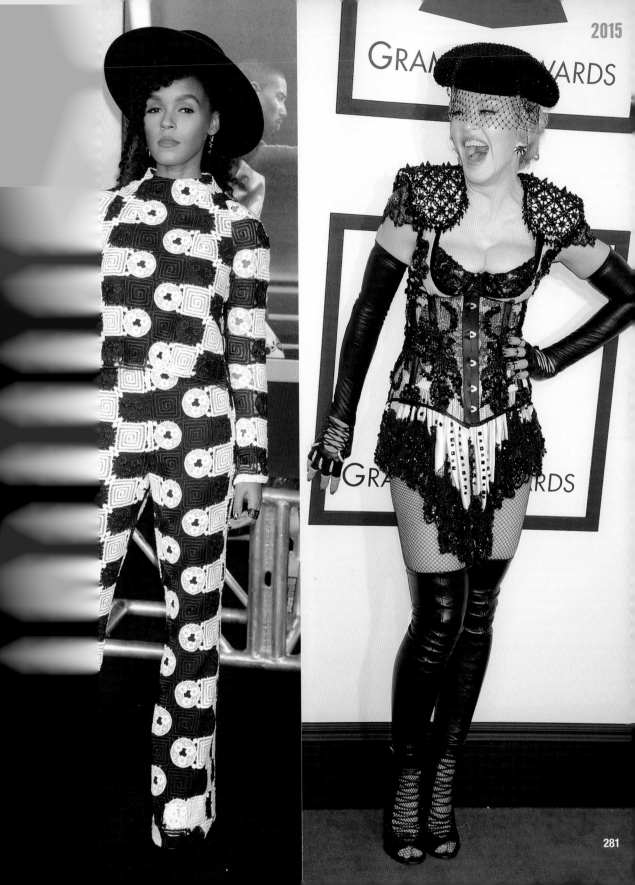

GRAMMY AWARDS

GRAMMY AWARDS

281

2016

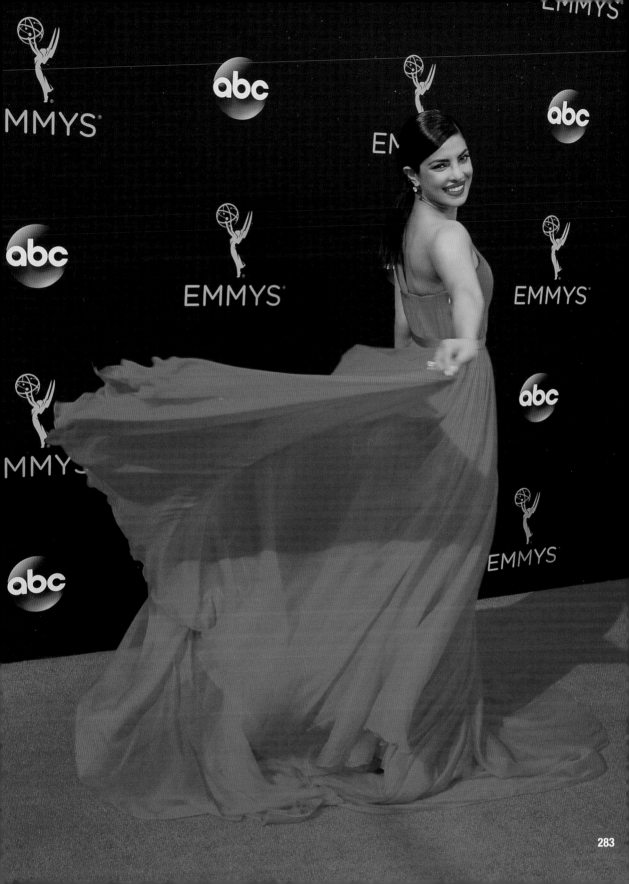

283

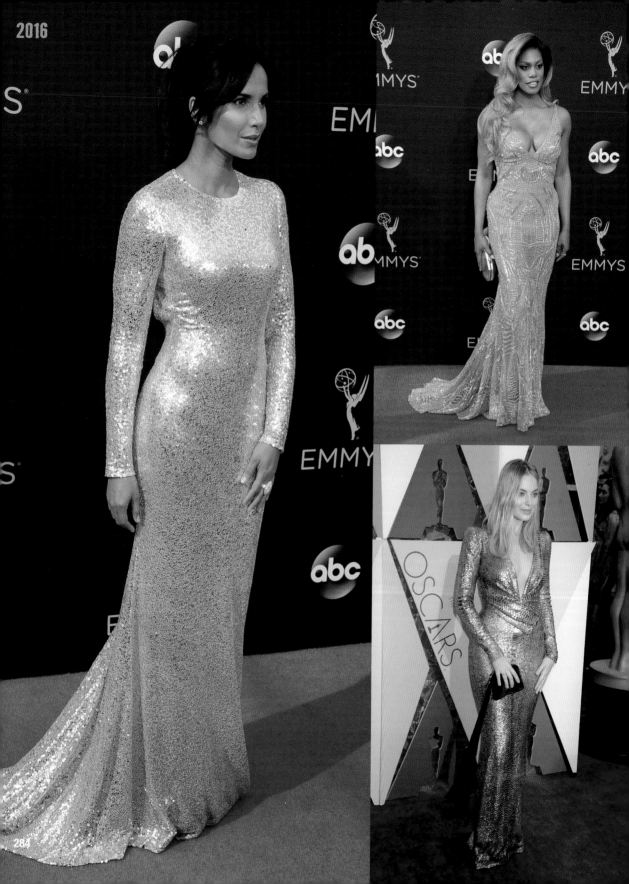

2016

284

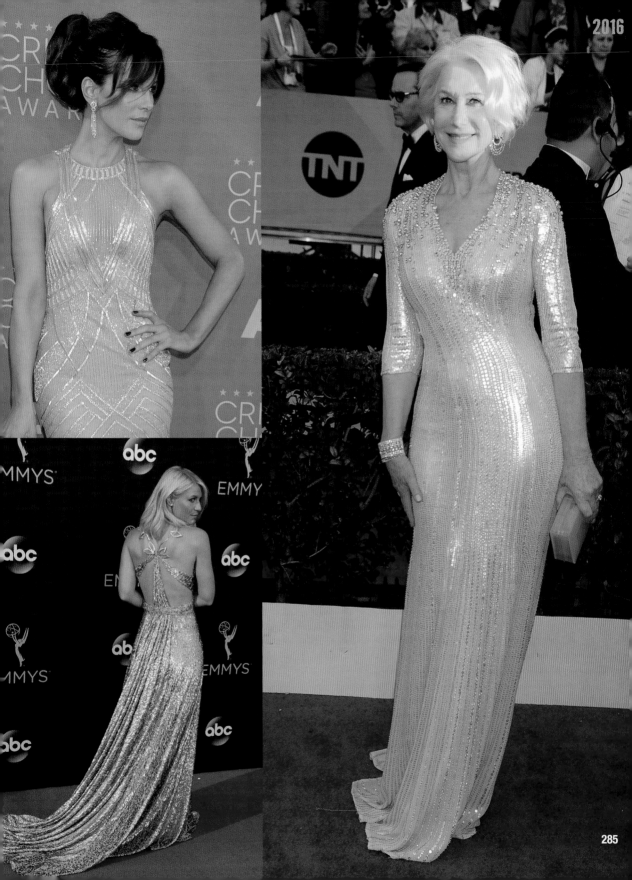

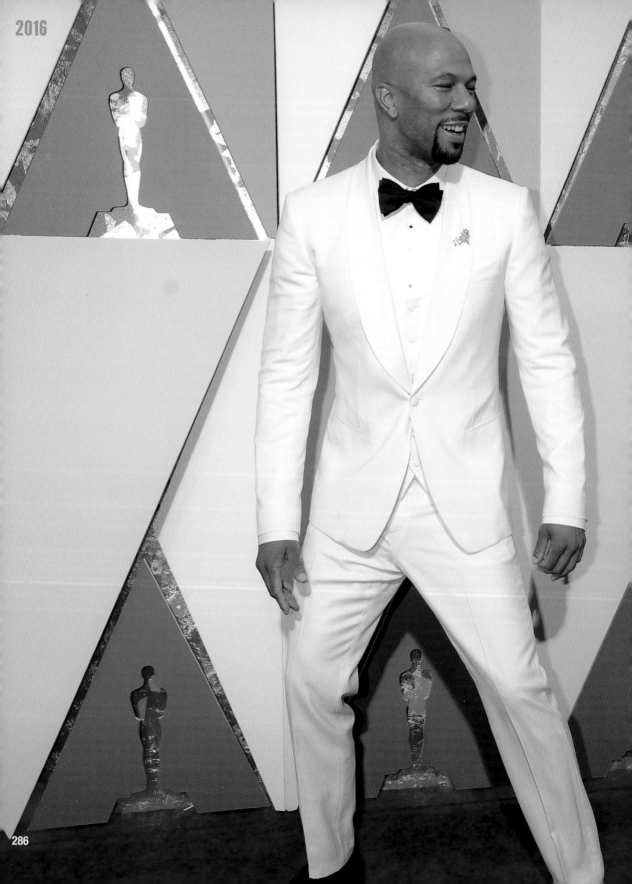

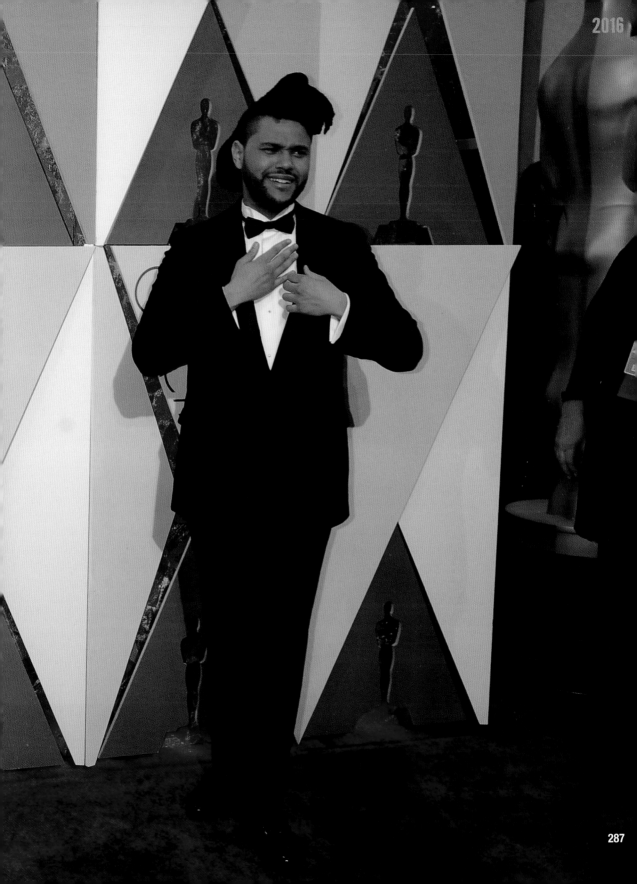

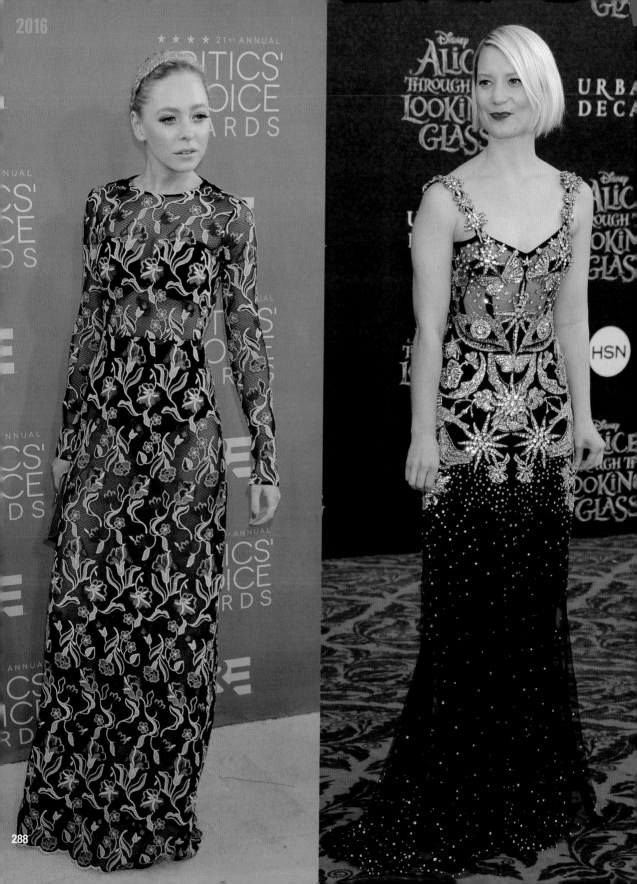

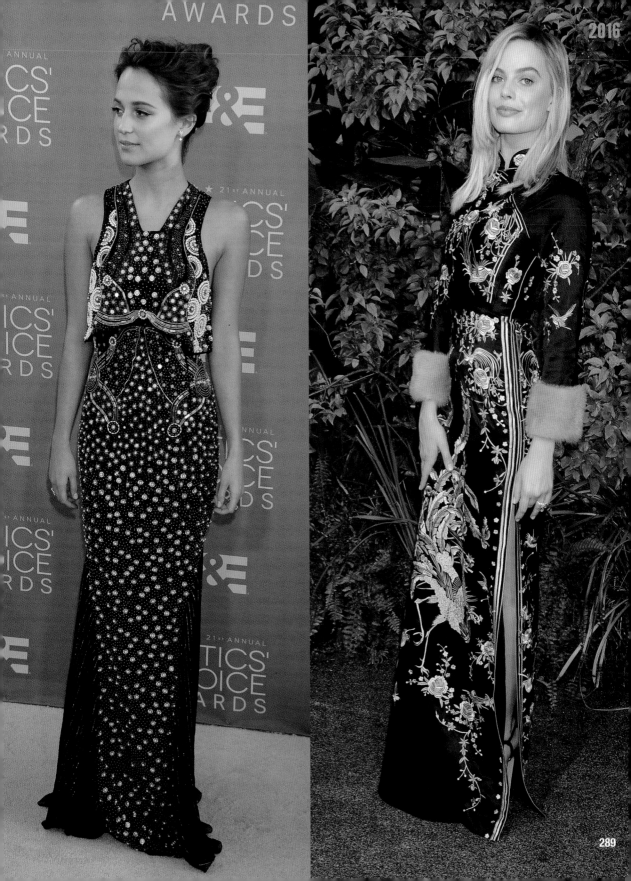

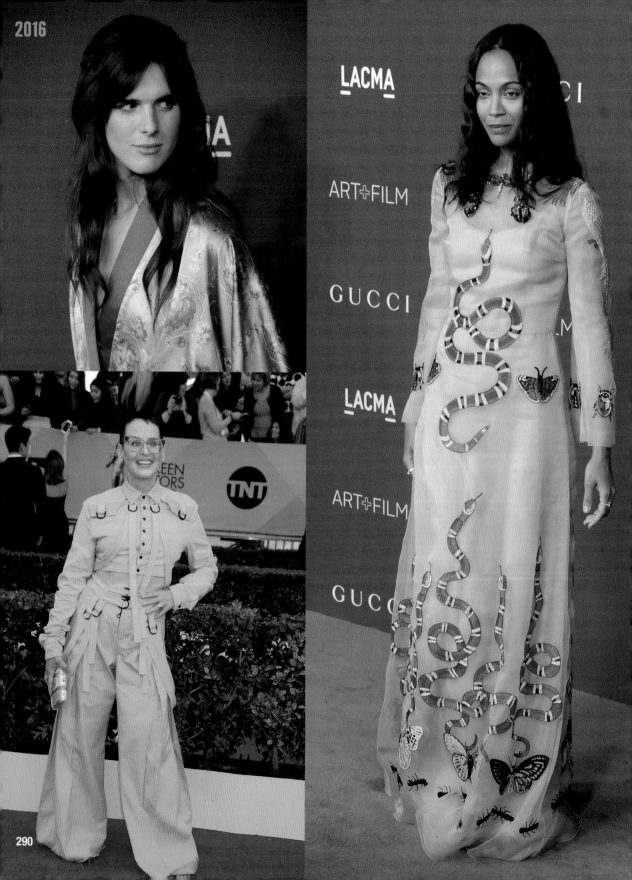

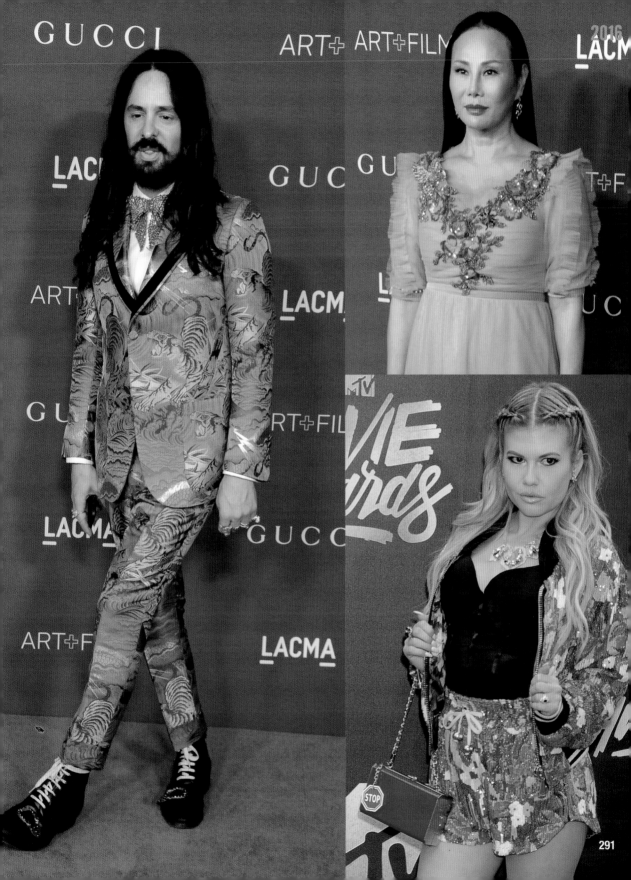

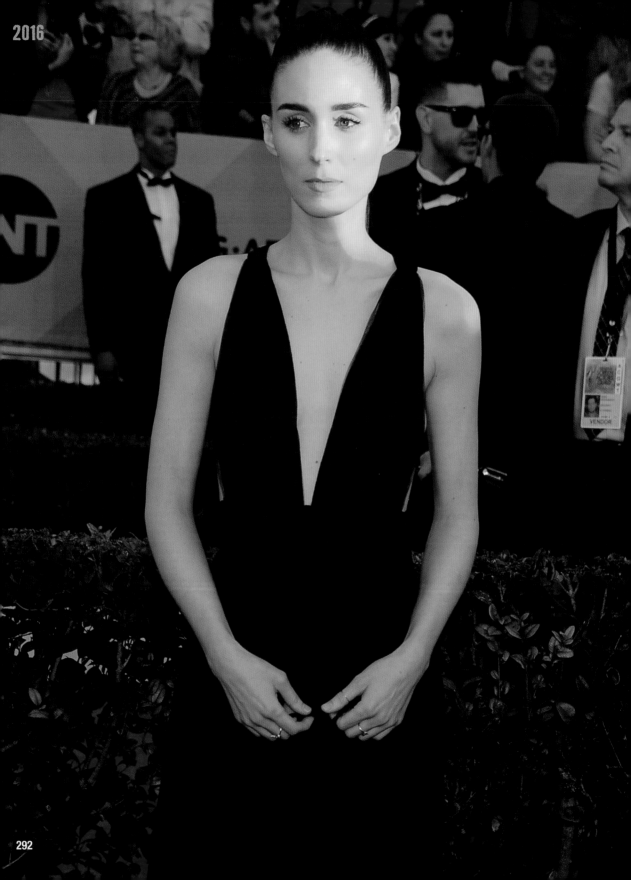

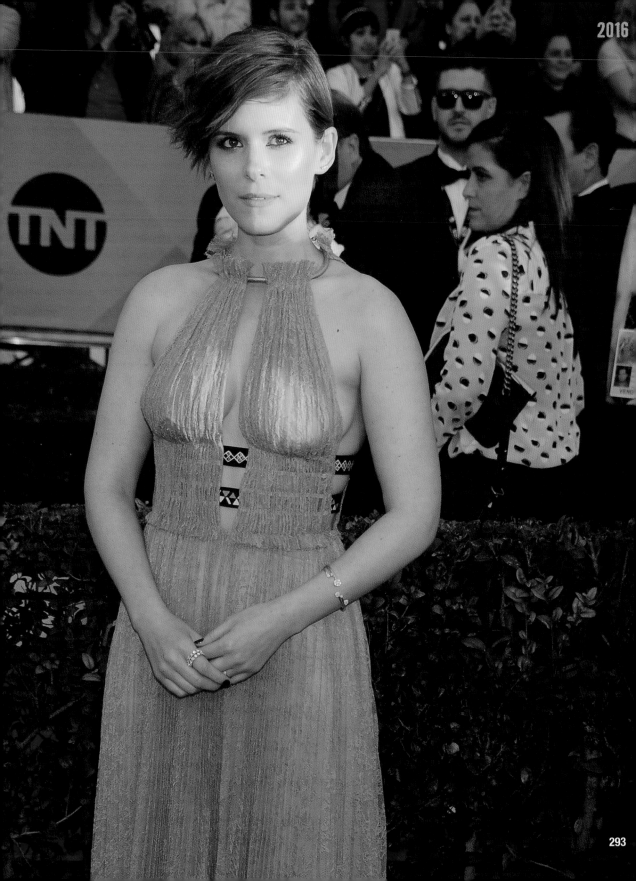

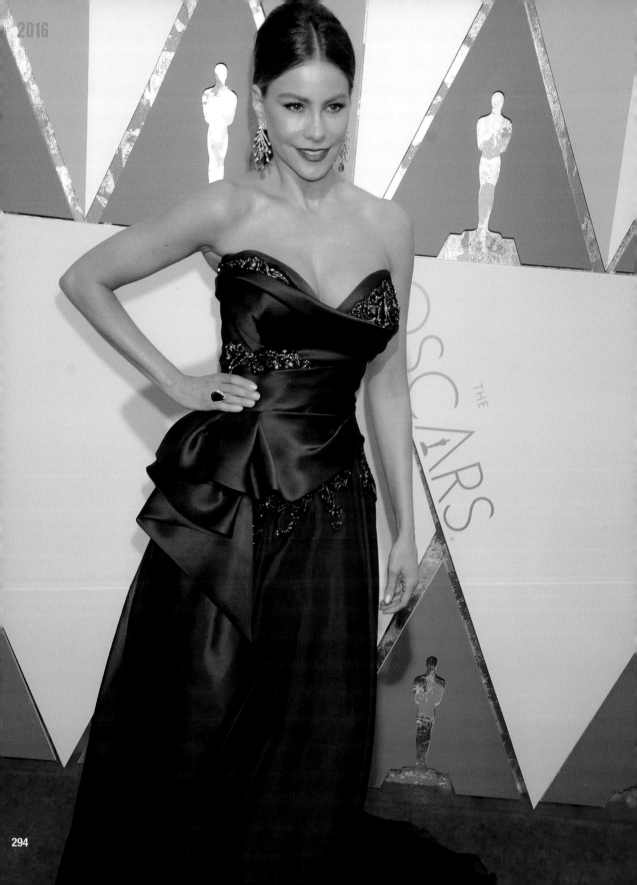

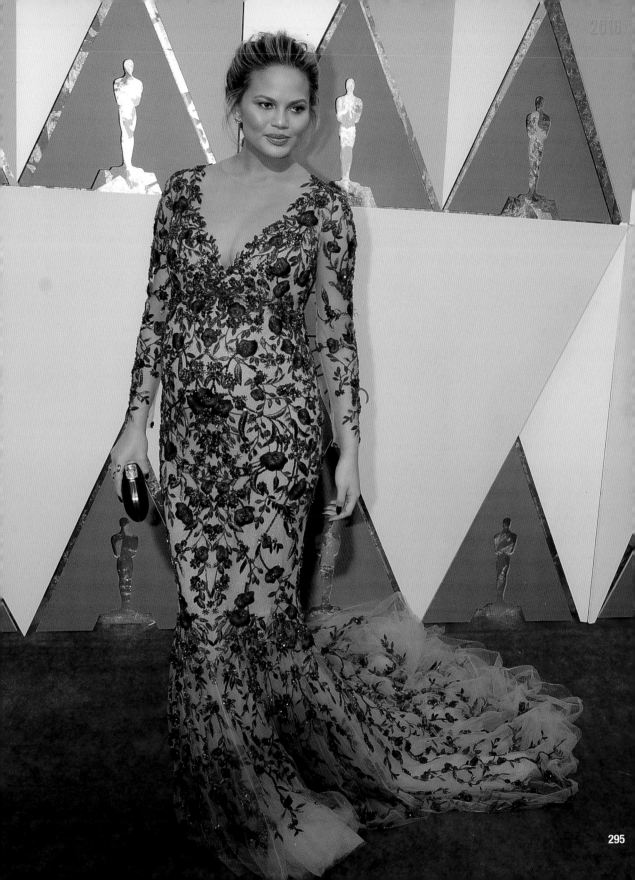

295

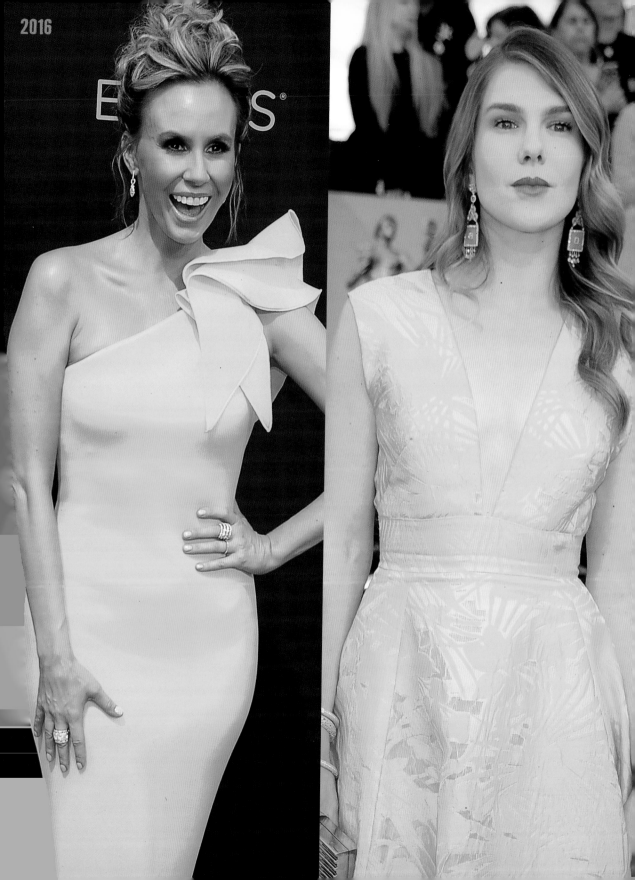

2016

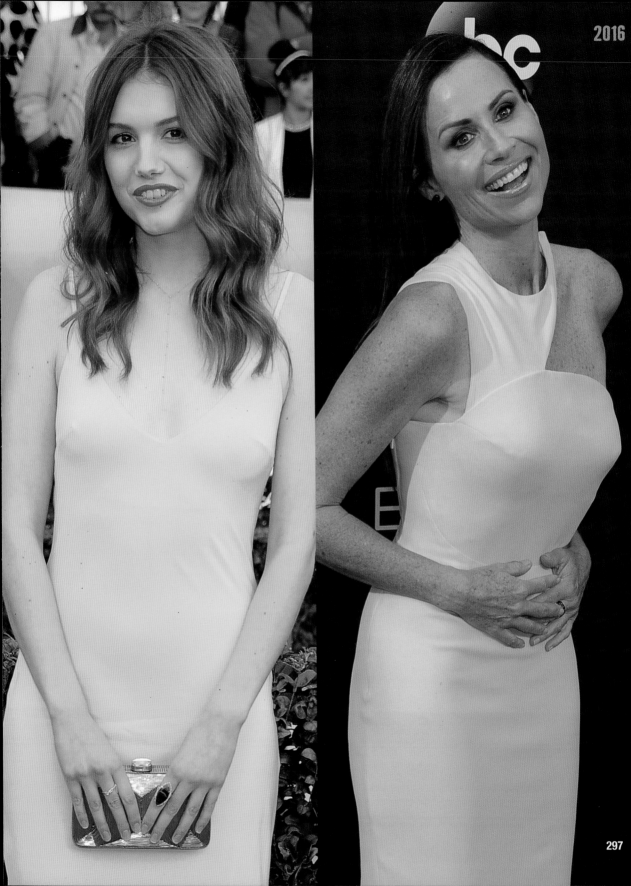

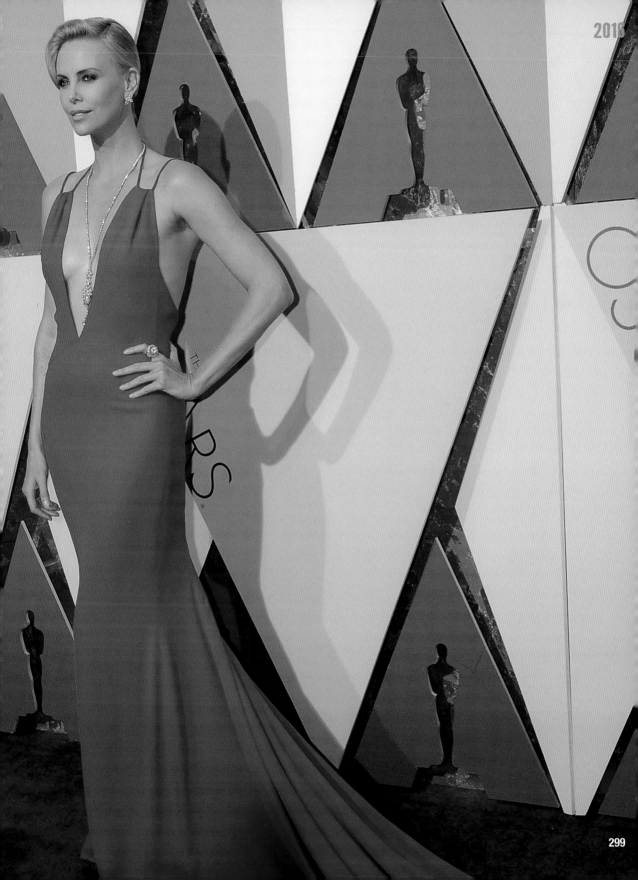

"IN MY DEFENSE, I DON'T RECALL ANY OF IT."
—FRANK TRAPPER

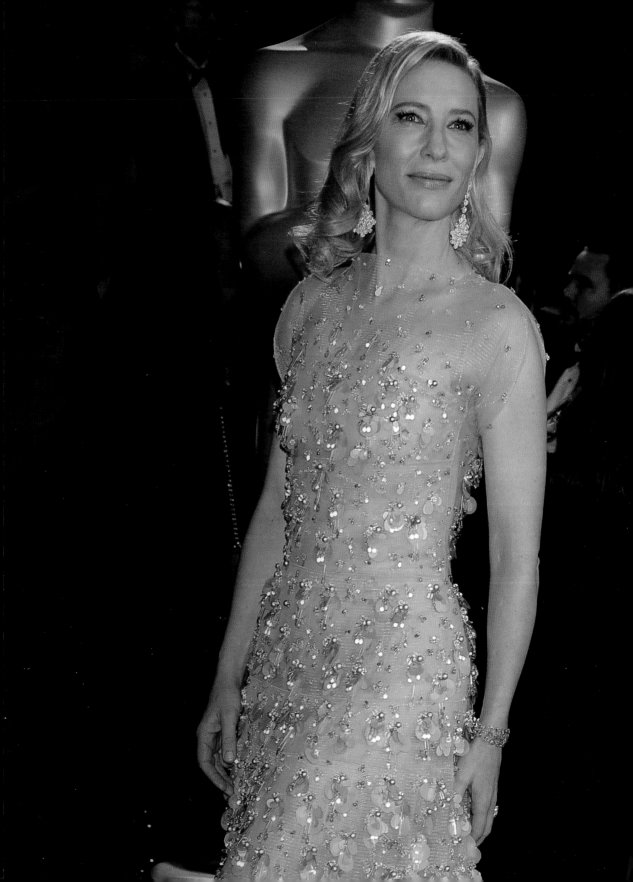

Frank Trapper is an acclaimed celebrity photographer who has been shooting the Hollywood scene for more than forty years. His images have appeared in numerous magazines and newspapers around the world, including Elle, Entertainment Weekly, Harpers Bazaar, GQ, People, and US Weekly. Based in Los Angeles, Trapper is represented by Getty Images.

Photo captions, pages 1 through 15:

1: **Drew Barrymore** (in Monique Lhuillier), Emmy Awards, 2009; 2-3: **Jennifer Lopez** (in Jean Dessès), Academy Awards, 2006; 4-5: **Brad Pitt** and **Jennifer Aniston**, Emmy Awards, 2004; 6-7: **Jon Voight** with son **James Haven**, daughter **Angelina Jolie**, and mother **Barbara Kamp**, Academy Awards, 1986; 8-9: **Julia Roberts** and **George Clooney**, American Cinematheque Award, 2006; 10-11: **Kelly Osbourne** (in Zac Posen), Golden Globe Awards, 2012; 12-13: **Kyra Sedgwick** (in Armani), Academy Awards, 2006; 14-15: **Milla Jovovich** (in Elie Saab gown, Jacob & Co. jewelry, and Edie Parker clutch), Academy Awards, 2012

Photo captions, pages 300 through 304:

300-301: **Carrot Top**, Blockbuster Movie Awards, 1997; 302-303: **Cate Blanchett** (in Armani Privé and Chopard jewelry), Academy Awards, 2014; 304: **Ariana Grande** (in Tibi), Primetime Creative Arts, Emmy Awards, 2011

The Editors wish to especially thank: The late Barry Sundemeir, who introduced Frank Trapper to Welcome Books, and without whom there would be no *Red Carpet*.

Published in 2018 by Welcome Books
A Division of Rizzoli International Publications, Inc.
300 Park Avenue South
New York, N.Y. 10010
www.rizzoliusa.com

Produced by Welcome Enterprises, Inc.
6 West 18th Street, New York, N.Y. 10011
www.welcomeenterprisesinc.com

Project Director: Lena Tabori
Book Design: Mary Tiegreen
Fashion/Designer Research: Robin Siegel
Editorial Assistant: Montana Bass

© 2018 Welcome Books
Photographs © 2018 Frank Trapper
Frank Trapper is represented worldwide by Getty Images

The following names of organizations, companies, and films, which appear throughout the book, are trademarked and/or registered, as are the trademarks and/or copyrights, as applicable, of various people and entities, each of whom reserve all rights: Academy Awards®, American Express®, American Film Institute®, American Foundation for AIDS Research™, American Music Awards™, Annual Motion Picture Ball™, Annual Pop Awards Dinner-BMI®, APLA™, Artist's Rights Foundation™, ASCAP Awards™, BAFTA/LA®, Billboard Music Awards™, Blockbuster Movie Awards™, Cable ACE Awards™, Christian LaCroix™, Director's Guild Awards®, Diversity Award™, Emmy Awards™, ESPY Awards™, Foreign Press™, GLADD Media Awards™, Golden Eagle Awards™, Golden Globe Awards®, Grammy Awards®, Harley Davidson™, Diversity Awards™, Hollywood Walk of Fame ™, Independent Spirit Awards™, James Bond™, The Lord of the Rings®, Louis Vuitton®, Macy's™, MTV Video Music Awards™, MTV Movie Awards™, MusiCares®, NAACP Image Awards®, Nostros Eagle Awards™, Passion Perfume™, People's Choice Awards™, Planet Hollywood™, Playboy Enterprises International Inc.™, The Rocky Horror Picture Show™, The SAG Awards®, Star Wars®, Soul train Music Awards™, Teen Choice Awards™, Television Hall of Fame Awards™, The Thalians Annual Ball™, TV Guide Awards™, VH1 Awards™.

All rights reserved. No parts of this book may be reproduced in any form or by any means, electronic or mechanical, including photocopying, or by any information storage or retrieval system, without permission in writing from the publisher.

Library of Congress Cataloging-in-Publication Data

Trapper, Frank.
 Red carpet : 20 years of fame and fashion / photographs by Frank Trapper.
 p. cm.
 ISBN 978-1-59962-143-2 (alk. paper)
 1. Glamour photography. 2. Fashion photography. 3. Celebrities--Portraits.
 4. Trapper, Frank. I. Title.
 TR678.T73 2007
 779'.2--dc22

 2017948808

ISBN: 978-1-59962-143-2

PRINTED IN CHINA

FIRST EDITION / 10 9 8 7 6 5 4 3 2 1

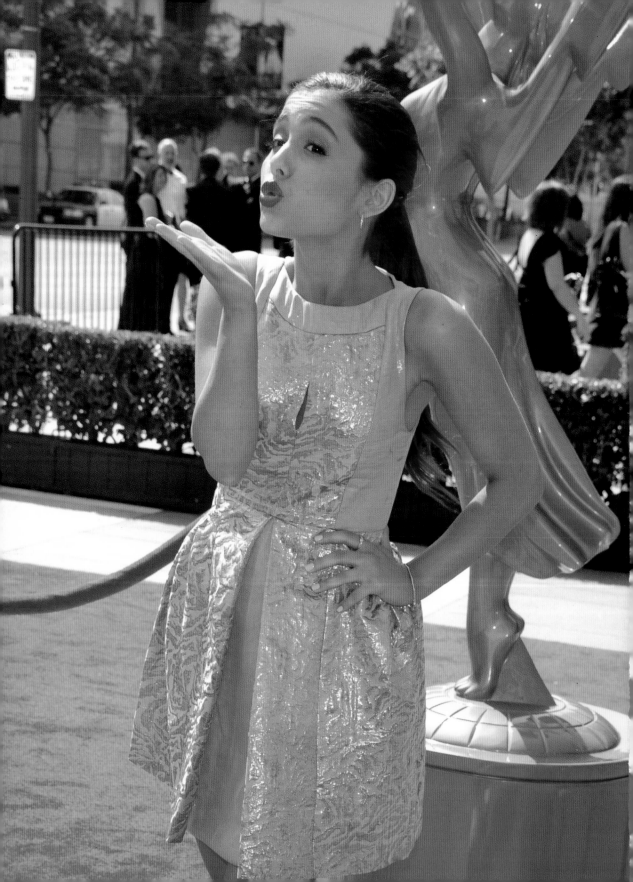

MAR 1 3 2013